THE ART
OF ENDURANCE

All photographs courtesy
of the DPPI photo agency.

DPPI

Texts by:
Alain Pernot and Andrew Cotton
Translated from the French by:
David Waldron

The law of 11 March, 1957, authorizing only, in the terms put forth in subparagraphs 2 and 3 of article 41, on the one hand, "copying and reproduction strictly reserved for the private use of the copying party and not destined for any collective usage", and on the other hand, that any analysis or short quotation, for the purposes of example or illustration, "any representation or reproduction, complete or partial, made without the consent of the editor or his representatives, will be considered a violation of this law (subparagraph article 40). Said representation or reproduction, by whatever means, constitues a violation sanctioned by articles 425 and following of the Penal Code.

© 2025, Éditions Cercle d'Art, Paris
ISBN 978 2 7022 1145 8

THE ART OF ENDURANCE

2024

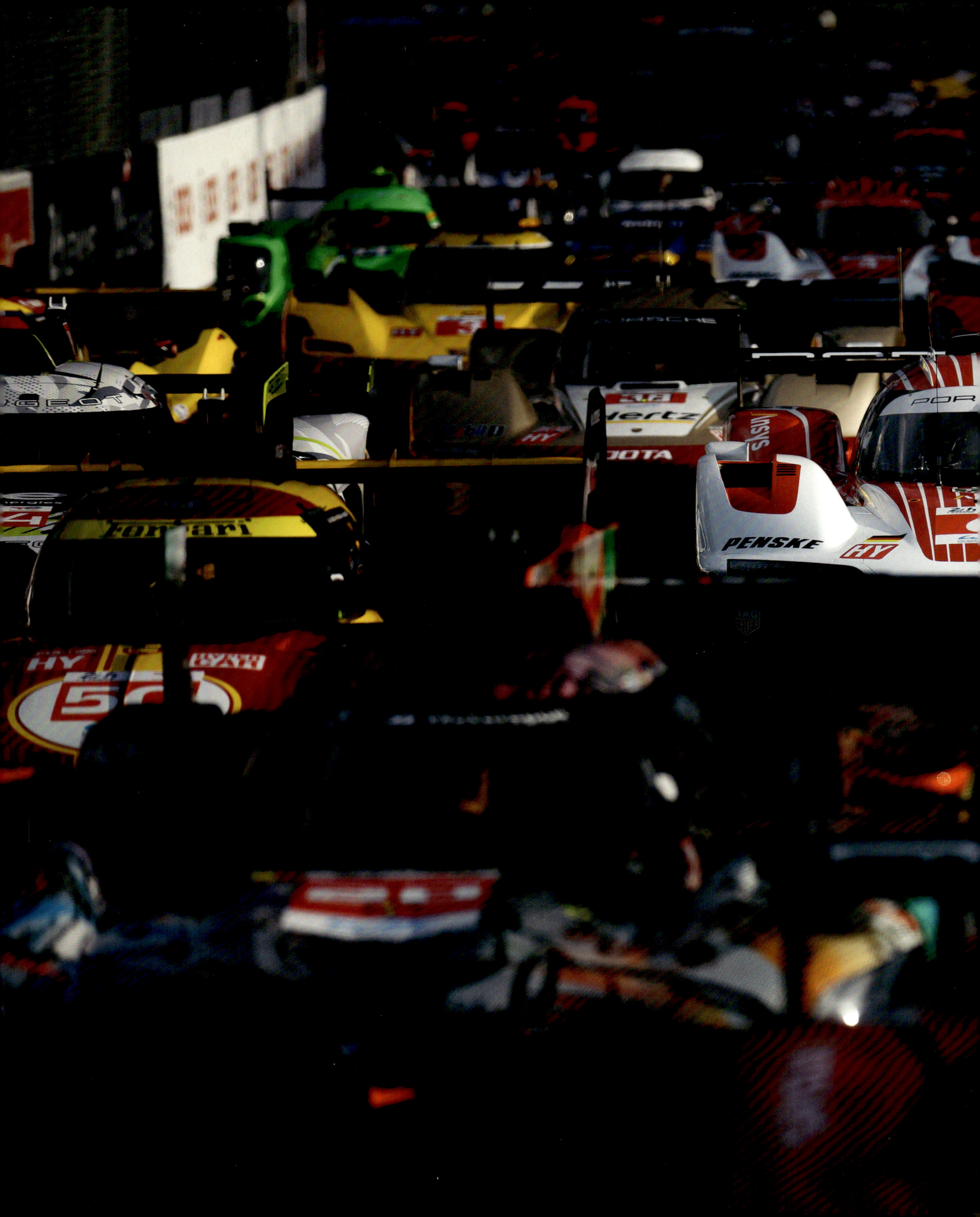

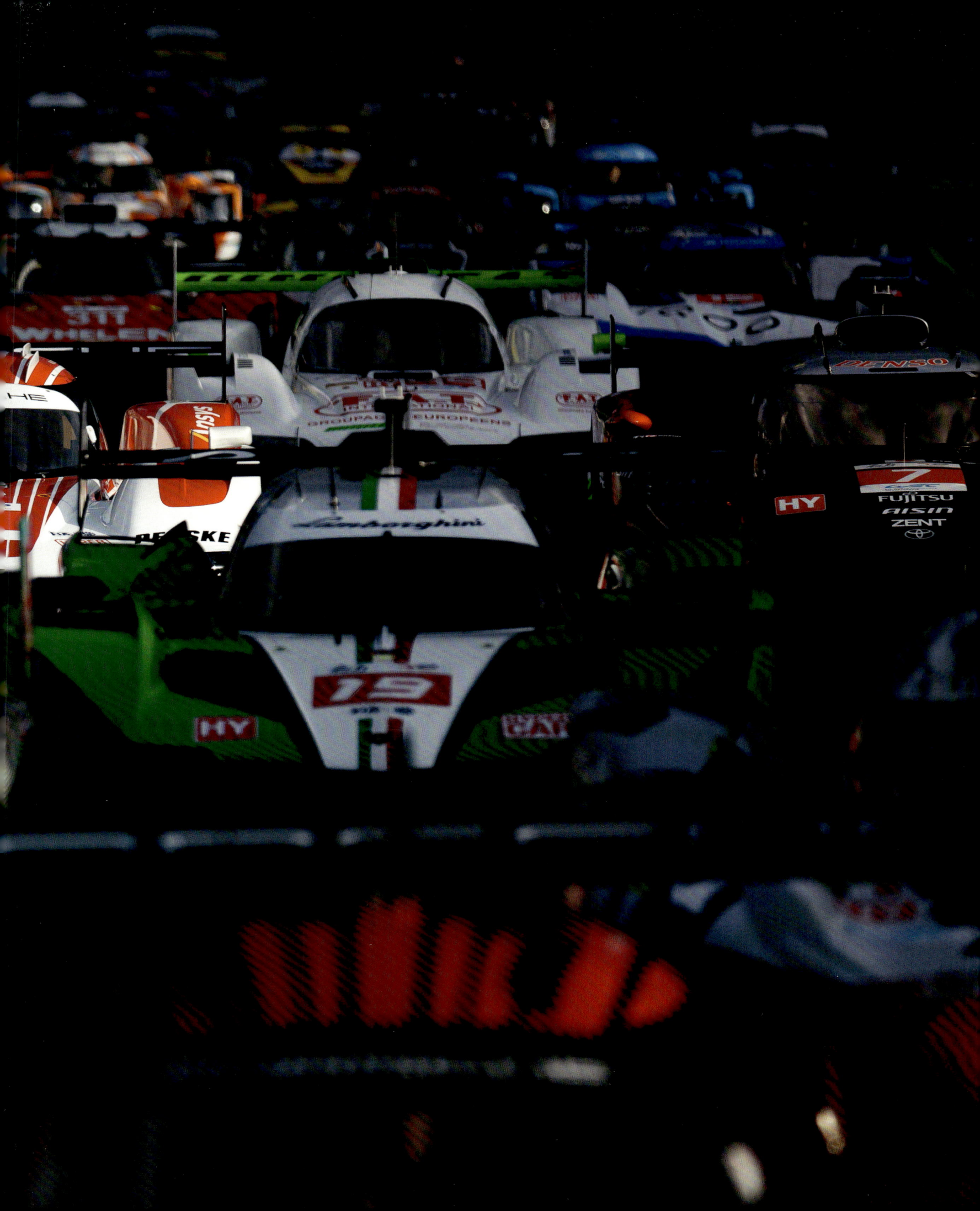

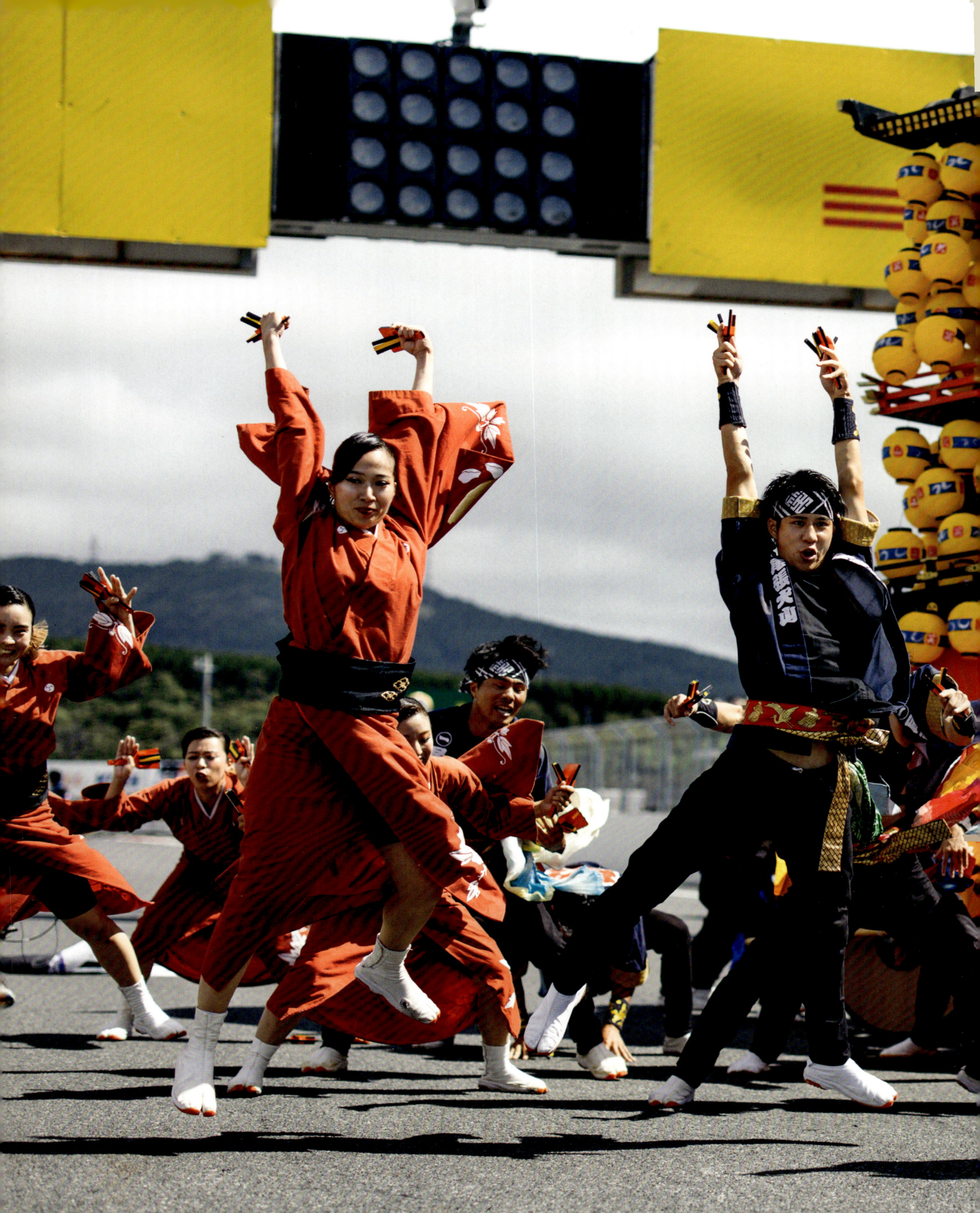

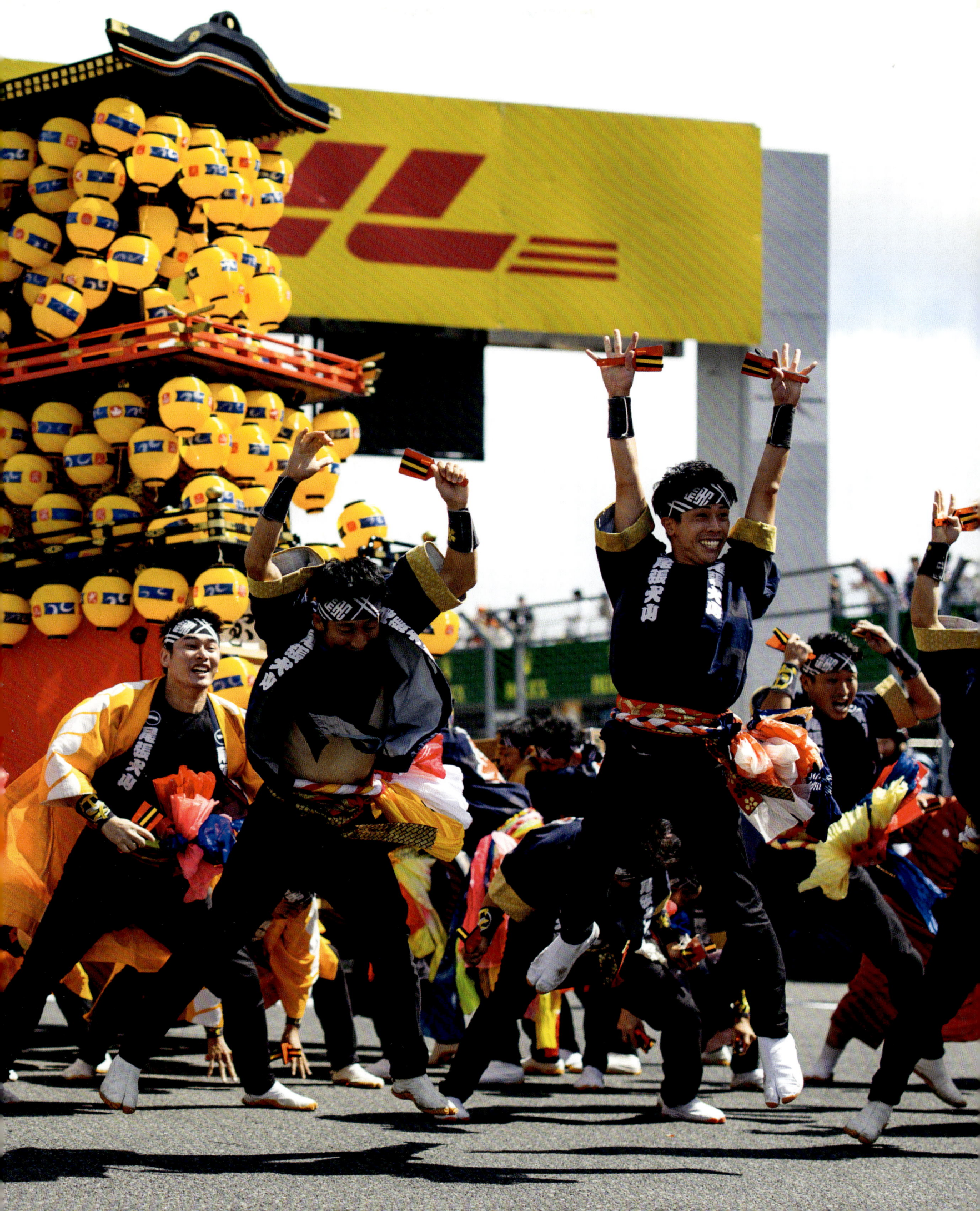

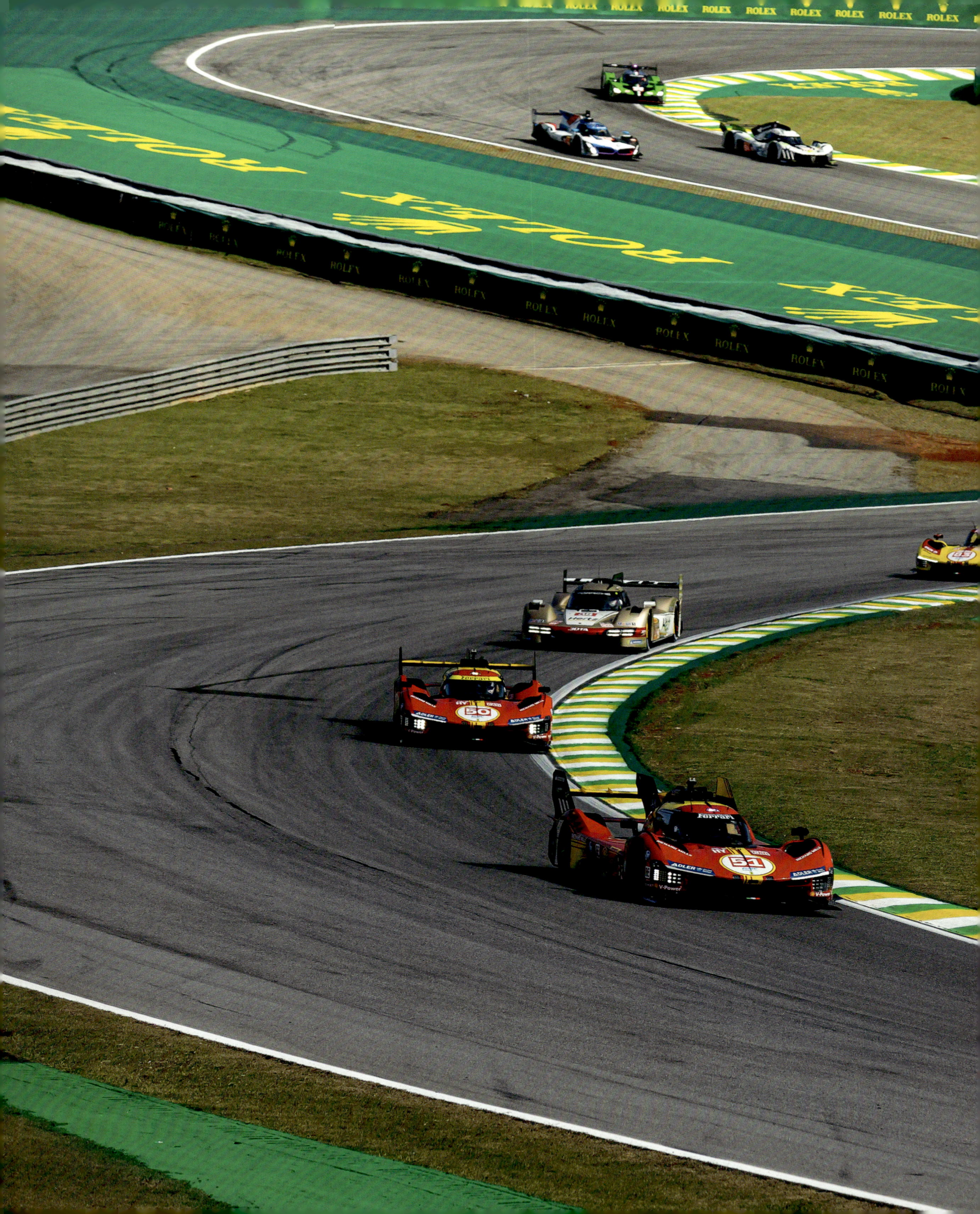

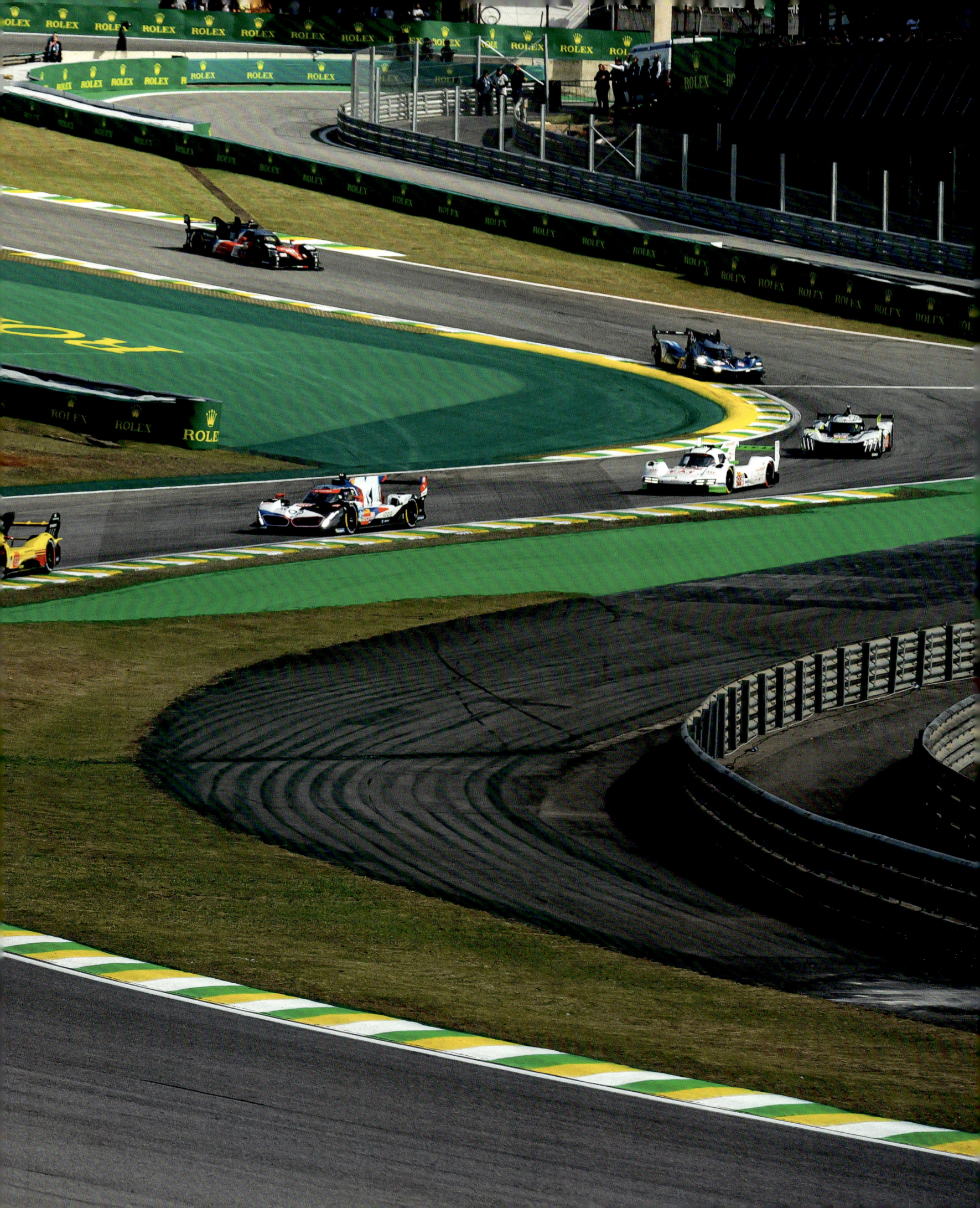

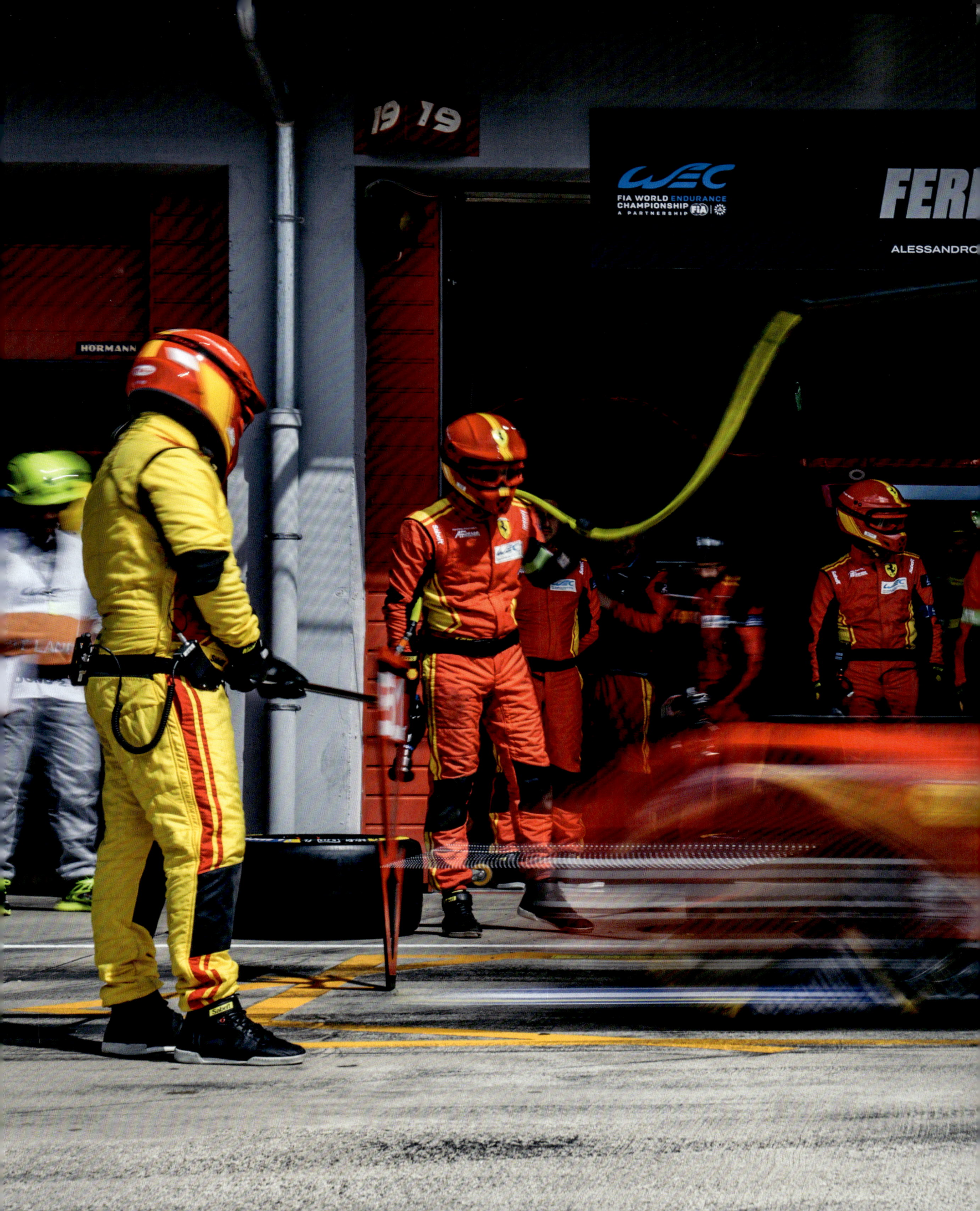

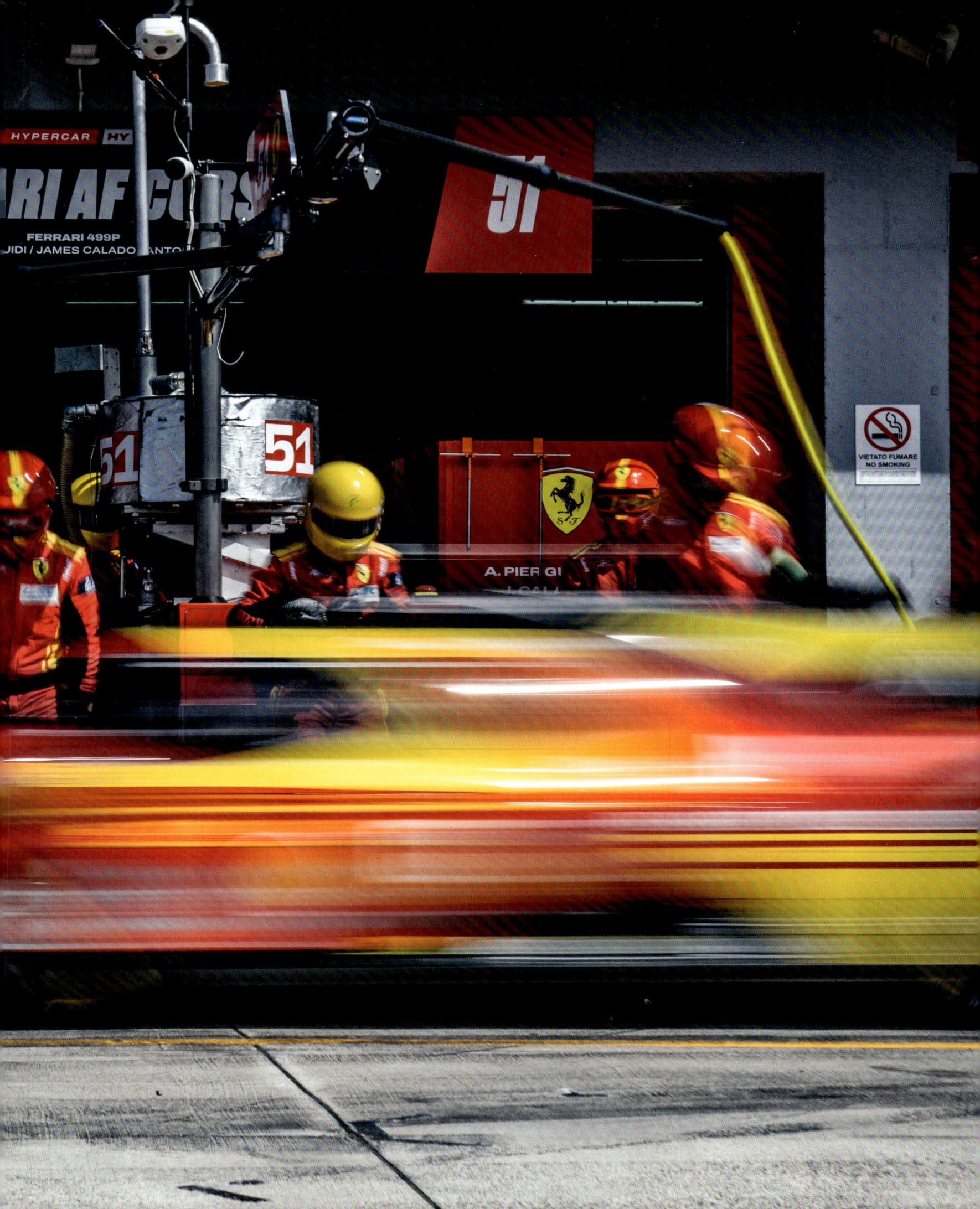

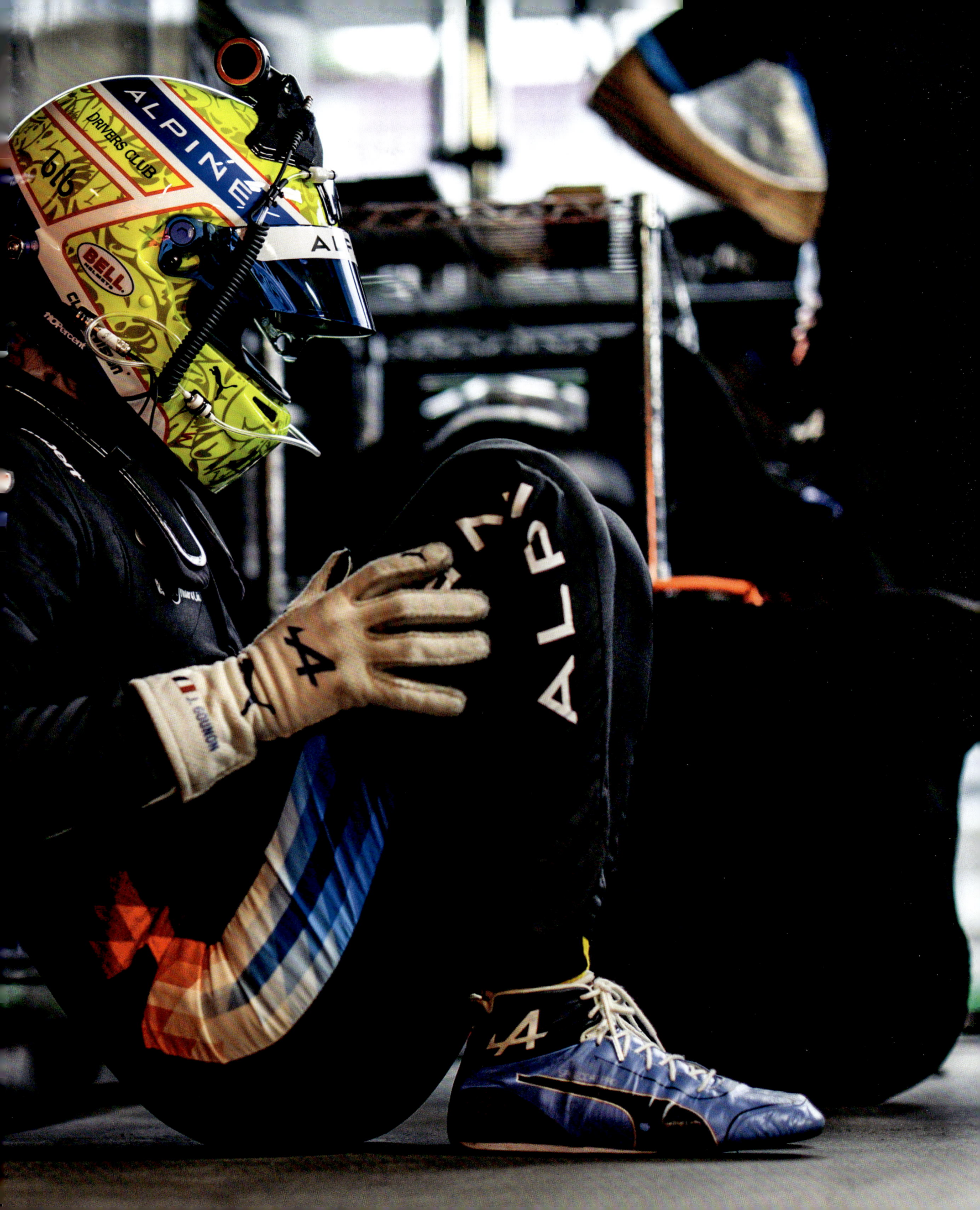

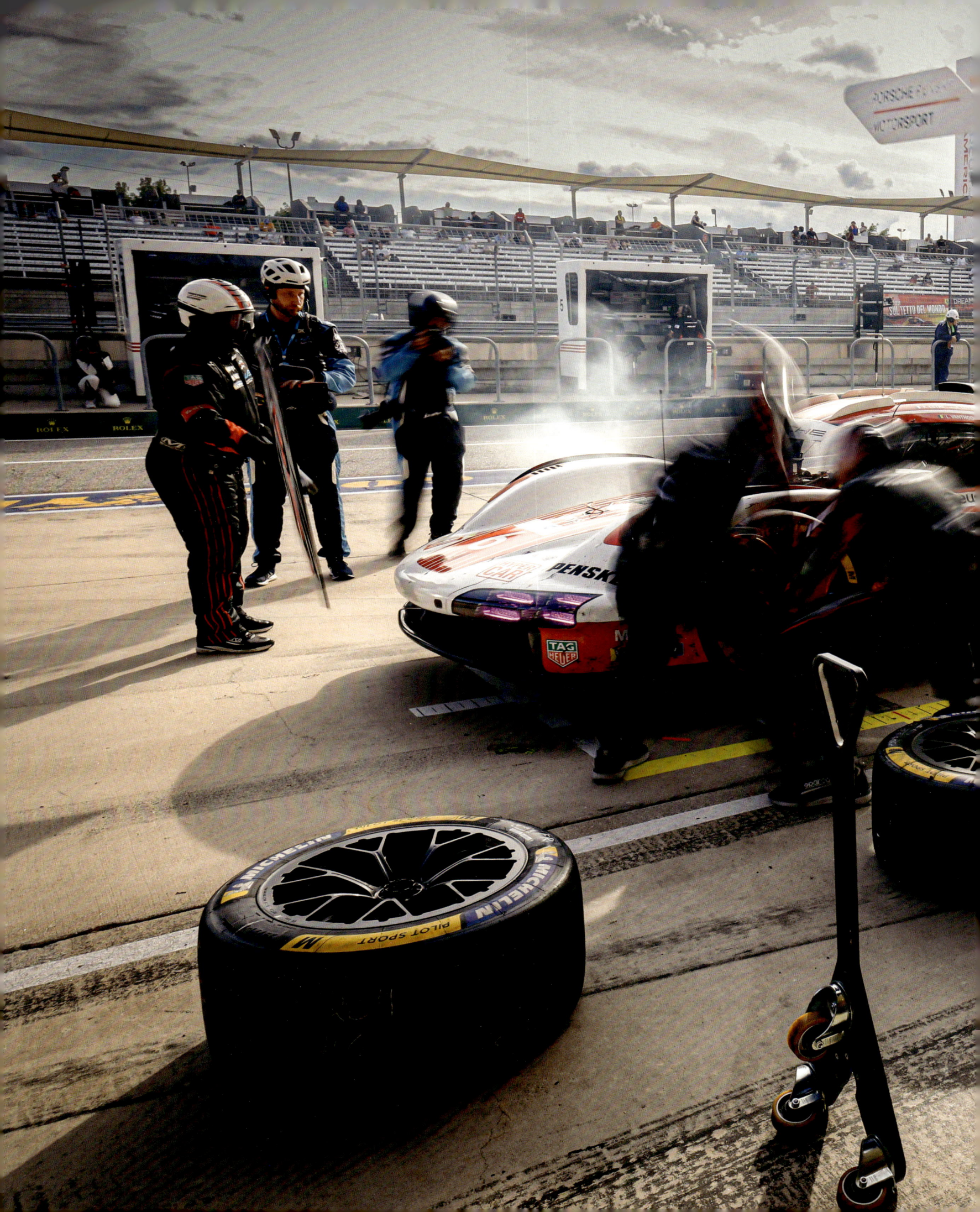

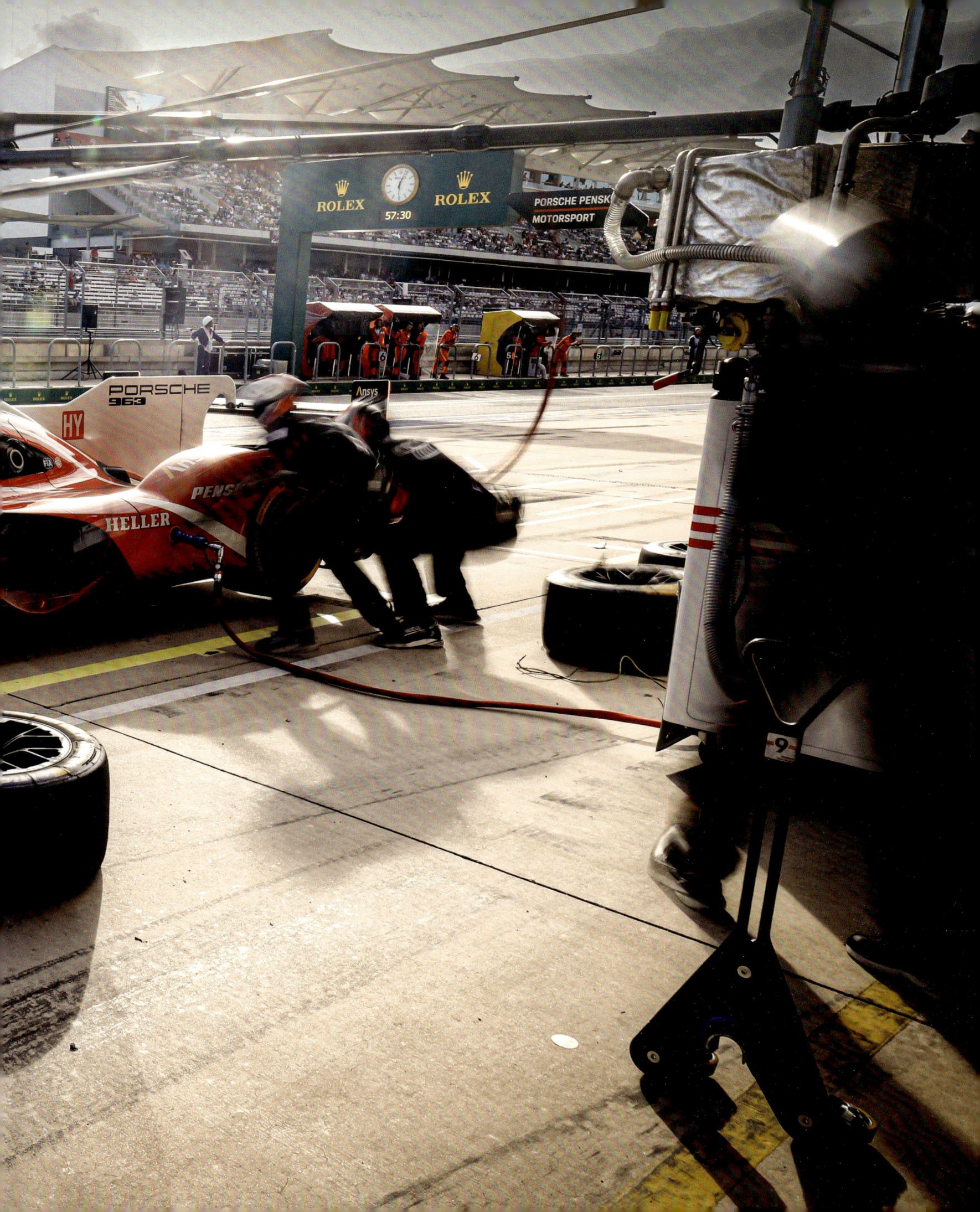

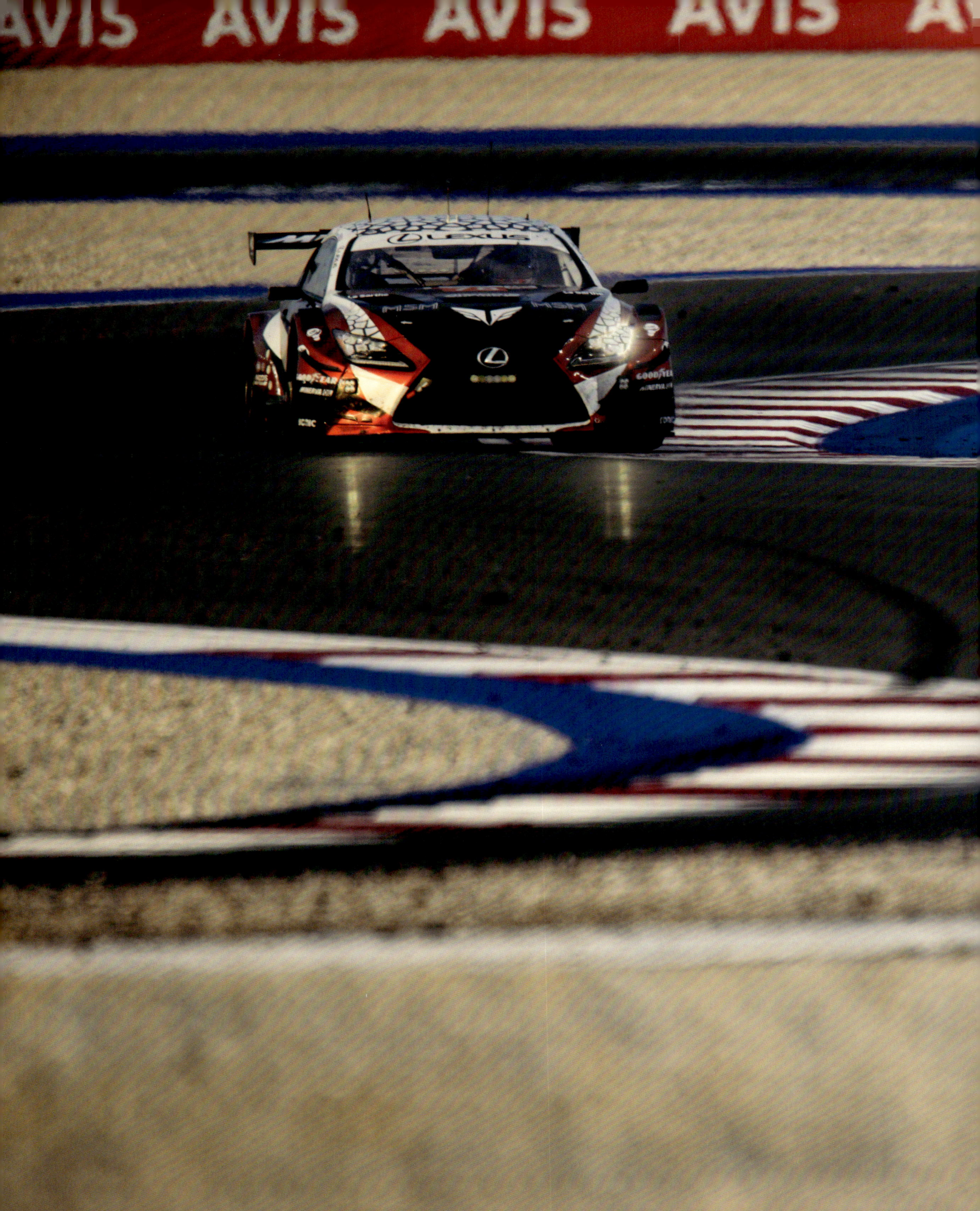

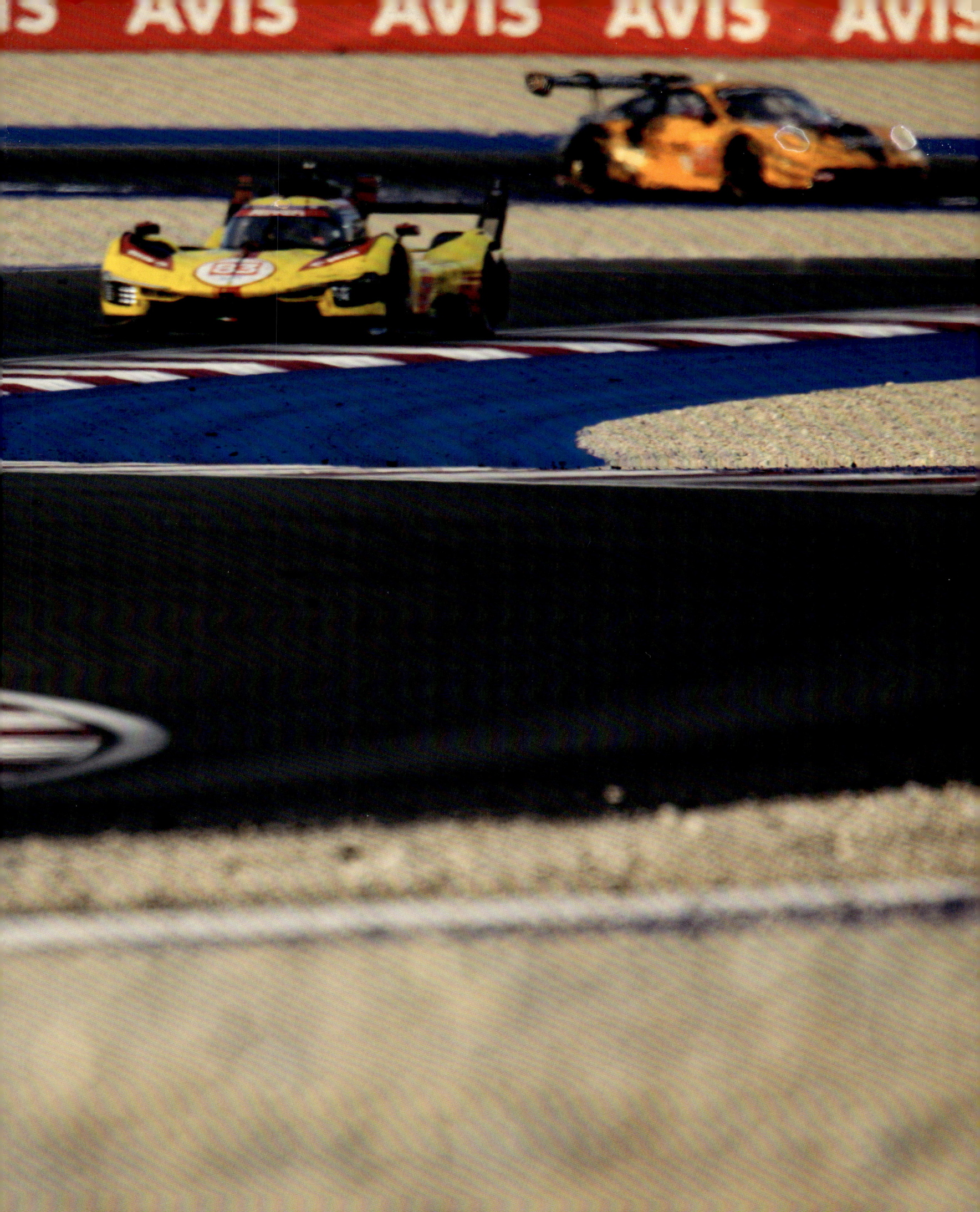

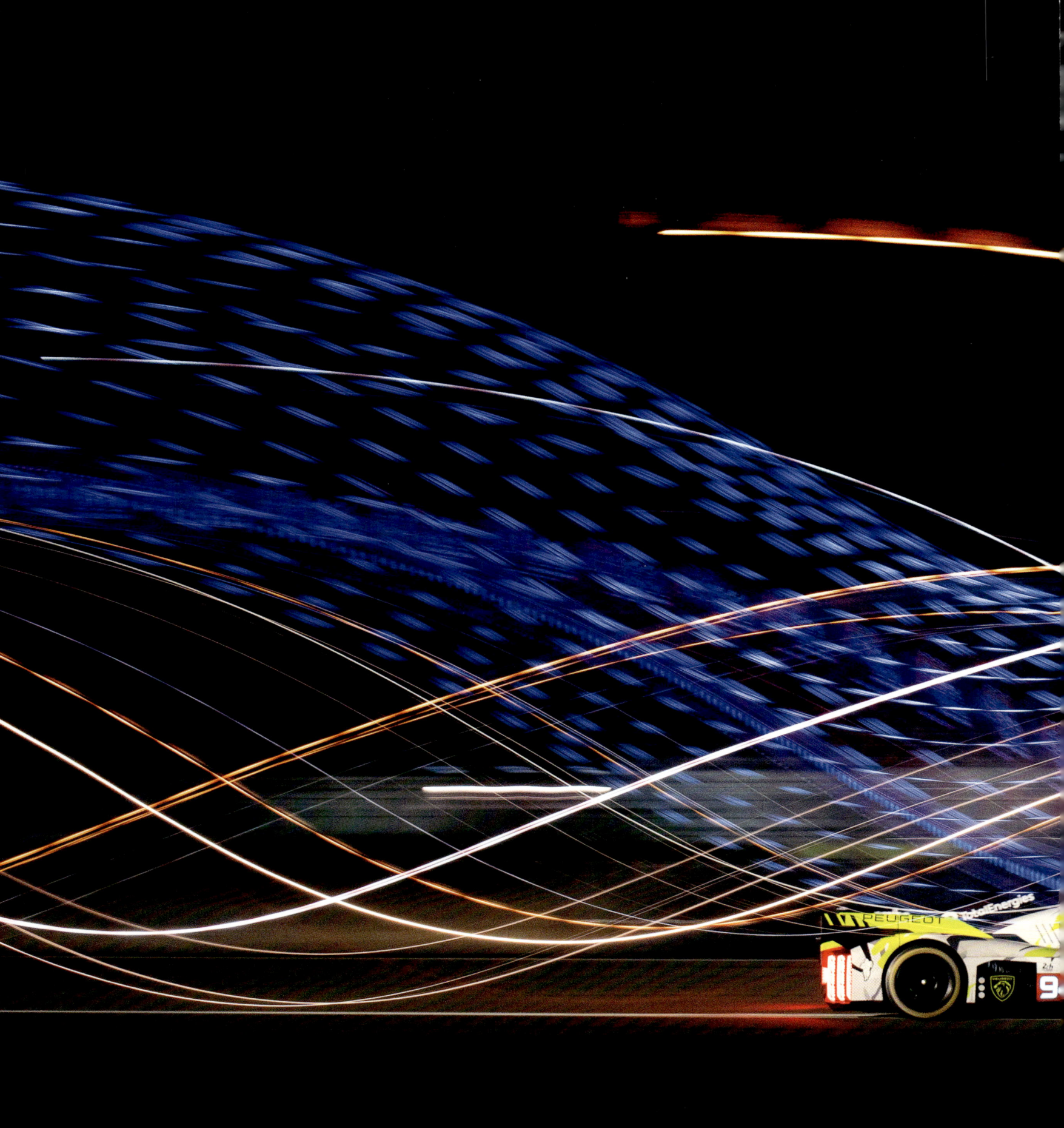

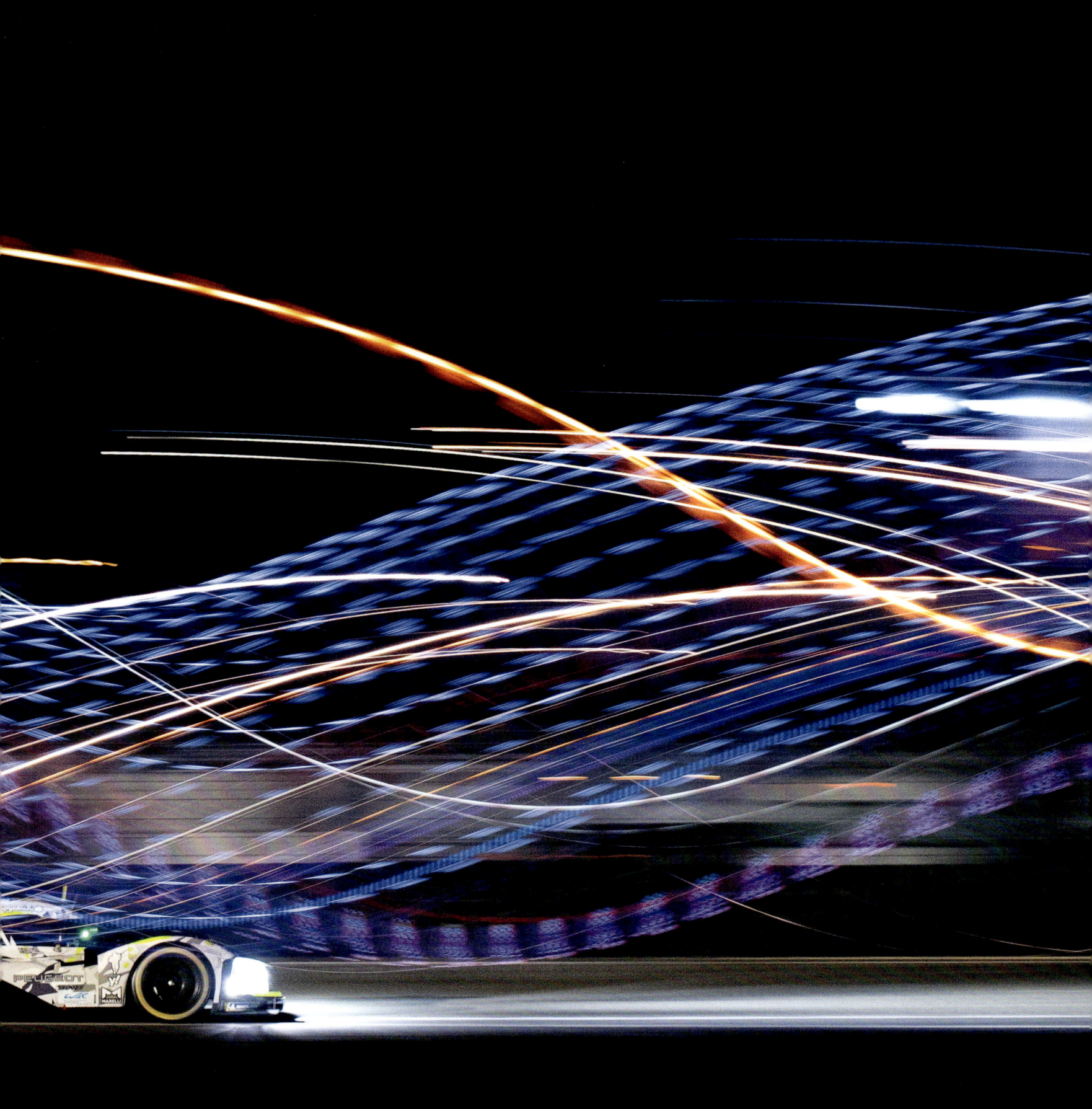

FOREWORD

/ PIERRE FILLON
Automobile Club de l'Ouest (ACO) President

/ FRÉDÉRIC LEQUIEN
FIA World Endurance Championship (FIA WEC) CEO

/ RICHARD MILLE
FIA Endurance Commission President

Welcome to 'The Art of Endurance' – a rare reflection on a sensational season captured in photographic perfection.

This premium and prestigious new publication is not only a celebration of camerawork and the men and women behind the lens, but just as importantly, an exclusive homage to high-speed heroics and the men and women behind the wheel.

The 2024 FIA World Endurance Championship was competitive and compelling in equal measure, for which we must thank and congratulate all of our partners, from the Fédération Internationale de l'Automobile and its President to our wonderful drivers, circuits, manufacturers and teams. This book immortalises the most memorable moments and dazzling duels, while riding the rollercoaster of emotions from the elation of victory to the despair of defeat.

Inspired by the most famous *livres d'art*, it is a sumptuous showcase of the power of photography and the essence of endurance racing presented in simple yet elegant style. Taking the reader on an all-access journey from the curtain-raising contest in Qatar to the title-deciding finale in Bahrain, the following pages re-live every highlight of a truly exceptional campaign in captivating colour.

Far from merely a photographic review, *The Art of Endurance* offers an unprecedented immersion into the universe of cutting-edge performance and pushing to the limit – values synonymous with success and hardcoded in the FIA World Endurance Championship's DNA since day one.

The incomparable images are interspersed with race recaps and exclusive interviews shining a spotlight on key figures, from the champions inside the cockpit to the unsung stars behind-the-scenes – every last one pulling out all the stops in the relentless pursuit of glory.

The Art of Endurance is a remarkable endeavour and a vibrant visual souvenir of a seminal season – the beginning of endurance racing's brightest era to-date. We invite you to enjoy it at your leisure, easing off the gas awhile to absorb every intricate insight before we pick up the pace ready to do it all over again in 2025...

CONTENTS

27
THE ARTISTS

- 28 ALPINE
- 30 ASTON MARTIN
- 32 BMW
- 36 CADILLAC
- 38 CORVETTE
- 40 FERRARI
- 44 FORD
- 46 ISOTTA FRASCHINI
- 48 LAMBORGHINI
- 52 LEXUS
- 54 McLAREN
- 56 PEUGEOT
- 58 PORSCHE
- 62 TOYOTA

64
MOTION ART

- 66 **ROUND 01** QATAR AIRWAYS QATAR 1812KM
- 94 **PIT STOP** *THE DOCTOR'S NEW DRUG*
- 98 **ROUND 02** 6 HOURS OF IMOLA
- 134 **PIT STOP** *KAMUI KOBAYASHI*
- 138 **ROUND 03** TOTALENERGIES 6 HOURS OF SPA-FRANCORCHAMPS
- 168 **PIT STOP** *SAM HIGNETT*
- 172 **ROUND 04** 24 HOURS OF LE MANS
- 220 **PIT STOP** *ANTONELLO COLETTA*
- 224 **ROUND 05** ROLEX 6 HOURS OF SÃO PAULO
- 254 **PIT STOP** *BREAKING DOWN BARRIERS*
- 258 **ROUND 06** LONE STAR LE MANS
- 288 **PIT STOP** *ANDRÉ LOTTERER*
- 292 **ROUND 07** 6 HOURS OF FUJI
- 324 **PIT STOP** *NICOLAS RAEDER*
- 328 **ROUND 08** BAPCO ENERGIES 8 HOURS OF BAHRAIN

356
RACE DATA

With nine carmakers disputing the headlining Hypercar division and just as many brands committing to the new LMGT3 category, the entry list for the 2024 FIA World Endurance Championship was exceptional – and illustrative of an unprecedented level of manufacturer interest in the sport.

THE ARTISTS

ALPINE

HYPERCARS

Alpine A424
Alpine Endurance Team

#35
Paul-Loup Chatin
Ferdinand Habsburg
Charles Milesi
Jules Gounon (Imola, Spa, Fuji, Bahrain)

#36
Nicolas Lapierre
Mick Schumacher
Matthieu Vaxiviere
Charles Milesi (Bahrain)

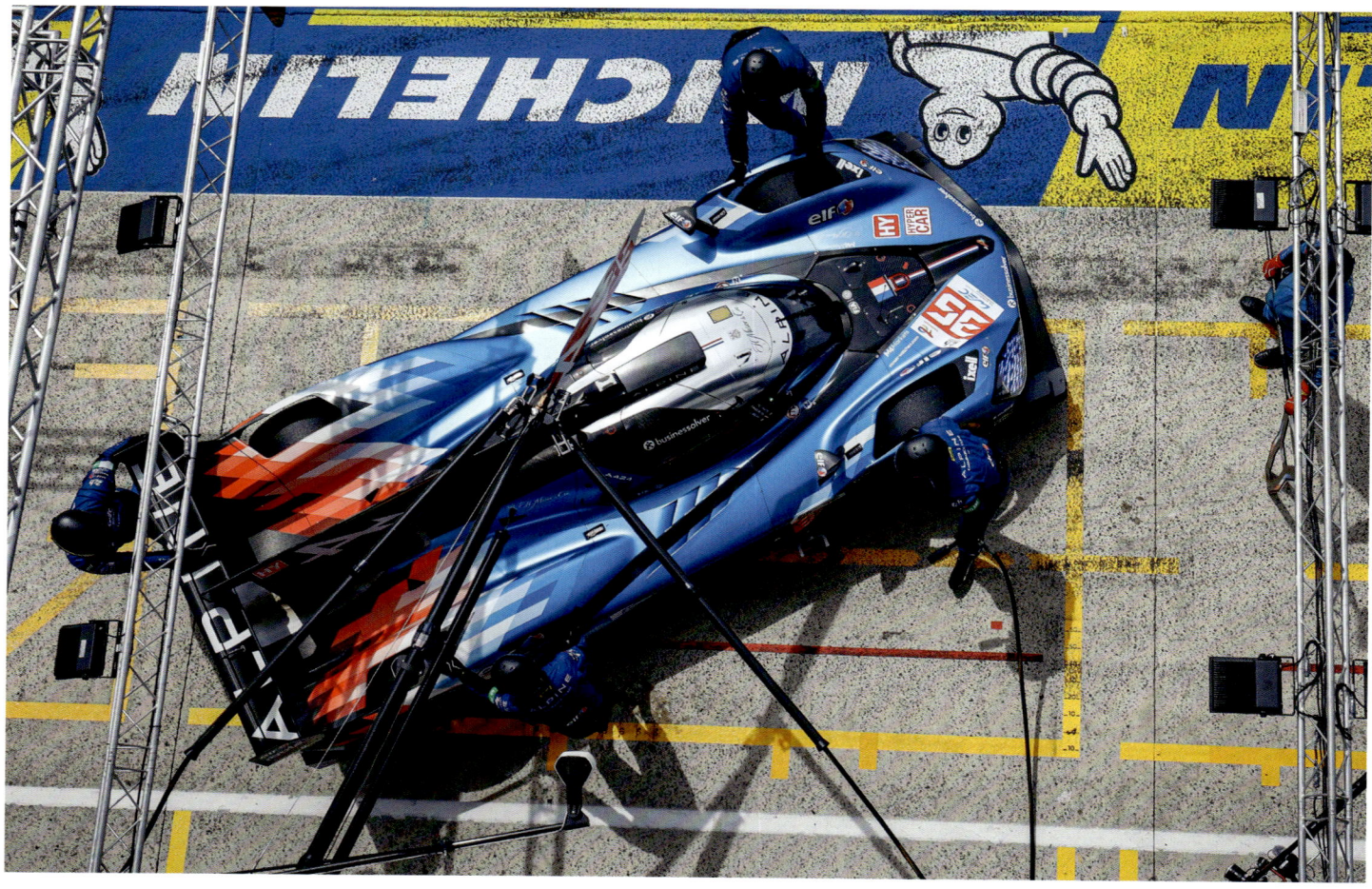

While attending the 24 Hours of Le Mans
in 2021, Luca De Meo, CEO of the Renault Group,
probably had no idea that he would fall under
the spell of endurance racing, but he did,
and that made the decision to join
the FIA World Endurance Championship inevitable.
In addition to its Formula 1 commitment,
Alpine was tasked with representing the brand
in Hypercar, the pinnacle of the discipline.
Alpine had long been a front-running team
in LMP2 with its partner Signatech Racing,
and entered the top class in 2024
with direct involvement from Alpine Racing.
The Alpine A424's very assertive style embodies
the lines of the brand's future road-going models.

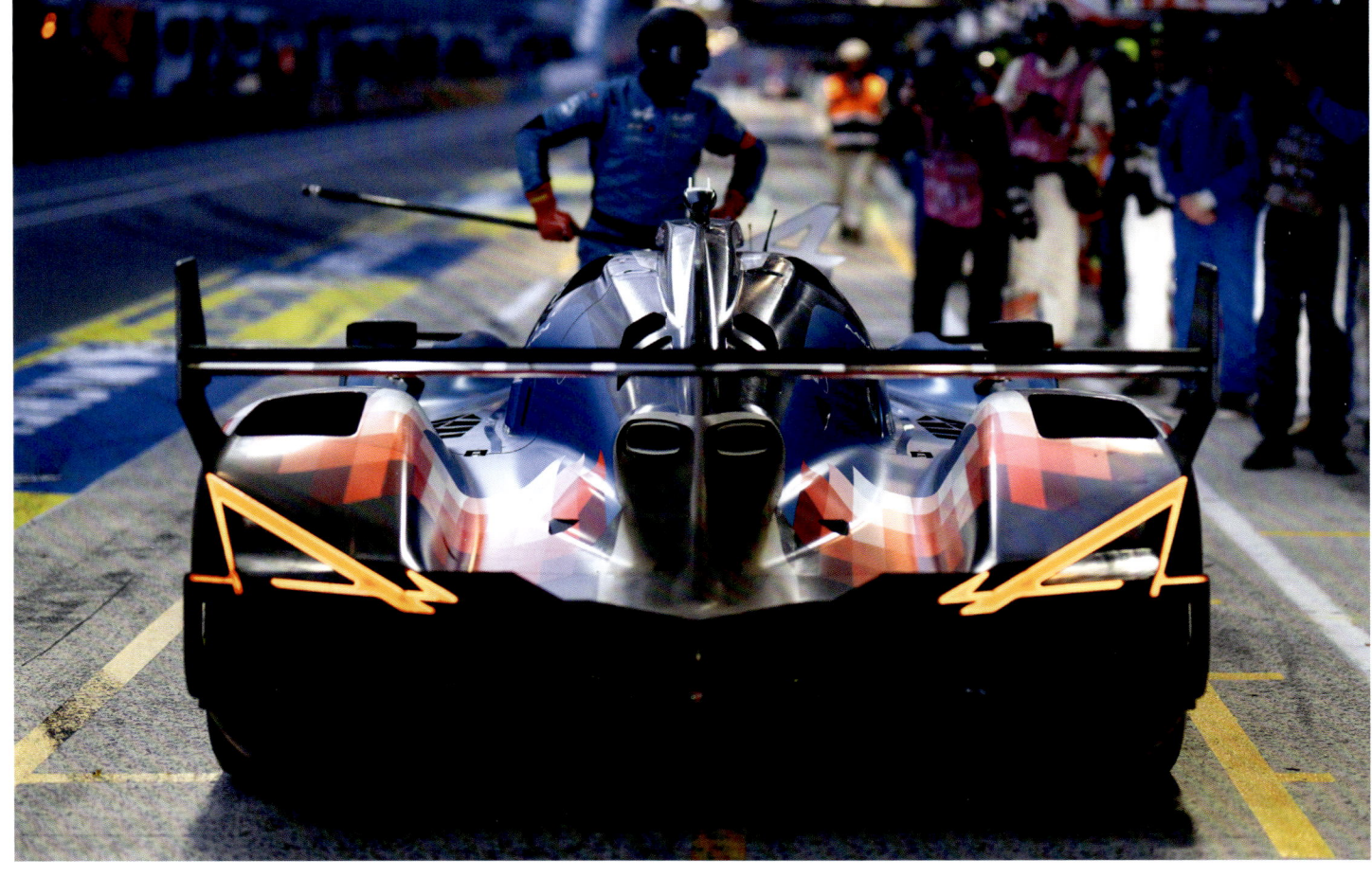

ASTON MARTIN

LMGT3 CARS

Aston Martin Vantage AMR LMGT3

#27
Heart of Racing Team
Ian James
Daniel Mancinelli
Alex Riberas

#777
D'Station Racing
Clément Mateu
Marco Sørensen
Erwan Bastard
Satoshi Hoshino (Le Mans)

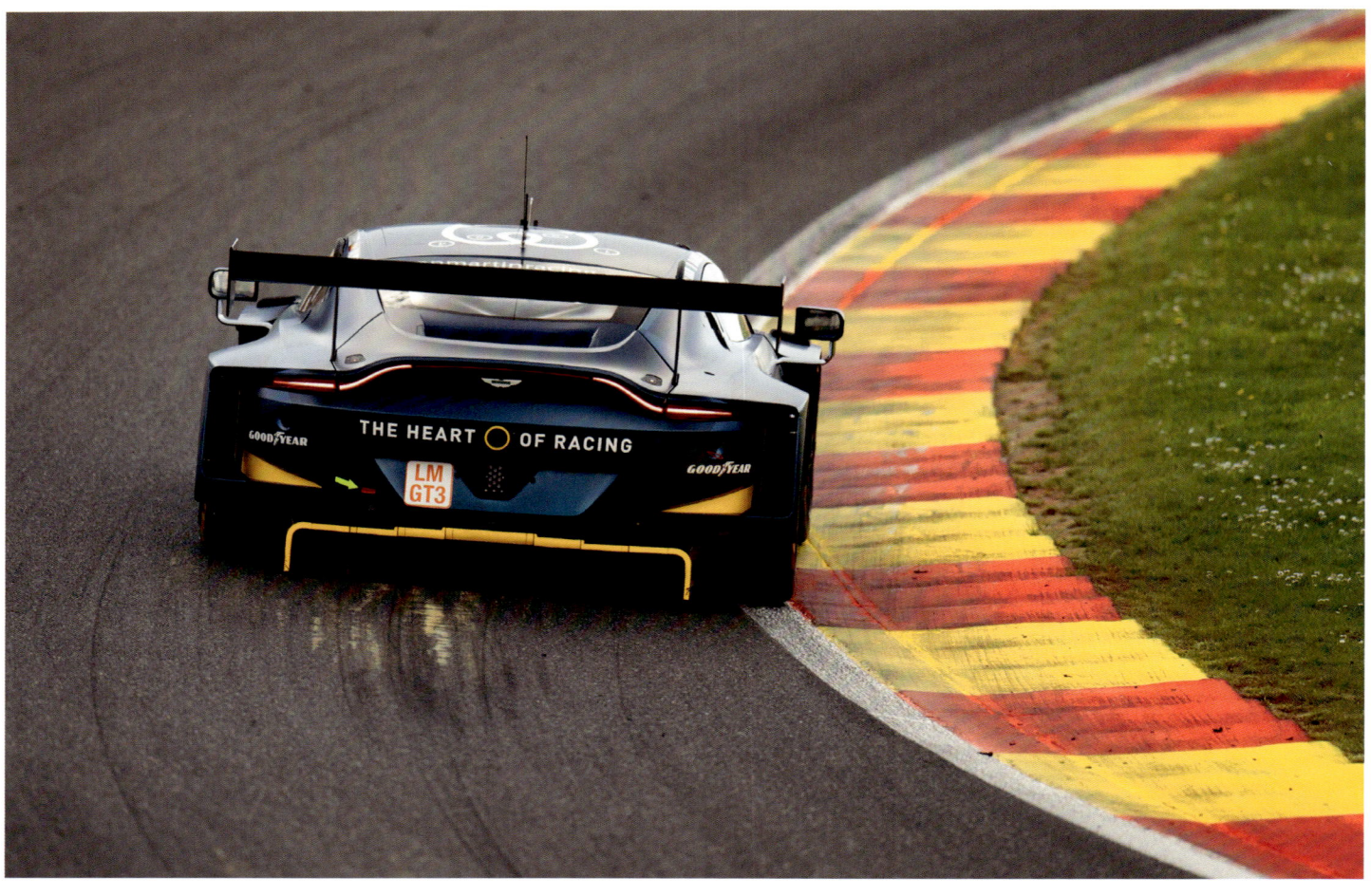

As a pillar of LMGTE competition since the creation of the World Championship in 2012, it was entirely natural that Aston Martin Racing should continue to contest the top GT class, now called LMGT3. To best prepare for this new challenge, the Gaydon firm brought out an updated version of its Vantage AMR – based upon the road-going car – which was entrusted to both America's Heart of Racing Team and Japanese outfit, D'Station Racing.

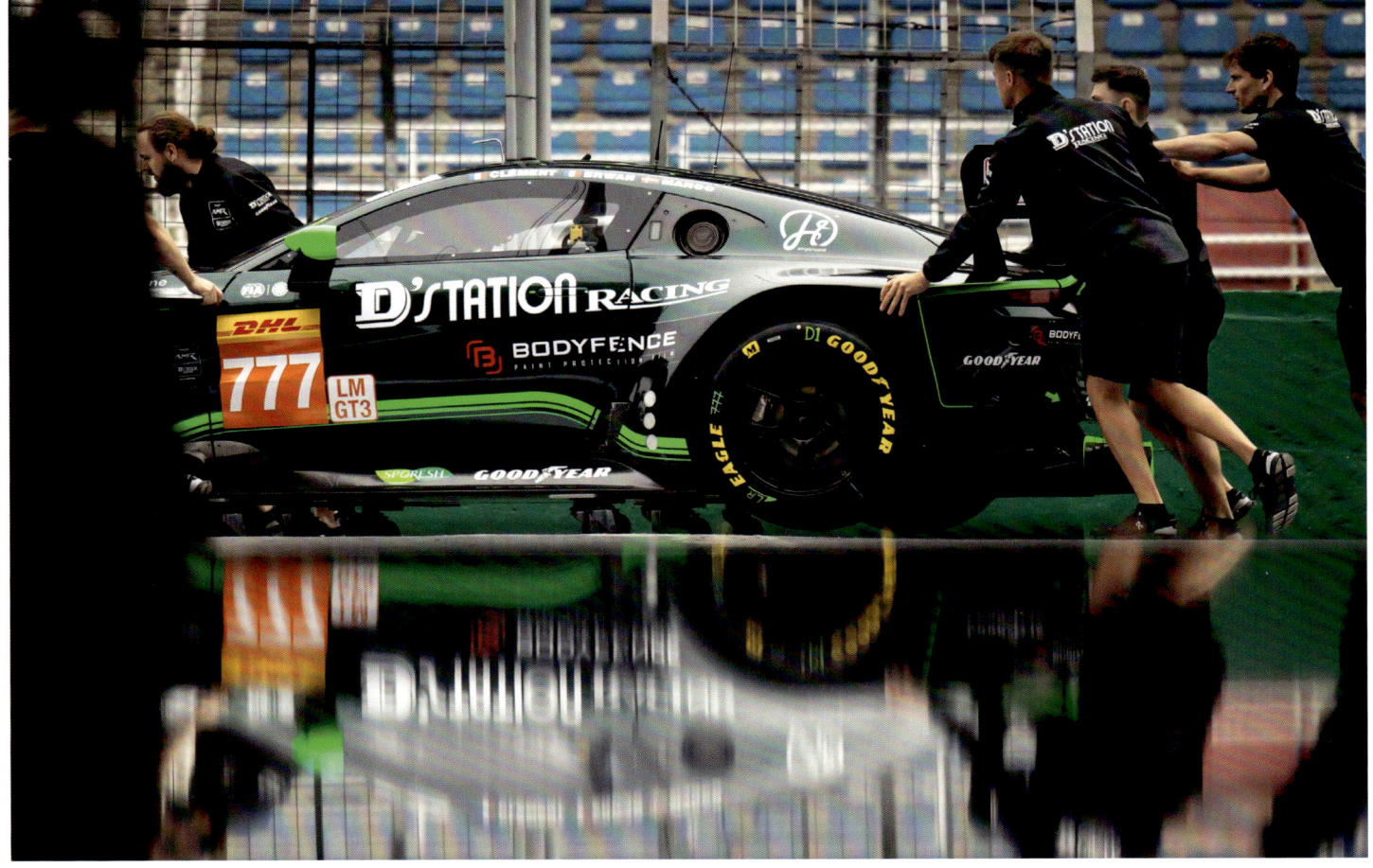

BMW

HYPERCARS

BMW M Hybrid V8
BMW M Team WRT

#15
Dries Vanthoor
Raffaele Marciello
Marco Wittmann

#20
Sheldon van der Linde
Robin Frijns
René Rast

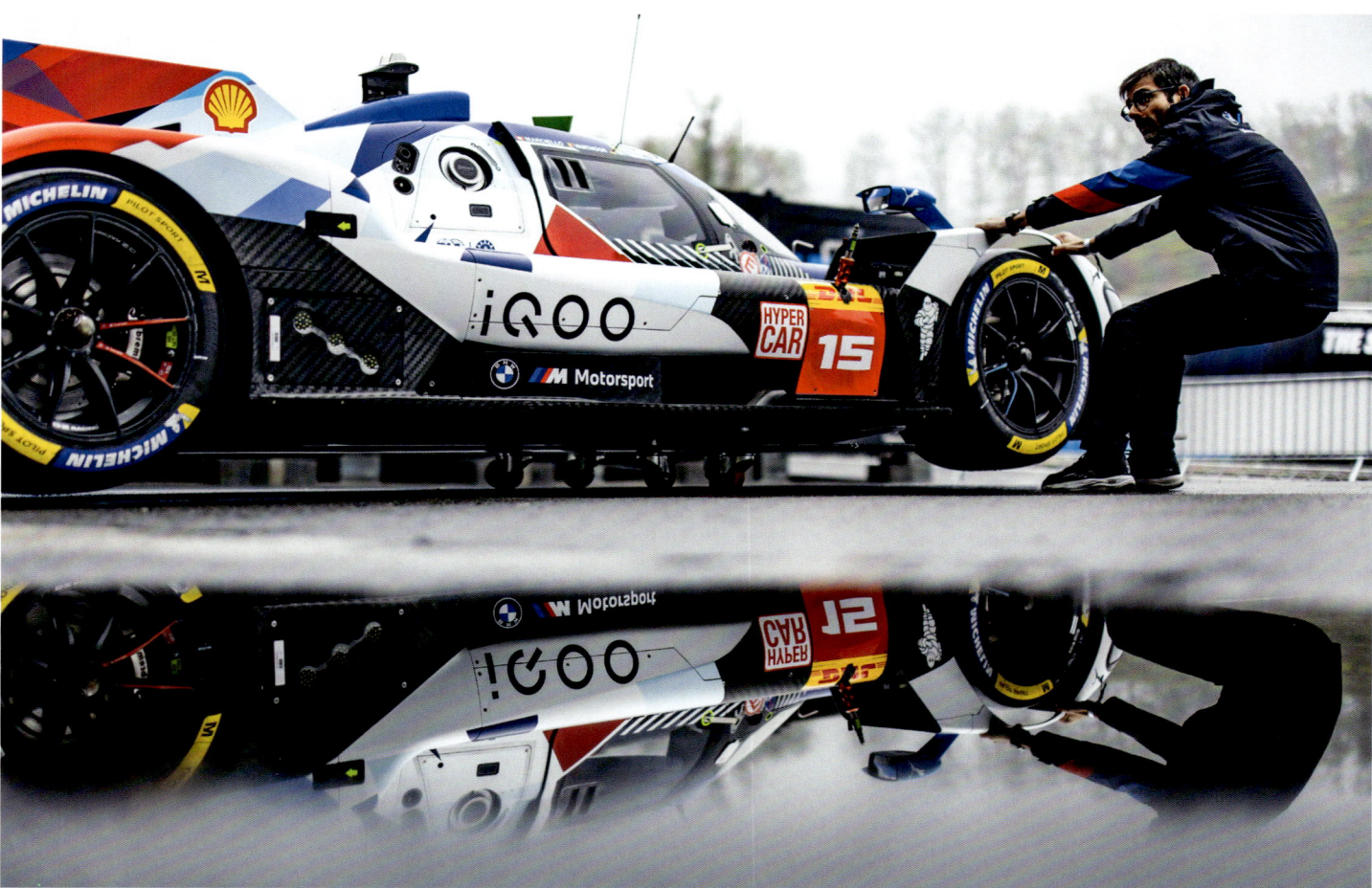

After a low-key participation in the FIA World Endurance Championship's LMGTE class during the 2018-2019 campaign, BMW made an impressive return in 2024 to compete in both LMGT3 and Hypercar.
The Bavarian brand was one of four to launch a simultaneous attack on the two WEC categories. The M Hybrid V8s raced in the USA in 2023, with Belgium's Team WRT subsequently given the responsibility of running them on the World Championship circuits alongside the M4 LMGT3 programme.
To the great joy of many motorsport fans, former motorcycling world champion Valentino Rossi stepped up to compete in multi-class racing in the LMGT3 division.

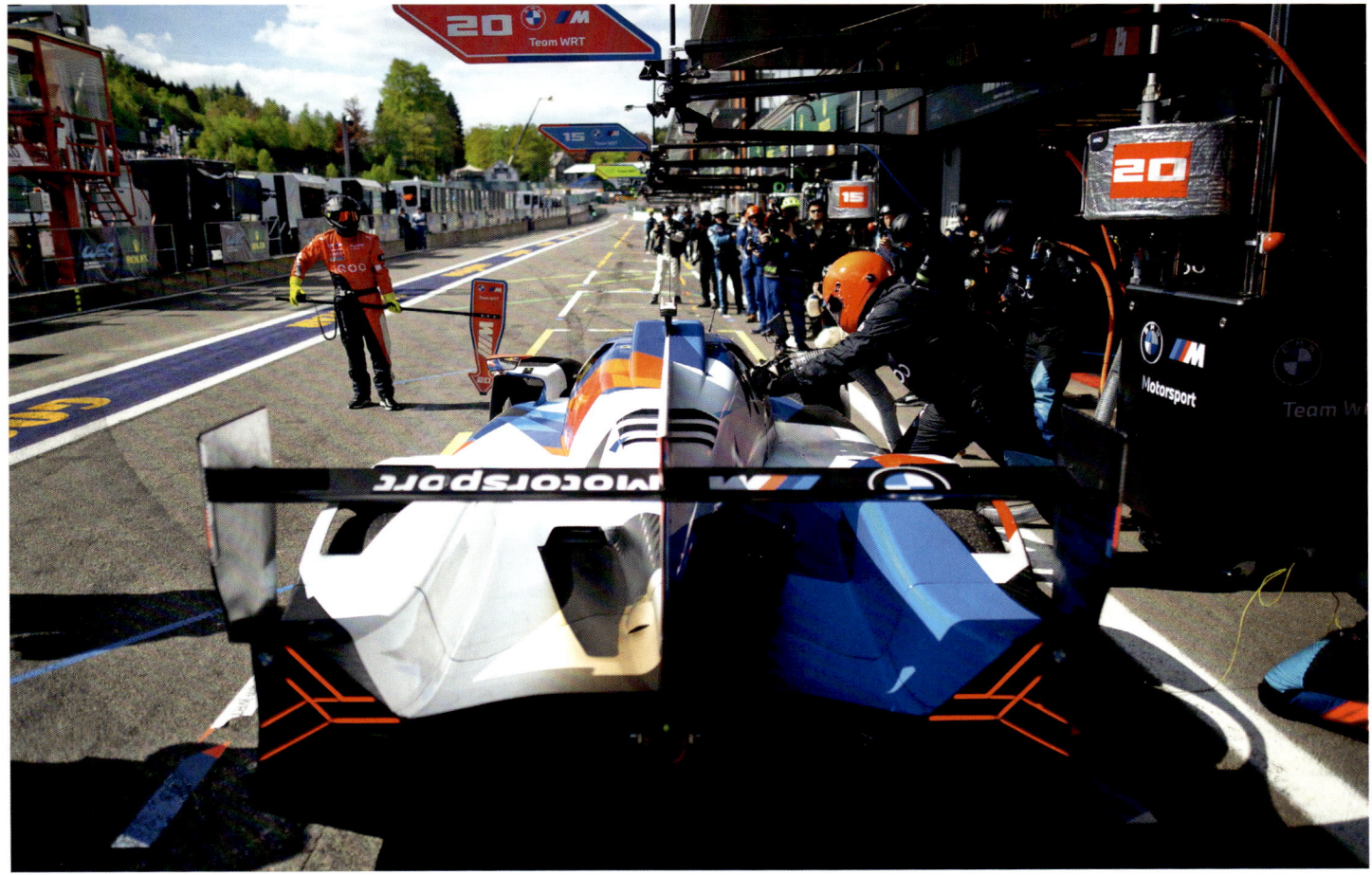

BMW

LMGT3 CARS

BMW M4 LMGT3
Team WRT

#31
Darren Leung
Sean Gelael
Augusto Farfus

#46
Ahmad Al Harthy
Valentino Rossi
Maxime Martin

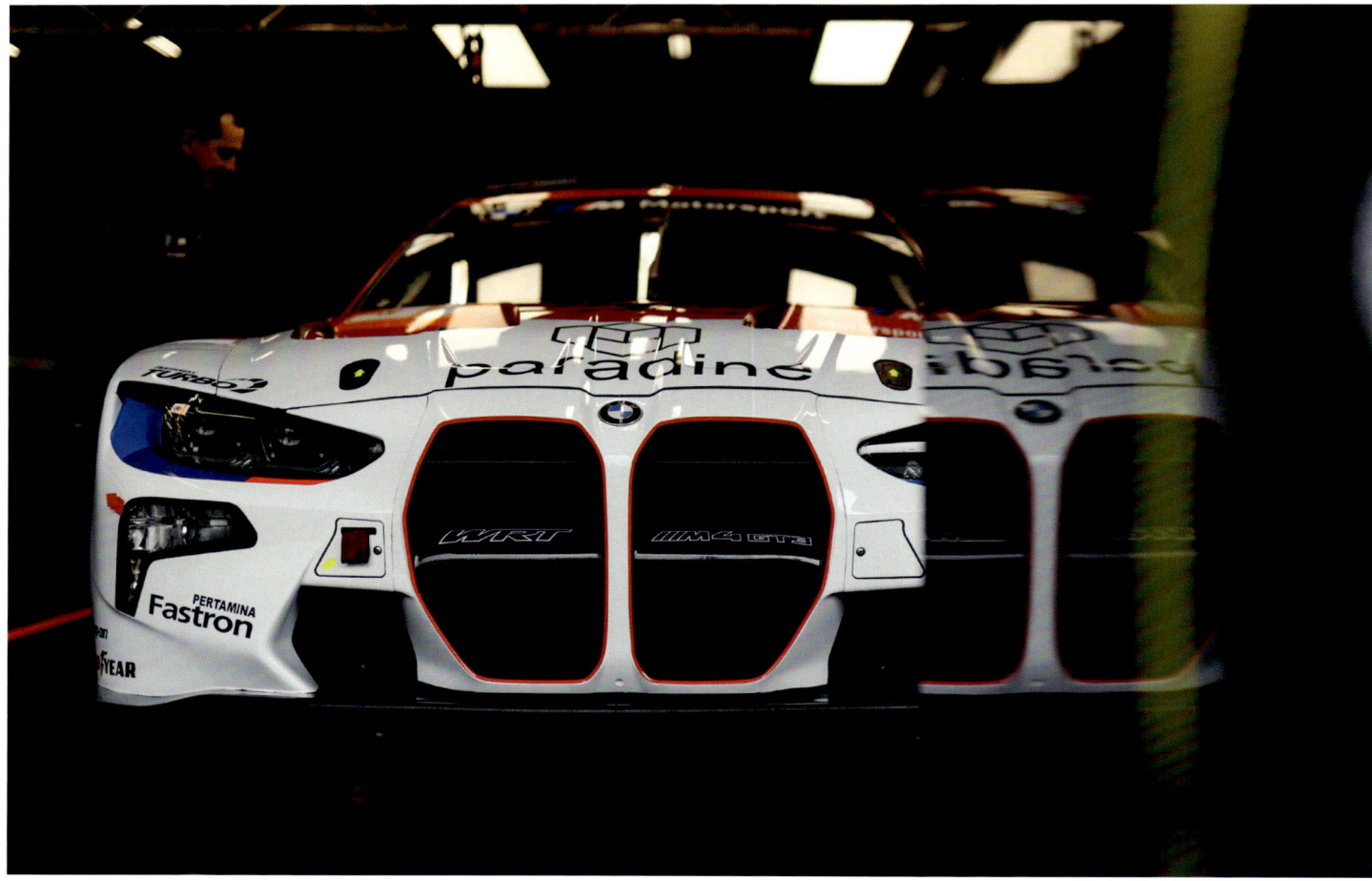

CADILLAC

HYPERCAR

Cadillac V-Series.R
Cadillac Racing

#2
Earl Bamber
Alex Lynn
Alex Palou (Le Mans)
Sébastien Bourdais (Qatar, Bahrain)

General Motors' luxury car brand,
which had already raced in the United States
with considerable success, took on the challenge
of the World Championship in 2023.
Its V-Series.R is the only Hypercar powered
by a naturally-aspirated V8 engine, with its unique
sound proving an instant fan-favourite.
Its debut season in 2023 was highlighted
by a superb podium finish in the 24 Hours
of Le Mans. Operated by Chip Ganassi Racing
in both the US and the World Championship,
the Cadillac team came into 2024 with a better
understanding of its car and great ambitions,
but it took a gamble by entering only one V-Series.R,
usually piloted by just two drivers.

CORVETTE

LMGT3 CARS

Corvette Z06 LMGT3.R
TF Sport

#81
Tom Van Rompuy
Rui Andrade
Charlie Eastwood

#82
Hiroshi Koizumi
Sébastien Baud
Daniel Juncadella

A faithful participant in the 24 Hours of Le Mans
since 2000, Corvette had until this year
only contested selected rounds
of the World Championship.
However, in 2024 that all changed.
The General Motors brand decided to develop
a GT3 version of its Corvette to meet
the requirements of the LMGT3 category.
The iconic American car is powered
by a mid-mounted engine and was entered
by the TF Sport team which had previously
raced Aston Martins.

FERRARI

HYPERCARS

Ferrari 499P

#50
Ferrari AF Corse
Antonio Fuoco
Miguel Molina
Nicklas Nielsen

#51
Ferrari AF Corse
Alessandro Pier Guidi
James Calado
Antonio Giovinazzi

#83
AF Corse
Robert Kubica
Robert Shwartzman
Yifei Ye

FERRARI

FERRARI

LMGT3 CARS

Ferrari 296 LMGT3
Vista AF Corse

#54
Thomas Flohr
Francesco Castellacci
Davide Rigon

#55
François Hériau
Simon Mann
Alessio Rovera

The return of Ferrari to the top-tier of endurance
racing in 2023 following a 50-year hiatus
was already an event in itself, with its victory
in the 24 Hours of Le Mans on the 499P's
maiden appearance at La Sarthe resonating
throughout the world of motorsport.
In the wake of its standout inaugural season,
Ferrari AF Corse continued its involvement with
an unchanged team and even greater ambitions.
For 2024, a third car was entered
by AF Corse as a privateer.
Alongside its commitment to Hypercar,
the Maranello firm was also represented
in the LMGT3 category with a pair of 296 LMGT3s.

FORD

LMGT3 CARS

Ford Mustang LMGT3
Proton Competition

#77
Ryan Hardwick
Zacharie Robichon
Benjamin Barker

#88
Giorgio Roda
Mikkel Pedersen
Dennis Olsen

Christian Ried (São Paulo, Fuji)
Ben Keating (Austin)
Giammarco Levorato (Bahrain)

Ford's relationship with endurance racing
has always involved iconic cars, and that theme
continued between 2016 and 2019
with a modern version of the legendary GT40.
For the 2024 campaign, it was the fabulous
Mustang that was chosen to carry the brand's
name in the World Championship in celebration
of the model's 60th anniversary.
With the encouragement of Ford CEO and
racing enthusiast Jim Farley, Ford Performance
created an LMGT3 version of the Mustang
for the World Endurance Championship.
The car was run by the German
Proton Competition team.

ISOTTA FRASCHINI

HYPERCAR

Isotta Fraschini Typo6-C
Isotta Fraschini

#11
Carl Wattana Bennett
Jean-Karl Vernay
Antonio Serravalle

Isotta Fraschini Milano, a prestigious Italian
brand founded at the beginning of the 20th century,
was reborn from the ashes thanks to the will
of a few passionate shareholders,
who made a commitment to Hypercar
for the 2024 World Championship campaign.
On the technical side, the Italian manufacturer
relied on the expertise of Michelotto
to design the Typo6-C, which underwent
nearly 10,000 kilometres of testing before
the start of the WEC. With just one car
entrusted to Duqueine Team and resources
not matching those of the major brands,
Isotta Fraschini approached the season
with humble expectations.

LAMBORGHINI

HYPERCAR

Lamborghini SC63
Lamborghini Iron Lynx

#63
Mirko Bortolotti
Daniil Kvyat
Edoardo Mortara
Andrea Caldarelli (Spa)

Lamborghini, one of the most iconic
sportscar brands, finally took the plunge
and entered the World Championship in 2024,
running its beautiful SC63 Prototype
in the Hypercar class alongside
the Huracán LMGT3 Evo2.
Partnering with the Iron Lynx team
in both categories, the manufacturer
from the Bolognese Sant'Agata region
served notice of its intent and commitment
by designing its very first 100% endurance
racing engine. Lamborghini spent its maiden
campaign in WEC finding its way in
a highly competitive field.

LAMBORGHINI

LMGT3 CARS

Lamborghini Huracán LMGT3 Evo2

#60
Iron Lynx
Claudio Schiavoni
Matteo Cressoni
Franck Perera
Matteo Cairoli (Bahrain)

#85
Iron Dames
Sarah Bovy
Michelle Gatting
Rahel Frey
Doriane Pin (Qatar, Imola)

LAMBORGHINI 51

LEXUS

LMGT3 CARS

Lexus RC F LMGT3
Akkodis ASP Team

#78
Arnold Robin
Timur Boguslavskiy
Kelvin van der Linde
Clemens Schmid (Spa, Austin, Fuji)
Ritomo Miyata (Spa)
Conrad Laursen (Bahrain)

#87
Takeshi Kimura
Esteban Masson
José María López
Jack Hawksworth (Le Mans)

The premium brand of the Toyota group
seized the opportunity offered
by the new LMGT3 regulations to enter
the World Endurance Championship.
Even though the RC F model had raced
in other GT competitions, this was clearly
a learning season for Lexus, as well as
for France's Akkodis ASP Team,
making its debut in the series after racking up
numerous successes elsewhere.

McLAREN

LMGT3 CARS

McLaren 720S LMGT3 Evo
United Autosports

#59
James Cottingham
Nicolas Costa
Grégoire Saucy

#95
Joshua Caygill
Nicolás Pino
Marino Sato
Hiroshi Hamaguchi (Le Mans)

Already present in Formula 1, IndyCar,
Formula E and Extreme E, McLaren tackled
the World Endurance Championship
for the first time in 2024. The McLaren name
cemented itself into endurance racing legend
when it won the 1995 24 Hours of Le Mans
with the legendary F1 GTR, so it was
no surprise that the firm should develop
a car for the new LMGT3 category.
Two 720S models were entered
by United Autosports, a team co-founded
by McLaren Racing CEO, Zak Brown
and former racing driver, Richard Dean.

PEUGEOT

HYPERCARS

Peugeot 9X8
Team Peugeot TotalEnergies

#93
Jean-Éric Vergne
Mikkel Jensen
Nico Müller

#94
Stoffel Vandoorne
Paul di Resta
Loïc Duval

Peugeot Sport engineers were attracted
to the Hypercar regulations by their freedom
for innovation. In cooperation with the brand's
stylists, the manufacturer's design team exploited
those rules to the maximum to create the 9X8,
whose daring appearance embodies
the visual codes of the French firm.
During its second full season in the championship,
Team Peugeot TotalEnergies hoped to emulate
the successes achieved in endurance racing
with the 905 and 908 models.

PORSCHE

HYPERCARS

Porsche 963

#5	**#6**	**#12**	**#38**	**#99**
Porsche Penske Motorsport	**Porsche Penske Motorsport**	**Hertz Team JOTA**	**Hertz Team JOTA**	**Proton Competition**
Matt Campbell	*Kévin Estre*	*Will Stevens*	*Jenson Button*	*Neel Jani*
Michael Christensen	*André Lotterer*	*Callum Ilott*	*Phil Hanson*	*Harry Tincknell*
Frédéric Makowiecki	*Laurens Vanthoor*	*Norman Nato*	*Oliver Rasmussen*	*Julien Andlauer*

PORSCHE

59

PORSCHE

LMGT3 CARS

Porsche 911 GT3 R LMGT3

#91
Manthey EMA
Yasser Shahin
Morris Schuring
Richard Lietz

#92
Manthey PureRxcing
Aliaksandr Malykhin
Joel Sturm
Klaus Bachler

The bond between Porsche and endurance racing
is historic and undeniable. It was thanks
to the success of the incredible 917
that the Zuffenhausen-based brand assumed
its rightful place on the international scene
at the beginning of the 1970s.
Faithful to this heritage, Porsche took up
the challenge posed by the new regulations
governing the World Endurance Championship,
building the 963 for the Hypercar division
and making the model available to the works
Porsche Penske Motorsport team as well as
privateer outfits in its maiden campaign in 2023.
In 2024, the 911 GT3 R joined it on the grid
in the LMGT3 category.

TOYOTA

HYPERCARS

Toyota GR010 Hybrid
Toyota Gazoo Racing

#7
Mike Conway
Kamui Kobayashi
Nyck de Vries
José María López (Le Mans)

#8
Sébastien Buemi
Brendon Hartley
Ryō Hirakawa

Toyota has been involved in the World
Endurance Championship since the beginning,
and was the first brand to take up the challenge
of the Hypercar category.
Crowned Manufacturers' world champion
for five years in succession, the Japanese firm
put its reputation on the line once again in 2024,
by facing tougher opposition than ever before.
CEO Akio Toyoda, grandson of the company's
founder, is a dedicated fan of the Toyota Gazoo
Racing team, whose European headquarters
are based in Cologne (Germany).

MOTION
ART

ROUND 01
MARCH 2nd

QATAR

QATAR AIRWAYS
QATAR 1812KM

QATAR

Miguel Molina *[right in the photo above]* took the lead at the start of the race, but by the time the driver changes began, the #50 Ferrari had already lost first place.

QATAR

/ HYPERCAR
A STELLAR START TO THE SEASON

For the first time in 2024, the FIA World Endurance Championship got underway in the Middle Eastern country of Qatar. The event, sponsored by Qatar Airways, immediately presented the field with a major challenge. Not only did the 19 entered Hypercars have to deal with the intricacies of a new circuit, but they also needed to manage an unconventional race distance of 1812 km – symbolic of Qatar's National Day of 18 December. It was completed in just under ten hours, making it the longest race of the season after the 24 Hours of Le Mans, beginning in high daytime temperatures and finishing after nightfall. With a newly-laid smooth track surface, competitors had to carefully consider tyre wear, as sand blowing in from the surrounding desert added to the difficulty for the nine manufacturer teams and their customers.

That much was confirmed straightaway, when the lone Cadillac and the #94 Peugeot made contact in the first corner. Miguel Molina (#50 Ferrari) made a wonderful start to take the lead from fourth on the grid, at the expense of the #5 Porsche that had secured the German brand its first pole position of the Hypercar era.

Nico Müller slotted into third position in his Peugeot, but soon overtook Michael Christensen in the Porsche to grab second – and he was not done there. The Swiss driver subsequently passed Molina to lead the race overall, as the 9X8 showcased its capabilities in its final outing in wingless configuration. The car led on merit for almost 40 laps to the delight of the team and Peugeot's many fans, but the Porsches were in hot pursuit and when Müller ran wide an hour-and-a-half in, Laurens Vanthoor needed no second invitation.

This was also the most competitive showing to date of the Penske Porsche Motorsport-run 963s, and a portent of what was to come over the remainder of the race. The red-and-white car set the pace and opened up a gap to the pursuing Peugeot and JOTA Porsches, which were embroiled in a battle for second.

With the #6 Porsche now clearly in control, neither Ferrari nor Toyota was able to mount a bid for victory. Despite its strong start, Ferrari's race began to unravel when the #51 lost its rear bodywork after contact with a GT car 80 minutes in, obliging it to pit for repairs. For Toyota, meanwhile, the GR010 Hybrid was simply not quick enough to keep up with either the Porsche or the Peugeot.

However it was not all plain sailing for the leading #6 Porsche either. A minor clash with a GT car damaged its number panel, which needed to be replaced just ten laps from the chequered flag. Kévin Estre was behind the wheel when the car peeled off into the pits for a quick fix, with the stop fast enough that the French driver could rejoin and secure the first win of the season. The #6 led the final 283 laps of the 335-lap contest to cement the first-ever triumph in the series for the 963 model, and the first for an LMDh car in WEC. "It wasn't as easy as it might have looked from the outside," said Estre after the finish. "We had many tricky situations and we also had contact with other cars; one collision caused significant damage. But, even with a less-than-ideal car, we did it!"

For Peugeot, by contrast, there was late heartbreak. The #93 driven by Jean-Éric Vergne was in second place when it stopped on the final lap having run out of fuel. Although Vergne managed to re-start on the electric motor, the team's podium hopes were cruelly dashed as the #12 JOTA Porsche and #5 Penske Porsche swept past the stricken Peugeot to round out the rostrum. This clean sweep of the podium reflected the impressive in-depth work carried out by Porsche over the winter, following a challenging first season with the car.

Cadillac finished fourth on-the-road having recovered from the first corner accident, but was later disqualified as its bodywork was found not to conform to regulations. That handed the position to the #83 AF Corse Ferrari crewed by Robert Kubica, Robert Shwartzman and Yifei Ye. This privately-entered 499P compensated for the setbacks of the factory cars, which finished sixth and twelfth. Toyota managed to salvage points for fifth with the #7 GR010 Hybrid after a difficult race for the reigning title-winning team, marking the first time in the Hypercar era that no Toyota driver appeared on the podium!

With its two cars reaching the end of the race and the #35 entry in seventh, Alpine recorded the best result of the 'rookies'. These debutants also included the Lamborghini SC63 and BMW's M Hybrid V8, both of which had already competed in the US but were new to the World Championship. "Finishing this event with our two crews allowed the entire team, from the mechanics to the drivers to the engineers, to learn a lot about our technical and our human package," commented Alpine's Team Principal, Philippe Sinault. "We are aware of having clearly made a step forward, but we're also well aware that the road is still very long!"

BMW, run by the Belgian WRT team, and Lamborghini which was fielded by the Iron Lynx team, had to be content with tenth and 14th places respectively. The sole Isotta Fraschini entry was forced to retire mid-race after suffering from a suspension issue that damaged the monocoque.

The cohabitation between Hypercars and cars
in the new LMGT3 category demanded extreme vigilance
on the part of drivers due to traffic management
and differences in performance!

QATAR

QATAR

QATAR

82 QATAR

/ LMGT3
A NEW ERA

The Qatar Airways Qatar 1812km will go down in the history of endurance racing as the first World Championship event to feature the new LMGT3 category. No fewer than nine manufacturers each developed two bespoke cars for the class, entered by 13 teams.

First blood went to Belgium's Tom Van Rompuy, who put his #81 TF Sport Corvette on pole position, bettering the time posted by Aliaksandr Malykhin in Manthey PureRxcing's #92 Porsche.

At the start of the race, the Corvette converted that advantage into the lead, but it proved to be short-lived as the rapid Malykhin soon found his way past. The Corvette subsequently began to suffer from tyre problems and dropped back, with any chance of a good result vanishing altogether after two-and-a-half hours when an electronic issue cost the #81 trio seven laps.

The biggest threat to the leading Porsche came from the sister entry, the #91, but that car also encountered electrical dramas. Next to star was the #27 Aston Martin entered by American outfit, Heart of Racing Team. The British sportscar was firmly in the mix for victory, but a small mistake cost it valuable time during the fourth hour. Spaniard Alex Riberas quickly made up the lost ground to rejoin the front-runners, but by then, the Porsche had already consolidated its lead. Although the drivers of the #97 Aston Martin made a final charge at the end of the race, they ultimately fell short by just five seconds.

So, the first drivers to write their names into the history books were Malykhin, Joel Sturm and Klaus Bachler with their Manthey-entered #92 Porsche. The result backed up the brand's overall victory in the headlining Hypercar category to make it a memorable day for the German manufacturer. The Aston Martins were clearly fast enough to mount a challenge, as proved by the two cars filling the remaining places on the podium. Riberas, Ian James and Daniel Mancinelli finished second in their #27 Heart of Racing Team Aston Martin, ahead of the D'Station Racing Aston Martin of Clément Mateu, Erwan Bastard and Marco Sørensen.

On his World Championship debut, Valentino Rossi teamed up with Maxime Martin and Ahmed Al Harthy to wind up just shy of the podium, in fourth place behind the wheel of the WRT-entered M4 LMGT3.

CAPTION INDEX

Pages 70-71
HYPERCAR #20
BMW M Hybrid V8 BMW M Team WRT

HYPERCAR #50
Ferrari 499P Ferrari AF Corse
Nicklas Nielsen & Miguel Molina

Pages 72-73
LMGT3 #95
McLaren 720S LMGT3 Evo United Autosports

HYPERCAR #7
Toyota GR010 Hybrid Toyota Gazoo Racing
Kamui Kobayashi

Page 77
HYPERCAR #51
Ferrari 499P Ferrari AF Corse

Page 78
HYPERCAR #6
Porsche 963 Porsche Penske Motorsport

LMGT3 #46
BMW M4 LMGT3 Team WRT

Page 79
LMGT3 #777
Aston Martin Vantage AMR LMGT3 D'Station Racing

HYPERCAR #36
Alpine A424 Alpine Endurance Team
Nicolas Lapierre

Pages 80-81
HYPERCAR #36
Alpine A424 Alpine Endurance Team

Page 82
LMGT3 #92
Porsche 911 GT3 R LMGT3 Manthey PureRxcing

Page 87
HYPERCAR #83
Ferrari 499P Ferrari AF Corse

HYPERCAR #5
Porsche 963 Porsche Penske Motorsport

Pages 88-89
HYPERCAR #35
Alpine A424 Alpine Endurance Team

HYPERCAR #93
Peugeot 9X8 Team Peugeot TotalEnergies

HYPERCAR #51
Ferrari 499P Ferrari AF Corse

Pages 90-91
LMGT3 #78
Lexus RC F Akkodis ASP Team

Pages 92-93
HYPERCAR #93
Peugeot 9X8 Team Peugeot TotalEnergies

HYPERCAR #6
Porsche 963 Porsche Penske Motorsport

Qatar adopted an unusual format for its first event
in the World Endurance Championship
with a distance of 1,812 kilometres and a finish after sunset,
which meant competitors had to cope
with fluctuating temperatures.

QATAR

QATAR

> " My respect also goes to Peugeot.
> It's bitter to be thwarted so close to the finish line.
> They deserved to be on the podium with us.

Thomas Laudenbach
Vice-President *Porsche Motorsport*

QATAR

THE DOCTOR'S NEW DRUG

Wherever the FIA World Endurance Championship goes, there is a sea of luminous yellow in the paddock and around the grandstands. Flags, hats, T-shirts and other merchandise bearing the number 46 – synonymous with Valentino Rossi – are ubiquitous, with fans desperate to catch a glimpse of the nine-time MotoGP champion in person.

In 2024, Rossi entered the WEC for the first time following an era-defining motorcycle racing career lasting more than two decades. In his new challenge on four wheels, his aim is to clinch another world championship crown, and with the WRT BMW team, he has all the tools with which to do so.

Rossi is working hard to reach the speed and consistency required to take on the best endurance racers around – and, ultimately, beat them. That is a big ask considering his two-wheeled background, but such a fierce competitor would not have embarked upon the programme if he did not believe it was possible to win.

Notwithstanding his incredible success in MotoGP, the Italian felt he was always destined to race cars. He started in go-karting with a view to following in his father's footsteps. Graziano Rossi began bike racing in the world championship in 1977, riding a Suzuki in the 500cc class. He won three times and scored five further podium finishes in the 250cc category, before switching to touring cars. The young Valentino only saw his father race cars, and so felt his path would always take him to four-wheeled competition. "But my story brought me to motorcycling," he says with a smile.

Rossi Jr. won a regional karting title in 1990, before finishing fifth in the national kart championship in Parma, prompting him to consider moving up to 100cc karts. However, the high cost of car racing pushed him towards a career on two wheels instead – and on bikes, he became a global superstar who attracted legions of fans in every country around the world. "I have always had in mind that I want to race cars, so I'm happy to have this chance," says the 'Doctor', so-nicknamed for his calm and clinical style on-track. "I have to improve some things, but I'm enjoying it."

Rossi initiated his four-wheeled adventure with toe-in-the-water outings in the Gulf 12 Hours in 2019, 2020 and 2023, in the latter of those years additionally entering the Bathurst 12-Hour race in Australia,

> *I have to improve some things, but I'm enjoying it.*

He began competing professionally and full-time in cars in the GT World Challenge in 2022 behind the wheel of an Audi R8 GT3. In a championship made up solely of GT3 machinery, there was nowhere to hide, with strengths and weaknesses ruthlessly exposed. Rossi spent two years learning how to handle a car at the highest of European levels. He claimed his maiden victory in the GT World Challenge Sprint Cup on home soil at Misano in 2023, before graduating to the FIA World Endurance Championship with the WRT team's BMW M4 LMGT3. 2024 is his second year with the Bavarian manufacturer.

Racing in WEC meant he would have to learn how to drive with traffic around him. In the GT3-only series, he was judged predominantly on his pace but in the World Championship, he has to deal with faster prototypes while also doing battle in his own category.

"It's a different race together with the Hypercars – it's more difficult," he acknowledges. "You need to be quick and concentrate on your race, but also try to pay attention to the Hypercars. The difference [in speed] is very big so when they arrive, they are very fast but that is part of the game."

That is not to say the Hypercar drivers are not aware of Rossi. One, following him at Imola, noted that he was still taking the same racing line in a car that he would normally take on a bike, using a shallower entry and exit, which is not necessarily the most efficient method on four wheels. "There is a big difference and I need more kilometres to understand it better," he agrees.

The Urbino native did not get as many kilometres as he wanted at Le Mans. Having learned the circuit in 2023 during the Road to Le Mans race, he contested the main event for the first time in 2024

He even led the class for a short while on the Saturday, but the team gambled, leaving Bronze-graded driver Ahmed Al Harthy out on a damp track in slick conditions, and the Omani crashed. "In the first part of the race, we were very competitive," says Rossi. "We were able to gain a lot of positions thanks to a good strategy and consistent pace. We led for two-to-three hours and I enjoyed being in P1!"

Despite that starring role, the results have not yet matched the Italian's ambitions and he is not as quick as he wants to be, but he is constantly learning and improving from some of the fastest GT drivers in the world. "At the beginning, I was partnered with Fred Vervisch and Nico Müller, and now I race with Maxime Martin and Augusto Farfus," he says. "You are in exactly the same car, and you have all the data to check. That's very good for me because I don't have a lot of experience so I try to learn, especially from Maxime because we have a very similar driving style."

Rossi is, according to his team boss, the most diligent of students. Kurt Mollekens, himself a formidable Formula 3 protagonist in the 1990s, says that of all the drivers, the 'Doctor' is the one who spends the most time behind the laptop. "Everybody may think that as a nine-time world champion, this is easy for him and he is here purely for pleasure," says the Belgian. "He is so keen to get himself to the level of the professional GT drivers, and he spends so much time looking at the data that he drives our data engineer crazy, but he is an extremely proud man who will not accept being slower than anyone else in the paddock."

> *He will accept being two-and-a-half or three tenths off, but he will not accept being seven tenths off the fastest drivers.*

That is not meant to be disrespectful to any other driver in the field, but Rossi has spent his career being the best and he expects to get there again. He does not, says the team boss, get involved in engineering the car. That, he believes, is best left to those who know what they are doing. "The good thing is we've always been able to give him all the tools and put some of the best GT drivers in the world alongside him in the same car, so he has everything to learn from and he is doing just that," says Mollekens. "He is trying very hard to get to their level and he will accept being two-and-a-half or three tenths off, but he will not accept being seven tenths off the fastest drivers."

One of the trappings of fame, of course, is that all of this is done in the public eye. The throngs of fans who come to the circuits to support Rossi and his BMW team-mates also do everything they can to get close to their idol. It is not uncommon to see the team employ extra security around its driver, who then has to perform both inside and out of the car. "The amount of time he spends with his fans is phenomenal," reveals Mollekens. "It is one thing when everything is organised and you have your time slots where he goes to see people, but he will sign autographs for every last guy in front of the truck. He will not sign five and then walk off."

"Here it is a bit more complicated because there is less security, and he maybe gets bothered a bit more at inconvenient times. Sometimes he has a job to do and doesn't have half-an-hour to go from his garage to the container, but in general he spends a lot of time with his fans and the time that he is not with them, he is in our garage working to get quicker."

Perhaps unsurprisingly for someone so greatly into detail, Rossi expects the garage and his personal belongings to be immaculately presented. His helmet, gloves, balaclava and even his earpieces have to be arranged in a particular way. "Of course, he has a few people around him who help with all of that and I am sure if I walked into his house, I would find the same thing. It's quite extreme, but it's fun to watch and it gives you an idea of how meticulous he is about everything," says Mollekens.

That dedication will, one day he hopes, lead Rossi into a prototype. Right now, the BMW M Hybrid V8 is competing in the top class of endurance racing in both IMSA and WEC, with a rookie test planned in the latter series at the end of the year. As unlikely as it seems, Rossi would be a rookie in a prototype, and is just waiting for the day that he gets the call to move up a level and be part of a headlining act once again.

A postscript. Such dedication on-track is paired with generosity away from it. Rossi lives on a farm with his own bike track where he and his brother frequently race one another. After his first season with WRT, he invited team members to his ranch to play around — something that has now become a tradition. Beyond the usual hi-jinks, for a driver who is learning the ways of professional car racing, building a team and thanking everybody for their support and hard work is a key element. The team has been patient with its new driver, and Valentino Rossi fully intends to repay that patience with wins

> "The amount of time he spends with his fans is phenomenal.

ROUND 02
APRIL 21st

IMOLA

6 HOURS OF IMOLA

IMOLA

Forza Italia! At the famous Autodromo Enzo e Dino Ferrari, the Ferrari 499Ps thrilled fans during qualifying by locking out the first three places on the starting grid!

IMOLA

IMOLA

/ HYPERCAR
OVERCOMING THE ELEMENTS

The Ferrari 499Ps locked out the top three positions in qualifying at their home race, and some 73,600 fans flocked to see the cars compete for victory at Imola's Autodromo Enzo e Dino Ferrari, hoping for a strong showing from both Ferrari and Lamborghini. Following a tribute to Ayrton Senna on the 30th anniversary of his fatal accident at the circuit, the race got underway in spectacular fashion. A collision in the braking zone for Turn One involved the two Alpines, two Peugeots and the #15 BMW, with the safety car deployed for the first time to clean up the carbon fibre littering the track.

At the re-start, the Ferraris remained ahead of the two works Porsches, which had begun with less fuel to try to gain ground in the early stages, followed by Mike Conway in the #7 Toyota.

Ferrari split the strategies of its two cars, with the #50 in the hands of Nicklas Nielsen completing four stints on the same set of medium tyres, thereby saving time at each of its pit-stops. After the Dane handed over to Miguel Molina approaching the midway point, the two Ferraris became embroiled in a fierce on-track duel, with the #51 ahead of its sister car and the #7 Toyota behind in third after overtaking the two works Porsches — but the weather was about to play its part in this six-hour showdown.

With temperatures dropping, rain threatened to sweep the Italian track. Nyck de Vries in the Toyota snatched second place from Molina's Ferrari following a Full Course Caution period, prompted by the Isotta Fraschini running off-track. Things got even better for Toyota at the next round of pit-stops as the #7 car moved into the lead.

After three hours and 42 minutes, the circuit was declared wet by the race director, with teams trying to second-guess how intense the rain would be – and how they should react. Toyota made the decision to stop and bolted on rain tyres, while all three Ferraris stayed out, hoping it was nothing more than a short downpour. It turned out to be the wrong decision.

As the rain intensified, Ferrari called its cars into the pits to change to wet-weather rubber, but the delayed decision meant they lost ground to others, and with the pit-stops went any hope of rewarding the fans with a victory. The factory 499Ps returned to the fray down in seventh and eighth, as their mission turned to one of recovery.

The battle for the win thus fell to Kamui Kobayashi's Toyota and Kévin Estre's Porsche, separated by only five seconds. The #8 Toyota sat third, although that car was under pressure from the WRT BMW of Sheldon van der Linde, which was performing well over Imola's high kerbs.

At the five-hour mark, the two Toyotas switched back to slick tyres, followed shortly afterwards by the Porsches. Toyota had timed it perfectly, and with a ten-second lead and 40 minutes still to run was looking strong. Estre, however, was not willing to settle for second and launched an attack on the leading car. He gave it everything but his race was compromised by overtaking under a yellow flag, for which he picked up a five-second penalty. Although he closed the gap to just a second, he was unable to find a way past the japanese rival.

Conway, de Vries and Kobayashi duly took the win in the #7 car ahead of the Porsche of Kévin Estre, André Lotterer and Laurens Vanthoor. Porsche snatched the final spot on the podium, thanks to Matt Campbell, Michael Christensen and Frédéric Makowiecki. Ferrari's first car over the line was fourth, in the shape of the #50 entry crewed by Nielsen, Molina and Fuoco.

Toyota's Team Principal and the man behind the wheel in the closing stages, Kobayashi, commented: "Our car was not the fastest this week, but the team performed so well. Mike and Nyck both did a fantastic job to bring us into contention before I took over. There was big pressure from the start of my stint; I was in the lead on slick tyres in the rain. We made the right call to switch tyres and build a gap, then we kept good pace on the wets. It was very tough. The team produced a great effort in terms of strategy and that gave us the chance to fight for the win."

Second place for Estre, Lotterer and Vanthoor increased their lead in the Drivers' World Championship, while Porsche strengthened its position in the Manufacturers' standings thanks to its double podium. For Ferrari, there was only disappointment after such a strong qualifying and opening stage of the race. "We know the 499P's performance on slick tyres is excellent in damp conditions, and even in the wet at the start it was pretty good, so we tried to extend our lead over our competitors," explained Ferdinando Cannizzo, Head of Endurance Race Cars. "However, in the end we misjudged the weather forecast and made a late call that compromised the overall result."

The #8 Toyota finished fifth, ahead of the #20 BMW of Sheldon van der Linde, Robin Frijns and René Rast – which at one stage had been involved in the fight for the podium – and the #51 and #83 Ferraris. For Peugeot, it was the first race with the EVO-spec car featuring a rear wing, which wound up ninth, while Cadillac scored its first points of the campaign in tenth.

CAPTION INDEX

Pages 98-99
HYPERCAR #83
Ferrari 499P AF Corse

Pages 104-105
HYPERCAR #7
Toyota GR010 Hybrid Toyota Gazoo Racing

HYPERCAR #51
Ferrari 499P Ferrari AF Corse

Pages 112-113
HYPERCAR #15
BMW M Hybrid V8 BMW M Team WRT

HYPERCAR #99
Porsche 963 Proton Competition

HYPERCAR #94
Peugeot 9X8 Team Peugeot TotalEnergies

Pages 114-115
LMGT3 #54
Ferrari 296 LMGT3 Vista AF Corse

LMGT3 #87
Lexus RC F LMGT3 Akkodis ASP Team

Page 117
HYPERCAR #7
Toyota GR010 Hybrid Toyota Gazoo Racing

LMGT3 #777
Aston Martin Vantage AMR LMGT3 D'Station Racing

LMGT3 #85
Lamborghini Huracán LMGT3 Evo2 Iron Dames

Page 118
LMGT3 #95
McLaren 720S LMGT3 Evo United Autosports

Page 121
LMGT3 #31 / #46
BMW M4 LMGT3 Team WRT

Pages 122-123
HYPERCAR #38
Porsche 963 Hertz Team JOTA

Pages 124-125
LMGT3 #27
Aston Martin Vantage AMR LMGT3 Heart of Racing Team

HYPERCAR #6
Porsche 963 Porsche Penske Motorsport

Pages 126-127
HYPERCAR #38
Porsche 963 Hertz Team JOTA

HYPERCAR #5
Porsche 963 Porsche Penske Motorsport

Pages 128-129
HYPERCAR #7
Toyota GR010 Hybrid Toyota Gazoo Racing

HYPERCAR #50
Ferrari 499P Ferrari AF Corse

Pages 130-131
LMGT3 #31
BMW M4 LMGT3 Team WRT

Page 132-133
HYPERCAR #7
Toyota GR010 Hybrid Toyota Gazoo Racing
Kamui Kobayashi

112 IMOLA

Imola was delighted to host a World Endurance
Championship event for the first time.
In particular, the spectators greatly appreciated
the opportunity offered by the organisers to visit the pits.

IMOLA

/ LMGT3

PERSISTENCE PAYS OFF

Having drawn first blood in the Qatar curtain-raiser, the crew of the #92 Manthey PureRxcing team approached round two of the season in Italy in a confident mood. Aliaksandr Malykhin duly set the fastest time in both qualifying and the Hyperpole session at Imola to place the Porsche on pole position. Despite a chaotic start to the race – with team-mate Yasser Shahin in the #91 entry returning to the pits with damage and losing more than 30 minutes to repairs – Malykhin retained his advantage ahead of the BMWs of Ahmed Al Harthy and Darren Leung.

The Porsche driver subsequently came under heavy pressure from behind, receiving a warning for exceeding track limits. A hard-charging François Hériau in the #55 Ferrari assumed control approaching the second hour, meaning the Prancing Horse led both the Hypercar and LMGT3 classes at its home circuit, to the clear delight of the partisan audience.

However, Hériau's joy was short-lived, and it wasn't long before the #92 Porsche reclaimed the initiative ahead of the two BMWs. Tyre degradation was a key factor around the anti-clockwise lap, with some teams changing only the more worn right-hand-side rubber during pit-stops.

When the rain appeared at the five-hour mark, the race took on a new complexion. After returning to the cockpit following a double stint by team-mate Joel Sturm, Malykhin opted for wet tyres

as did most of his rivals, but the WRT team elected to leave its professional drivers out on slicks, elevating them to the lead. That meant Augusto Farfus and Maxime Martin had to walk the tightrope between staying on-track while also racing each other in low-grip conditions, but with the aid of ABS, they drove superbly and the bold strategy served the team well. However, Martin later picked up a penalty for speeding under the Virtual Safety Car, which pretty much decided the result in favour of the #31 crewed by Farfus, Leung and Gelael, ahead of the #46 of Martin, Al Harthy and Rossi.

The #92 Porsche, which lost ground in the tricky conditions, had to be content with the final step of the podium in third, but Manthey Racing team manager Nicolas Raeder had no regrets: "Of course you hope for more when you start from pole position, but we're satisfied with this outcome in terms of the championship," he said.

Behind the #55 Ferrari and #27 Heart of Racing Team Aston Martin, McLaren celebrated its first-ever points in the FIA World Endurance Championship as Joshua Caygill, Nicolás Pino and Marino Sato secured sixth place.

IMOLA

IMOLA

" The race itself was crazy! With wet tyres on a drying track, and the first lap back on slicks, that was awful.

Kévin Estre
Driver - #6 Porsche 963
Porsche Penske Motorsport

IMOLA

IMOLA

127

While Ferrari delayed too long to switch to rain tyres,
Toyota opted for the right strategy but even so,
the winning car still had to cope with some tricky situations
before clinching victory.

132 IMOLA

IMOLA

KAMUI KOBAYASHI

/ DRIVER & TEAM PRINCIPAL
Toyota Gazoo Racing

WHAT IS YOUR FAVOURITE THING ABOUT ENDURANCE RACING?

By far, I think sharing the car with team-mates. The feeling is completely different compared to sprint races. In endurance racing, there are a lot of ups-and-downs during the race, and you all have to work and combine everything together to achieve a result over 24 or six or ten hours. That's a completely different philosophy compared to single-seaters, in which I spent most of my life. And this philosophy became my passion. We're driving exactly the same car and sometimes we're using the same tyres, but we each have slightly different feedback. I'm learning quite a lot as well from my team-mates. At the end of the day, we all have to work together to make things better. It's my passion to work on the car to make a better car, and I feel I've learned a lot in endurance racing.

YOU ARE THE ONLY TEAM PRINCIPAL IN FIA WEC WHO'S ALSO AN ACTIVE DRIVER. HOW CHALLENGING IS IT TO COMBINE THOSE TWO ROLES, ESPECIALLY DURING A RACE WEEKEND?

During the race weekend, it's not so much of a problem to be honest, because deciding something big is not really part of my job in such a context. There is an organisation in place for that. Each person in the team has a professional responsibility and we have to trust them. I'm not the person who says to anyone in the team that they're doing something right or wrong. The most important part on my side is done before going to the track – how we organise as a team, how we decide our race philosophy and how we make everyone confident going into the weekend. That's how we build a team and make it stronger. If you always rely on just one person, their decision is not necessarily right every time. This is a team sport. Combining the two roles on a day-to-day basis is challenging. There are many things to organise and many projects to execute, and there's a lot of work going on behind-the-scenes because Toyota is a pretty big company.

BEFORE AKIO TOYODA MADE THIS PROPOSAL TO YOU, DID YOU EVER THINK ABOUT MANAGING A TEAM?

No, not at all. Never. I was surprised by the proposal but I immediately knew I wanted to do it. We speak quite often and I'm always learning from him. He shares his management skills and what he's looking for in the immediate future and in the long-term future as well

His vision is quite big. I have to say, there's not much pressure on me in this job and this role. Toyoda-San often asks if the company makes people smile. For example, he thinks we need better technology because it will help people to have a better life. And as the Toyota team in WEC, we are part of this challenge.

SOMETIMES A TEAM PRINCIPAL HAS TO HAVE A TOUGH TALK WITH A DRIVER WHEN THEY MAKE A MISTAKE. HOW DOES IT WORK WHEN THE TEAM PRINCIPAL AND THE DRIVER ARE THE SAME PERSON?

I think in general, we don't need to have tough talks, to be honest. A driver is a human being at the end of the day. Sometimes, they can make a mistake. I never have tough talks with my team-mates. It's more up to others within the team to do that!

IN THE PAST, THE #7 CAR SEEMED TO LACK SUCCESS COMPARED TO THE SISTER CAR. DO YOU BELIEVE IN BAD LUCK?

Oh yes. It's a driving force in my life! I haven't had the best of luck in my life. I had quite a lot of challenging things happen but I'm still here. I'm still racing and I still enjoy racing. I'm now 38-years-old but I don't feel I have any kind of drop-off in my performance. I think many people want to be in my position – driving at my age – and many people are not able to do so. I haven't had much luck, but I'm still here. So, from that point-of-view, maybe I have been lucky after all!

IN 2017, YOU SET THE QUALIFYING LAP RECORD AT LE MANS. WHAT DOES THAT RECORD MEAN TO YOU?

I'm proud of it. The car was really amazing to drive at Le Mans, and everything went phenomenally well for me. It suited my driving style. In terms of track conditions, it was the best moment. I don't need a lot of practice, to be honest. I jump in the car and I can set good lap times. At Le Mans, there is always a lot of traffic, but that day, everything came together. At the time, there was no Hyperpole and we had a shortened qualifying session because of a long red flag. We'd just had a green flag again after a 30-minute break. I wasn't really ready to jump in, but my engineer said, 'get in, you have to go now – this is maybe the only time you can get a clear lap'. So, I jumped into the car and on my first lap, actually, I did this lap time. In the end, I didn't expect that time to come up but the car was amazing.

" *We're driving exactly the same car and sometimes we're using the same tyres, but we each have slightly different feedback. I'm learning quite a lot as well from my team-mates.*

TOYOTA WAS THE PIONEER OF THE HYPERCAR CLASS. DO YOU CONSIDER THAT TO BE AN ADVANTAGE OR NOT?
To be honest, I think there's not much advantage after two or three seasons, and also, our car is quite old now. We have a good car but it's not that simple, because there's not much room for improvement. The other teams have more room to improve. We are quite limited with the tyres which are an important factor. Now we have no tyre blankets anymore so obviously the maximum capacity of the tyre is less than when we were using them. And our car was designed at a time when tyre blankets were allowed.

HOW DO YOU REFLECT ON THE 2024 CAMPAIGN?
It's been a challenging season, for sure. Every manufacturer definitely improved and the fight became tougher. We've really been battling for position. We had a kind of disadvantage that everybody knows, so it's been a challenging situation. I think we didn't have the best of luck this year. In São Paulo, for example, we were fighting for the win until we had a problem with the car and had to stop. We lost many opportunities to win. Nevertheless, the team has become stronger in terms of strategy and the work of the mechanics. At one point, I felt more energy in the team. That's something that's hard to see for people on the outside, but I feel it as a team member. So, this has not been our best season, but winning the manufacturer's World Championship is the result of a huge team effort from everyone.

THIS YEAR, YOU HAD A NEW TEAM-MATE IN NYCK DE VRIES. HOW DID HIS INTEGRATION GO?
He's very motivated. He's a very clever driver and of course, a fast one too. He had some experience of endurance racing from LMP2, so he knows how it works. I think he's done a great job with what he's achieved in his first season.

HYDROGEN TECHNOLOGY IS SET TO BE INTRODUCED IN ENDURANCE RACING IN 2028. WILL YOU STILL BE A RACING DRIVER AT THAT TIME OR ONLY A TEAM PRINCIPAL?
Hopefully, a race car driver! I will continue racing as long as I feel able to race. I still enjoy it and I still perform quite well, so until maybe I have a problem with my eyes I will continue. And I don't have to wear glasses yet...

ROUND 03
MAY 11th

SPA

TOTALENERGIES
6 HOURS OF SPA-
FRANCORCHAMPS

142 SPA

"Unbelievable, absolutely unbelievable! I knew we'd be strong this weekend. Our pace was good and we were able to use the red flag perfectly. At the end of the day, we benefitted from that. Sometimes things just play out the way they should!

Callum Ilott
Driver - #12 Porsche 963
Hertz Team JOTA

SPA

145 SPA

A legendary feat of bravery on the Spa-Francorchamps circuit is the Raidillon sequence, which the Hypercars go through at around 283 Kph and the LMGT3s at 250 Kph.

/ HYPERCAR
PRIVATEERS IN PRIME POSITION

The TotalEnergies 6 Hours of Spa-Francorchamps has been a regular fixture on the FIA World Endurance Championship calendar – not to mention one of its most unpredictable. From chaotic starts to unlikely weather patterns, it is an event that usually throws up surprises, and the 2024 edition was no different. This time, the weather remained stable and there was no drama at the start, but the race played out in unusual fashion.

In blazing sunshine, the #5 Porsche of Frédéric Makowiecki rounded La Source in the lead, having taken advantage of the pole position lap set by team-mate Matt Campbell. He was followed by the Cadillac of Alex Lynn, the Proton and JOTA Porsches and the #6 963, run by the Porsche Penske Motorsport team.

Julien Andlauer then served notice of his intent. At the wheel of the Proton Competition Porsche, he made a decisive pass on the Cadillac at Raidillon on lap six and subsequently set off after the leading 963, which he caught and overhauled with a daring move at the Bus Stop Chicane.

At the end of the first hour, Porsches filled the top three places, followed by the #51 Ferrari, the #35 Alpine, the #83 Ferrari and the #12 Porsche. The best-placed Toyota was hit with a five second stop-and-go penalty, dropping it to 11th, while the Cadillac fell back to 12th.

With 90 minutes gone, an accident eliminated the #38 JOTA Porsche, which came together with the #46 BMW in traffic. Andlauer stopped to hand over to Neel Jani, who found himself unable to close the Porsche's door on his 'out' lap from the pits. "I tried several techniques following the team's instructions over the radio until I remembered how I close my son's bedroom door in the evening, holding the handle so as not to make any noise," he explained afterwards. "I tried that method, and it worked!"

Despite that minor setback, the Proton Porsche retained the lead from the two chasing Ferraris, the #51 ahead of the #50. Just before the halfway point, Michael Christensen then lost control of the #5 Porsche on the exit of Pouhon and hit the guardrail, ending his race.

Jani stayed in front until shortly after mid-distance, when James Calado in the #51 Ferrari passed him at Les Combes. As the Briton consolidated his lead, the Swiss star came under attack from the second Ferrari, which was recovering having started from the rear of the Hypercar grid. Jani yielded the position to make it a Ferrari one-two, but not long after the four-hour mark, Earl Bamber in the #2 Cadillac got a run on the #99 Porsche as well, and as they came upon an LMGT3 BMW, the speed differential resulted in contact. Taking evasive action to avoid a bigger crash, Bamber also collided with the BMW. Both cars slammed into the guardrail on the Kemmel Straight, causing extensive damage. The race was stopped to allow the barriers to be safely repaired.

This took more than 90 minutes, and as the theoretical end of the race approached, Race Control made the decision to re-start it for the remaining time from the moment of the accident. Therefore, at 19:20, the cars returned to the track for the final 1h47m sprint, but there was a twist. Those who had built up an advantage lost it – which is normal in such a situation – but more significantly, the race had been paused in the middle

of a pit-stop sequence. Some cars had already stopped for fuel, and would therefore benefit from needing one less stop than those that had yet to pit – which included the two pace-setting Ferraris...

The #12 Porsche 963, by contrast, had already pitted, and behind the wheel, Callum Ilott took the lead four laps after the re-start. The JOTA entry had been down in tenth place, more than a minute behind the leaders before the action had been halted, but as others stopped to refuel, Ilott moved ahead of the #6 works Porsche and with 85 minutes left on the clock, the battle for victory looked to be between the two German cars.

Kévin Estre applied as much pressure as he could on Ilott, but it wasn't to be for the factory driver. The young Brit was in perfect control and duly secured the win for the JOTA team – the first privateer to take victory in WEC's Hypercar era and the second success of the season for Porsche. Another independent Porsche also stood out, as Andlauer fought back from ninth place after his refuelling stop, pulling off some spectacular overtaking moves at Raidillon on his way up to fifth at the chequered flag.

Celebrations began in the Porsche camp as Ilott crossed the finish line, triumphing ahead of works cars from Porsche, Ferrari and Toyota. The Porsche 963 clearly carries on the tradition of the 956 and 962 models, which had given privateers the opportunity to win races outright in the 1980s and 1990s. Although the crew of the #6 works Porsche did not prevail, the result nonetheless consolidated their lead in the World Championship standings, enabling them to look forward to the 24 Hours of Le Mans with confidence.

151 SPA

The Toyota team, already victorious in the previous
seven editions of the 6 Hours of Spa-Francorchamps,
was hoping to continue its winning streak,
but ultimately, the Japanese squad was obliged
to settle for a meagre tally of points.

SPA

/ **LMGT3**

IT'S NEVER OVER UNTIL THE CHEQUERED FLAG FALLS

From the moment the Hyperpole session got underway, it was clear that the weekend in Belgium would feature intense competition in the LMGT3 category. Pushing hard in a bid to secure Porsche's third successive pole position, Aliaksandr Malykhin lost control of his #92 Manthey PureRxcing 911 GT3 R at the top of Raidillon and hit the guardrail hard, causing heavy damage to the car. Local hero Sarah Bovy, meanwhile, stamped her authority on her home track in the #85 Lamborghini, taking pole at one of the most challenging circuits of the season.

From the start of the race, the Belgian driver gave it everything and established a commanding early lead. Her nearest challenge came from James Cottingham in the #59 United Autosports McLaren, along with the #91 Porsche of Yasser Shahin and the #46 BMW driven by Ahmad Al Harthy. However, after 90 minutes, the BMW was out, an innocent victim in another car's accident – and the consequent safety car period eradicated Bovy's hard-earned advantage. The Lamborghini then slipped to second when Rahel Frey took over at the pit-stop, but the Swiss driver was soon back ahead thanks to a superb overtake on Nicolas Costa's #59 McLaren at Les Combes.

At the following round of fuel stops, the #91 Porsche moved to the front of the field and was still there when a big crash led to a pause in the action at 17:14. The incident eliminated

the #31 BMW, which like its sister car was the innocent victim as the Cadillac Hypercar collided with a Porsche on the Kemmel Straight.

Following a two-hour delay, the race re-started and the Iron Dames Lamborghini, now driven by Michelle Gatting, re-took the lead. However, it didn't last long as a technical problem during a pit-stop scuppered their chances of victory.

From that point on, there were so many contenders that it was impossible to predict who would prevail. After a brief stint in charge for the #54 Ferrari, Franck Perera's Lamborghini emerged as a potential winner in the closing stages, but the Iron Lynx-run car then needed to stop again for fuel at the beginning of the last lap!

That handed the initiative to the #92 Porsche, which had been rebuilt by the Manthey mechanics following its 'off' in qualifying. However, Klaus Bachler, who was also tight on fuel, was unable to hold off Richard Lietz, who overtook him at Les Combes and went on to take the chequered flag first in a thrilling finish.

Porsche duly secured a one-two ahead of the #60 Lamborghini, which registered its first podium in WEC, and the #59 McLaren. That car was promoted to fourth place after the #85 Iron Dames Lamborghini was hit with a five-second penalty – a late blow for the crew that had led for more than half of the race.

CAPTION INDEX

Pages 138-139
HYPERCAR #20
BMW M Hybrid V8 BMW M Team WRT

Page 142
HYPERCAR #63
Lamborghini SC63 Lamborghini Iron Lynx

LMGT3 #92
Porsche 911 GT3 R LMGT3 Manthey PureRxcing

LMGT3 #81
Corvette Z06 LMGT3.R TF Sport

LMGT3 #27
Aston Martin Vantage AMR LMGT3 Heart of Racing Team

Page 143
HYPERCAR #12
Porsche 963 Hertz Team JOTA

Pages 144-145
LMGT3 #81
Corvette Z06 LMGT3.R TF Sport

HYPERCAR #51
Ferrari 499P Ferrari AF Corse

Page 146
LMGT3 #78
Lexus RC F Akkodis ASP Team

LMGT3 #77
Ford Mustang LMGT3 Proton Competition

Page 151
HYPERCAR #50 / #51
Ferrari 499P Ferrari AF Corse

Pages 152-153
HYPERCAR #8
Toyota GR010 Hybrid Toyota Gazoo Racing
Sébastien Buemi

HYPERCAR #99
Porsche 963 Proton Competition

Page 156
LMGT3 #85
Lamborghini Huracán LMGT3 Evo2 Iron Dames

LMGT3 #88
Ford Mustang LMGT3 Proton Competition

Pages 160-161
LMGT3 #95
McLaren 720S LMGT3 Evo United Autosports

HYPERCAR #12
Porsche 963 Hertz Team JOTA

Pages 162-163
HYPERCAR #94
Peugeot 9X8 Team Peugeot TotalEnergies

LMGT3 #59
McLaren 720S LMGT3 Evo United Autosports
Grégoire Saucy

HYPERCAR #20
BMW M Hybrid V8 BMW M Team WRT

Page 167
HYPERCAR #12
Porsche 963 Hertz Team JOTA

"

I am mega proud of everybody. It's coming together. We had great qualifying pace, which was a positive step forward after Imola. The race was looking pretty strong... and then there was the gearbox issue.

Joshua Caygill
Driver - #95 McLaren
United Autosports

163 SPA

164 **SPA**

165 **SPA**

An historic day in the FIA World Endurance Championship, with the outright win for the #12 Hertz Team JOTA Porsche 963 marking the first victory in the series for a private team.

SAM HIGNETT

/ DIRECTOR AND FOUNDER
Hertz Team JOTA

WHY DID YOU CHOOSE ENDURANCE RACING AS A PLAYING FIELD FOR THE JOTA TEAM?

I think it was a natural thing based on opportunity. The first thing JOTA ever did was the Renault Clio V6 Trophy in the very early 2000s, and then one of our drivers, John Stack, acquired a Group N Honda Integra, with which we did the Nürburgring 24 Hours and Spa 24 Hours and that really sort of paved the way. I guess the defining factor was that I didn't have any money to race, so I needed a gentleman driver to fund it. And the only way you can do that is in endurance

IT SEEMS YOU QUICKLY TOOK TO THIS KIND OF RACING. WHAT ARE ITS MOST APPEALING FACTORS?

It's the team effort. In sprint racing, you have an amazing team that works incredibly hard. Then the driver gets in the car, and that's it. There are a couple of pit-stops but no more team engagement, whereas in endurance racing, you're far more engaged with the drivers. Everybody has to work well together. It's far more of a team atmosphere and I think that's the appeal for all of us in this sport.

HOW WOULD YOU DEFINE THE JOTA TEAM SPIRIT?

We like to refer to ourselves as a family. There are plenty of staff who have been here for many years. We like to make sure that as many staff stay with us as long as possible. At the end of the day, it's being part of a team that gets the most out of us. Endurance racing especially is really, really hard work, so it's got to be enjoyable and we do our best to make it as enjoyable and appealing as possible.

WAS IT A TARGET FROM THE VERY BEGINNING TO ENTER THE TOP CLASS OF ENDURANCE RACING?

Yes, absolutely. LMP2 is a fantastic category, in which we had great success. Then there's always the ambition to try and win Le Mans and WEC overall. So when the Hypercar regulations came out, we saw there was an opportunity for a private team to get involved. Then, with my business partner David Clark, we started to raise the funding to run as a privateer

HOW BIG IS THE STEP BETWEEN LMP2 AND HYPERCAR?

I think LMP2 was at such a high level at that stage with us, United, WRT and Prema competing against each other that the transition into Hypercar wasn't that difficult, to be honest. There was barely any increase in the number of staff. It became a lot more expensive, but that's about all. Mechanically and management-wise, the team remained exactly the same except Dieter Gass came in. The only changes were perhaps in engineering. To get the ultimate pace out of the LMP2 car was a hardware exercise. With a Hypercar, it's more of a software exercise, so some of the engineering team's roles changed.

WHAT WAS IT LIKE TO COPE WITH THE PORSCHE 963?

LMDh cars are enormously complicated from an electronics and software point-of-view, but mechanically, there isn't that much difference. The improvements now are in software. What doesn't help is the hybrid system. That's quite onerous on the team in terms of maintaining the battery and organising all of the components – and I think the Porsche is probably one of the more complicated of the Hypercars.

AFTER A LEARNING SEASON IN 2023, WHAT WERE YOUR EXPECTATIONS FOR 2024?

The expectation was to be on the overall podium at least once, if not more, and it was great to achieve that in the first race in Qatar, which was probably our strongest race this season. And then, obviously, the overall win at Spa was fantastic. But we have to be honest – there was a large amount of luck that helped us to do that.

SPA WAS THE FIRST TIME A PRIVATE TEAM HAS EVER WON A WEC RACE AND THE FIRST TIME A BRITISH TEAM WON. WHAT WERE YOU MOST PROUD OF?

I think what I was most proud of was our engineering group having the foresight to see that Earl Bamber's accident was significant enough that it was going to be a red flag. So we made the very brave call to get the car into the box. Yes, we were in the right place on the circuit to do that, but so was one of the Ferraris and so were a couple of other cars. It was only us and then Penske that did so. Penske will admit they followed us because they saw us coming in. So I think the proudest achievement there was

> *I think the proudest achievement at Spa was the rate at which we reacted in the race, which might be down to us being a private team and not having to answer to anybody.*

the rate at which we reacted, which might be down to us being a private team and not having to answer to anybody. If we want to make a big, bold decision like that, we can, whereas I see potentially within manufacturers, they can't take that much risk and have to be a bit more sensible with strategy. The problem is once you've had success, then you want more success, and we have to manage our expectations sometimes as to what we can really achieve as a private team. Our budget is tiny compared to the factory teams.

A FEW WEEKS LATER, AN ACCIDENT DURING LE MANS PRACTICE PUT THE TEAM IN THE POSITION OF HAVING TO REBUILD A CAR IN LESS THAN TWO DAYS. DID YOU EVER DOUBT THAT THE TEAM WOULD BE ABLE TO DO IT IN TIME?
I don't think any of us ever doubted that we would be able to get the car into the race. Whether the car would even complete the first lap, let alone the whole race, was a completely different question. The only hurdle was finding a spare chassis, and hats off to Urs Kuratle and the guys at Porsche – they moved heaven and earth to find one for us. And then our guys worked 48 hours straight to get that chassis built and out onto the circuit, so to finish the race on the lead lap was something very special.

NOT LONG AFTER, IT WAS ANNOUNCED THAT JOTA WOULD BECOME THE CADILLAC WORKS TEAM IN 2025. WAS THAT A TARGET?
Yes, absolutely. It was always the goal. What we're doing as a private team running two cars in Hypercar isn't financially sustainable. We've done it for a season and it's worked out very well, but we really needed the works opportunity to take us to the next level, and luckily that has come our way. We started talking with GM at the beginning of this year. The opportunity came shortly before Spa and the deal was done-and-dusted by the time we got to Le Mans.

HOW IS IT TO DEAL WITH DRIVERS?
I would imagine it's easier managing six drivers in endurance racing than two drivers competing directly against each other in a grand prix team! I think we're reasonably hard on the drivers. We don't tolerate egos or unwarranted ideas of grandeur. For me, a driver is a team member and is no more important than the guy who's washing the wheels.

HOW HAS IT BEEN TO WORK WITH A FORMER F1 WORLD CHAMPION IN JENSON BUTTON?
I've been very impressed with Jenson. You kind of forget who Jenson is when you spend a lot of time with him. And then when we went to Japan, I think all of us were bowled over by his hero status there. Nevertheless, he doesn't have crazy expectations of hotels or restaurants or physios. He's a good team player and a great guy to have in the team. He really does elevate the team and brings the best out of everybody.

HOW DO YOU FEEL DURING THE RACE? CALM, NERVOUS, FOCUSED?
I find the race very stressful, so I'm generally walking around and now it's become a bit of a running joke as to how many steps I can do during a race! I did over 100,000 steps during Le Mans. That's my record.

ROUND 04
JUNE 15-16th

LE MANS

24 HOURS
OF LE MANS

LE MANS

LE MANS

After the record attendance of its centenary edition in 2023, the 24 Hours of Le Mans managed to do even better by attracting 329,000 spectators – and that figure did not even include the residents of Le Mans who enjoyed the Hypercar parade in the city centre!

Pierre Fillon, President of the Automobile Club de l'Ouest, picked a remarkable starter for the 2024 edition in footballing legend Zinédine Zidane, who was completely captivated by what goes on behind-the-scenes of this iconic event.

LE MANS

LE MANS

LE MANS

183 LE MANS

/ HYPERCAR
A THRILLER FROM START-TO-FINISH

With 23 Hypercars at the start, the field for the 92nd edition of the 24 Hours of Le Mans was nothing less than exceptional. The circuit is partly composed of public roads alongside the permanent racetrack, making it impossible for teams to test there in advance. That means the official pre-event test – held one week before the race – is critical, and in its first outing at La Sarthe in 2024, Porsche Penske Motorsport reaffirmed the progress it has made with the Porsche 963 prototype by putting three of its cars in the first four places on the timesheets.

After practice and qualifying on Wednesday, Thursday saw the eagerly-anticipated Hyperpole session that sets the top eight positions on the grid. Dries Vanthoor had posted the fastest time in qualifying in the #15 BMW, but in Hyperpole, the battle came down to Porsche vs. Cadillac, with Kévin Estre prevailing for the former courtesy of an incredible 3m24.634s lap, earning the admiration of team-mate, André Lotterer: "The car's potential was not quite there, but Kévin added a touch of magic." Alex Lynn wound up second-quickest, just over a tenth-of-a second adrift, but the blue Cadillac would have to carry a grid penalty following an accident in the previous race at Spa-Francorchamps.

The start was given by footballer Zinédine Zidane, and it was immediately apparent that the race order did not reflect the times set in qualifying. Nicklas Nielsen, in the #50 Ferrari,

led the opening lap, and as the cars came around for the fourth time, the #51 499P driven by Antonio Giovinazzi had slotted into second place. The Italian even nudged his Ferrari briefly into the lead before Nielsen fought back, but the #50 subsequently conceded the advantage when it was hit by a ten-second penalty for an unsafe release from its refuelling stop.

The rain made its first appearance 90 minutes in, and most of the drivers stopped to fit wet-weather rubber. This early in the race it seemed the sensible option, but Ferrari opted to stay out on slick tyres and that turned out to be the fastest strategy. After a short spell in front for the #51, the yellow #83 Ferrari entered by AF Corse picked up the baton at the head of the field. Against all expectations, it stayed there until the end of the eighth hour – and then disaster struck…

At 22:35, the leader collided with Vanthoor's BMW while overtaking it at high speed. The German car slammed into the guardrail, prompting a safety car intervention lasting more than an hour-and-a-half to move it out of the way and effect barrier repairs. Race Control considered Robert Kubica to be responsible for the clash and slapped the #83 499P with a 30-second stop-and-go penalty – severely compromising the privateer Ferrari's shot at victory. Shortly after midnight, the heavens opened once more and with the rain intensifying approaching mid-distance, Race Control redeployed the safety car, which would remain on-track for almost four-and-a-half hours.

At just after 08:00 on Sunday morning, the conditions were judged safe enough to release the cars, with the #8 Toyota at the head of the field from the #6 Porsche and the #50 and #83 Ferraris. Although the asphalt was still not dry, the leading car pitted just over an hour later to change to slick tyres, handing the initiative to Porsche.

The race was again interrupted by the safety car at 09:39 following a hefty accident for the #27 Aston Martin LMGT3 at Indianapolis. As the field was about to be unleashed, Nico Müller then lost control of the #93 Peugeot in the same corner. Although his car got back on-track, the safety car period was extended until just after 10:30.

Once the action resumed, it was almost like starting from scratch! The #2 Cadillac was on a staggered strategy and sporadically occupied the lead, but by the 20th hour, the Ferraris were back in charge, followed by the #8 Toyota, the #6 Porsche and the #7 Toyota. Around noon, however, the #83 Ferrari headed for the pits trailing a cloud of blue smoke and was forced to retire.

Rain returned during the 22nd hour, and the #8 Toyota found itself sandwiched between the leading #50 Ferrari and the sister #51 entry. With only two hours left on the clock, six cars representing four brands were covered by less than a minute, and it was game on for the win. The battle intensified when the #8 Toyota, driven by Brendon Hartley, was tipped into a spin after contact with the #51 Ferrari piloted by Alessandro Pier Guidi. The New Zealander lost around 40 seconds, while his Italian rival picked up a five-second penalty for causing the collision. After that incident, the two Ferraris were left with a 23-second advantage over the #7 Toyota, which had started from 23rd position due to an 'off' in qualifying.

Standing in for Mike Conway – injured in a cycling accident ten days earlier – José María López went into full attack mode to get back onto terms with the Italian cars. Behind the wheel of the #7 Toyota, he staged an extraordinary drive to overtake the #51 Ferrari before closing the gap to the leading 499P. At the wheel of the #50 Ferrari, Nielsen was suddenly spotted on the cameras trying to shut the driver's door out on-track. Being unable to do so, he was shown the black flag by the stewards which forced him to return to the pits, with the Toyota taking full advantage to snatch the lead. The two primary contenders for victory were now on staggered refuelling strategies, with everything to play for.

In the final hour, the #50 Ferrari was gifted a 49-second buffer when López spun in the Dunlop curve and took a trip through the gravel trap, but as the heavens opened once more, the Argentinean continued Toyota's epic comeback by eating into Nielsen's lead. The Dane, however, skillfully managed his remaining fuel load and in front of a record-breaking 329,000-strong crowd, crossed the finish line 14 seconds ahead of the Toyota with only two per cent energy left to secure Ferrari's 11th win at La Sarthe.

The legendary Italian manufacturer's second successive triumph came in the face of even tougher opposition than in 2023 and in particularly challenging conditions. Ferdinando Cannizzo, Head of Endurance Race Cars, was delighted. "Humility, passion and determination were the foundations of this victory," he said. "We arrived at Le Mans knowing we didn't have the most competitive car, but we knew we could play to our strengths. Over the last few days, starting with the Test Day, we demonstrated the value of the entire team by analysing critical points and finding the best solutions for a good race. In recent months, although we didn't use any 'jokers', we focused on improving our 499P in every way. Even in the toughest moments of the race, we faced every problem with single-minded concentration. In the last phase, when it was time to push, we decided to continue with the medium tyres despite the risk of rain, capitalising on our 499P's potential."

Ferrari's performance was backed up by the third-place finish of the #51 entry, which was followed by the #6 Porsche, #8 Toyota and #5 Porsche in fourth, fifth and sixth respectively. Both Toyota and Porsche were extremely disappointed with the result. Represented by six cars – three factory-backed and three privately-run – the German manufacturer failed to achieve a podium finish and was never genuinely in the hunt for victory. "I think we only made a small mistake at the start, when we switched to wet tyres," said pole-sitter Estre. "Apart from that, we really had a good race. When you see the number of penalties and spins the others had, we have nothing to reproach ourselves. The car was much better than last year. The balance was good, but we lacked acceleration and top speed. We were flat-out the whole time. It's a huge disappointment that we'll just have to swallow."

Confirming the reliability of the Porsche 963, the independent JOTA team placed its two Hypercars in the top ten, on the same lap as the winner. Eighth position for the #12 driven by Will Stevens, Callum Ilott and Norman Nato – ahead of the sister car – was particularly rewarding. During qualifying, Ilott's crash had heavily damaged the monocoque after making it through to the Hyperpole. The JOTA mechanics were involved in a race against the clock to rebuild the car around a spare tub

made available by Porsche – a gargantuan task that normally takes two weeks, but which was completed in time to carry out a Friday evening shakedown on the airfield next to the circuit.

After finishing on the third step of the podium the previous year, Cadillac was hoping for another standout performance at La Sarthe, but despite impressing in Hyperpole and having three cars at the start, the American brand had to settle for the #2 crew's seventh place-finish. "I think we've made big leaps and bounds forward," said Earl Bamber. "Now we just need a good result to show for it."

On its works debut in the 24 Hours of Le Mans, Lamborghini rounded out the top ten with the #63 SC63 crewed by Mirko Bortolotti, Daniil Kvyat and Edoardo Mortara. The #19 sister car, driven by Romain Grosjean, Andrea Caldarelli and Matteo Cairoli, finished 13th, similarly two laps behind the winner. After a difficult start to the season, this was a remarkable achievement for the Italian manufacturer, which was entering two cars in a WEC round for the first time. Isotta Fraschini, another Italian team debuting in the 24 Hours of Le Mans, managed to avoid the countless pitfalls of this edition and wound up a promising 14th.

Like Lamborghini, Peugeot brought its two cars to the finish, but down in 11th (#94) and 12th (#93) places. This was less successful than the previous year, when the 9X8 had placed eighth after leading the race. Overall, French teams suffered in their home event in 2024, with both Alpines retiring before the sixth hour due to engine failures.

On its return to Le Mans in the top-tier category, BMW also endured a difficult weekend. The #15 M Hybrid V8 encountered its first setback when Marco Wittmann spun after just 20 minutes of racing, necessitating a long pit-stop. The car rejoined well down the timesheets and was subsequently forced out by its collision with the #83 Ferrari. The #20 Art car similarly had an eventful race. It lost any chance of a good result when Robin Frijns spun in the third hour, prompting a lengthy pit visit for repairs. The car returned to its garage a few hours later, only emerging in the final hour to take the chequered flag as an unclassified finisher.

CAPTION INDEX

Pages 172-173 **HYPERCAR #50**
Ferrari 499P Ferrari AF Corse

Page 174 *Hypercar Parade*

Page 175 *Pitwalk*

Pages 176-177 *Zinédine Zidane and Pierre Fillon announcing the start of the race*

Pages 180-181 **HYPERCAR #38**
Porsche 963 Hertz Team JOTA

HYPERCAR #83
Ferrari 499P AF Corse

Pages 182-183 **HYPERCAR #8**
Toyota GR010 Hybrid Toyota Gazoo Racing

HYPERCAR #5
Porsche 963 Porsche Penske Motorsport

Page 190 **LMGT3 #87**
Lexus RC F LMGT3 Akkodis ASP Team

LMGT3 #46
BMW M4 LMGT3 Team WRT

Page 191 **HYPERCAR #8**
Toyota GR010 Hybrid Toyota Gazoo Racing

Pages 192-193 **HYPERCAR #83**
Ferrari 499P AF Corse

LMGT3 #777 / #27
Aston Martin Vantage AMR LMGT3
D'Station Racing / Heart of Racing Team

Pages 194-195 **HYPERCAR #6**
Porsche 963 Porsche Penske Motorsport

LMGT3 #27
Aston Martin Vantage AMR LMGT3 Heart of Racing Team

HYPERCAR #50
Ferrari 499P Ferrari AF Corse
Antonio Fuoco

Pages 196-197 **HYPERCAR #93**
Peugeot 9X8 Team Peugeot TotalEnergies

HYPERCAR #12
Porsche 963 Hertz Team JOTA

On his first participation in the 24 Hours of Le Mans, Valentino Rossi *[#46 BMW]* had the privilege of leading the LMGT3 class during what would unfortunately be his only stint in the race.

LE MANS

194

After a difficult start to the season, Ferrari returned to the scene of its only previous WEC victory. Here, the fiery Antonio Fuoco waits to take over from team-mate Nicklas Nielsen at the wheel of the #50 Ferrari 499P.

196 LE MANS

/ **LMGT3**

PORSCHE CONQUERS THE CONDITIONS – AND ITS COMPETITORS

As if the fight for class victory was not intense enough between the 18 cars entered for the full World Championship campaign, there were five additional crews on the entry list for the 24 Hours of Le Mans – all driven by the ambition to be the first to triumph under the new LMGT3 regulations. One of these 'guest' teams was Inception Racing, which grabbed pole position for the race as America's Brendan Iribe outpaced his rivals in the Hyperpole session to score a wonderful result for British manufacturer McLaren. Iribe's team-mate, Frederik Schandorff, took full advantage of this qualifying performance to retain the lead at the start, with the Dane holding on for more than an hour before the JMW Motorsport Ferrari found its way past.

The World Championship regulars attempted to assert some control, but against all expectations it was the #87 Lexus that seized the initiative during the second hour in the hands of Esteban Masson, on the Japanese brand's debut at La Sarthe. Conversely, during the morning warm up, the sister car driven by Kelvin van der Linde had been rear-ended by the #7 Toyota Hypercar of Nyck de Vries, leaving the Akkodis ASP Team mechanics – similarly new to Le Mans – in a hectic race against the clock to repair the car in time.

At the beginning of the fourth hour, the #46 BMW of Ahmad Al Harthy led the pack. Forty-six minutes later, he was replaced by Valentino Rossi, making his maiden appearance in the legendary event. To the immense joy of his countless fans, the former motorcycling champion completed a faultless triple stint. In fact, he was still in the lead when he handed over to Maxime Martin just as it started to rain.

As night fell upon the completion of the first quarter of the race, the Porsches began to push. They had played a waiting game up to that point, but were now eager to establish themselves. At the wheel of the #92 911 GT3 R, Joel Sturm took up the running ahead of the BMW and the #91 Porsche piloted by Richard Lietz. The rain made conditions very difficult and tyre choice was critical. Shortly after the eight-hour mark, Al Harthy returned to the cockpit of the #46 BMW, now shod with slicks, but the Omani driver was caught out by the slippery surface and the M4 LMGT3 slammed into the guardrail after the Dunlop footbridge, ending its race.

Despite the challenges, the Manthey team's Porsches were pretty much inch-perfect, only briefly headed during the pit-stop sequences. Those other leaders included Masson's #87 Lexus – again – Grégoire Saucy's #59 McLaren and van der Linde in the #78 Lexus, the latter making a great comeback after starting from the pit-lane.

The weather worsened during the night and made the track too dangerous to continue racing. Just 15 minutes shy of the halfway mark, Race Control neutralised the action with the safety car. It was not until sunrise that it was deemed suitable to re-release the field. At 08:10, the safety car finally pulled off into the pits, with the two Porsches running first and second, followed by the #95 McLaren, the #87 Lexus and the #31 BMW.

In the 17th hour, the race began to unravel for the championship leaders, when Klaus Bachler suffered a gearbox problem

that obliged his Porsche to pit. The stop lasted 24 minutes and dashed the #92 crew's victory hopes. The #91 trio, however, remained determined to defend Porsche's honour against the assault from BMW, Lexus, McLaren, Aston Martin and Lamborghini, which was making its 'works' bow at Le Mans. The Iron Dames crew – the all-female line up in the #85 Huracán – even snatched the lead for two laps.

However, there was further drama still to come. Halfway through the 19th hour, the second-placed #27 Aston Martin crashed heavily at the super-quick Indianapolis corner, thankfully without injury to its driver, Daniel Mancinelli, who was able to escape from the overturned car. The accident did, though, prompt a further safety car intervention, bunching the field up once more.

When the cars were released, the #91 Porsche slipped past the #87 Lexus into the lead and stayed there to the end, with only the #31 BMW seemingly in a position to threaten its supremacy. Four hours from the finish, it was also the only car on the same lap, but the Team WRT M4 LMGT3 wasn't quite quick enough and in the final hour, Lietz opened up a decisive margin to rubber-stamp a very popular triumph. The Austrian had already won the 24 Hours of Le Mans in the GT2 category, then in LMGTE Pro, and was now victorious at the wheel of an LMGT3. A veteran of 18 starts at La Sarthe, he perfectly guided his two rookie team-mates, Australia's Yasser Shahin and Dutchman Morris Schuring to an impeccable win.

Behind the #91 Porsche and the #31 BMW, Ford similarly finished on the podium with the #88 Mustang, which pipped the sister #44 Proton Competition machine to the chequered flag. Fourth last year, Sarah Bovy, Rahel Frey and Michelle Gatting in the Iron Dames Lamborghini again reached the end of the race, but this time in fifth, capping an encouraging debut for the Italian manufacturer. Fellow newcomer Lexus brought its two cars home in seventh and tenth places.

CAPTION INDEX

Pages 202-203
HYPERCAR #99
Porsche 963 Proton Competition

LMGT3 #31
BMW M4 LMGT3 Team WRT

Pages 204-205
HYPERCAR #8
Toyota GR010 Hybrid Toyota Gazoo Racing

HYPERCAR #83
Ferrari 499P AF Corse

Page 207
LMGT3 #91
Porsche 911 GT3 R LMGT3 Manthey EMA

Pages 208-209
LMGT3 #59
McLaren 720S LMGT3 Evo United Autosports

Pages 210-211
HYPERCAR #7
Toyota GR010 Hybrid Toyota Gazoo Racing

HYPERCAR #50
Ferrari 499P Ferrari AF Corse
Nicklas Nielsen

Pages 212-213
LMGT3 #88
Ford Mustang LMGT3 Proton Competition

LMGT3 #55
Ferrari 296 LMGT3 Vista AF Corse

Pages 214-215
HYPERCAR #6
Porsche 963 Porsche Penske Motorsport

HYPERCAR #50
Ferrari 499P Ferrari AF Corse

HYPERCAR #7
Toyota GR010 Hybrid Toyota Gazoo Racing

Pages 216-217
HYPERCAR #4
Porsche 963 Porsche Penske Motorsport

HYPERCAR #50
Ferrari 499P Ferrari AF Corse

Pages 218-219
HYPERCAR #50
Ferrari 499P Ferrari AF Corse
Miguel Molina & Antonio Fuoco

LE MANS

LE MANS

After a low-key performance in practice, the Ferraris showed
their real potential at the start of the race.
Against all expectations, the #83 499P occupied the lead
for most of the opening third of the event.

In the dead of night, the weather conditions made the track almost undriveable, so the race had to be neutralised for around four-and-a-half hours.

" It was an extremely difficult race with many ups and downs, during which we had to make difficult decisions every hour – both the team and the drivers on the track.

Patrick Arkenau
Head of Racing *Manthey Racing*

LE MANS

LE MANS

Despite the pressure from the #7 Toyota at the end of the race, Ferrari held onto its lead to secure its second consecutive victory in the 24 Hours of Le Mans with the #50 499P driven by Nicklas Nielsen, Miguel Molina and Antonio Fuoco.

LE MANS

219

ANTONELLO COLETTA

/ GLOBAL HEAD OF ENDURANCE AND CORSE CLIENTI
Ferrari

HOW DO YOU ASSESS THE 2024 SEASON AFTER YOU WON THE 24 HOURS OF LE MANS FOR THE SECOND TIME WITH THE 499P?

For us, 2024 has been another very successful season. When you win Le Mans for the second time, at the second attempt, that's a fantastic achievement. This is the second year of our project, our team, our line-up of drivers, the organisation, so we are extremely proud. It's clear, looking back, that we could have had more victories. Qatar, Interlagos and Fuji were maybe not the best tracks for us, but in all the other races we were in a position to win. At Imola, we lost the race due to a misunderstanding within the team. At Spa, we were running first and second when the action was halted just after the four-hour mark. In Austin, we were leading when we had an accident, although I am very happy that our customer team had the chance to win. Then in Bahrain, we led for six hours and 20 minutes of an eight-hour race, so we can be very satisfied with the performance of the car and the team. We know there is still a long way to go and we have a big margin to improve our consistency in the races, our strategy and all the little details. We know we need to grow and address some issues, but the important thing is to work very hard within the team without putting pressure on one individual or another. We need to put on the table all the ideas, and with maximum humility we will see how to improve our competitiveness.

LOOKING BACK TO THE FIRST SEASON OF THE 499P IN 2023, DID YOU EXPECT THE CAR TO BE SO QUICK AND RELIABLE STRAIGHTAWAY?

No, but in just the first race, at Sebring, we were on pole. That was amazing and very strange for us, because we had tested without any other competitors on-track and didn't know the value of our car. At the same time, we kept working on its consistency and reliability, which is an everyday focus. Even now, when you are faster than the previous year, you still have to work on reliability for each part and improve where you can. If we want to win, we need to finish the race. If we want to be more consistent, we also need to be reactive, calm and make the best decisions, without emotion.

HOW IS THE 499P PROGRAMME REGARDED AT MARANELLO? IS IT BECOMING MORE ESTABLISHED, AT THE SAME LEVEL AS FORMULA 1?

As we said when we presented the car, this is really a project that involves the entire company. Of course, within our own department we're looking after the management, development and operations of the car, but it's important to share information and have technical synergies, as you can see with the Ferrari F80. With the Hypercar project, the mood at Ferrari has completely changed. Many years ago, there was only F1. Now, Formula 1 exists, but you also have endurance, which attracts maximum visibility and attention from our top management. We are so happy about that because 10 or 15 years ago, it was complicated to explain that we won our championship, or important races, with the GT. Step-by-step, we have grown. Today, when a Ferrari wins, regardless of whether it is in Formula 1, in the World Endurance Championship or in one of the great endurance classics such as the 24 Hours of Daytona, a flag is displayed to celebrate that

HOW IMPORTANT IS GT RACING NOW FOR FERRARI?

Even though it's a Pro-Am class, GT is part of the endurance family. That's clear and, for us, it's an important business. It is also in our DNA. Since the beginning, we have been consistently involved with many models that have helped to write Ferrari's history. Now, we have the Hypercar and we have the GT, which is an important asset. The 296 GT3 is a very strong project in WEC, where we won in Japan and Bahrain this season, but we also won the 24-hour races at Daytona and the Nürburgring, and we only lost the 24 Hours of Spa for a stupid issue in the pit-lane. The car is very competitive, like a little prototype, and we have sold a lot of them. After two years, our production is more-or-less the same as after five years of the 488 GT3. The future is very strong for this programme. Like in Hypercar, we have some areas to improve, and probably in one or two years I don't know when, we will make another Evo. This car for me is really one of the best, if not the

> *"We need to put on the table all the ideas, and with maximum humility we will see how to improve our competitiveness."*

YOU PRODUCE A 499P MODIFICATA WHICH IS DERIVED FROM THE 499P. HOW SUCCESSFUL IS THIS CAR?

First of all, we are very proud. In the rules, there is an article that explains that manufacturers can produce a derivative of their car based upon the race version. After the middle of the first season in 2023, we started the Modificata project and it was totally crazy to do it. But, by the end of the same season, we were ready to introduce the project at the Ferrari Finali Mondiali. We showcased the programme to all of our best customers in the world via Corse Clienti, and its success has been amazing. We could sell a lot of cars, but unfortunately, we can only build a small number compared to the requests that we receive. The style of the car is very similar to the 499P, but there are technical differences. The Modificata is 100 per cent four-wheel-drive with maximum power. It has different tyres, different turbos and completely different electronics, and I was very happy to see 12 cars at the 2024 Ferrari Finali Mondiali. That was amazing.

ROUND 05
JULY 14th

SÃO PAULO

ROLEX 6 HOURS
OF SÃO PAULO

SÃO PAULO

SÃO PAULO

After a ten-year hiatus, the Interlagos circuit was back
on the World Endurance Championship trail to the great
delight of drivers, who loved taking up the challenge of racing
on this undulating rollercoaster!

SÃO PAULO

230

SÃO PAULO

/ HYPERCAR
A WARM WELCOME BACK TO BRAZIL

Interlagos returned to the FIA World Endurance Championship for the first time since 2014. The immensely popular circuit had undergone extensive renovation since the series had last visited Brazil, but retained the same challenging layout for drivers and teams. The two Toyotas lined up on the front row of the grid, and the Japanese cars began the race as favourites having shown good pace throughout free practice and qualifying. However, as always, they faced strong opposition.

In warm temperatures and on a dry track, the six-hour contest got underway in spectacular fashion, as Brendon Hartley locked up and went straight on at the first corner. He rejoined behind team-mate Mike Conway, but over the next two hours the damage to the New Zealander's tyres told as he was not able to maintain the same rapid rhythm as the sister car.

Things were not perfect for Conway, either, with the Briton receiving a drive-through penalty for speeding behind the safety car, but such was his pace that he was able to re-take the lead from Hartley shortly after. However, things got much worse for the #7 entry before mid-distance when it required a long stop to change a fuel pressure sensor.

The resulting loss of time dropped the car towards the rear of the Hypercar field, leaving the #8 Toyota to fly the flag for the Japanese manufacturer.

While Toyota was having its issues, so too was Porsche. The championship-leading car of Laurens Vanthoor came together with the privateer JOTA Porsche of Will Stevens, earning the British driver a penalty, and the Porsche Penske Motorsport car subsequently lost more time returning to the pits for a new tyre and nose.

Porsche's chances of winning took a further blow when Michael Christensen handed over to Matt Campbell at the #5 car's penultimate stop, and the team had to change the rear section as it had picked up some damage. That elevated the #6 sister entry to second, with the two Porsche Penske Motorsport 963s ultimately winding up just seven seconds apart in second and third, albeit more than a minute behind the victorious #8 Toyota.

There were more dramas elsewhere in the field, with a late stop-and-go penalty for the #38 JOTA Porsche for running with rear tyres below the legal pressure limit, which gained the #7 Toyota another position. Kamui Kobayashi then passed the Ferrari of Alessandro Pier Guidi with a committed move less than five minutes from the chequered flag to secure fourth.

Ferrari finished fifth and sixth, disappointed with the pace of its car compared to the Toyota and the Porsche. The team's only penalty came for James Calado for speeding under a full course yellow, but the Italian outfit felt it did not have the speed to challenge for glory in any case. The #38 JOTA Porsche dropped to seventh after its aforementioned penalty, but the privately-entered cars had raced strongly. A small error put the #12 sister JOTA 963 off into the tyres, removing its rear wing. After setting the pace in opening practice, Team Peugeot TotalEnergies had an encouraging weekend as the revised #93 9X8 of Mikkel Jensen, Nico Müller and Jean-Éric Vergne enjoyed a clean run to eighth. Ninth went to the #15 BMW M Team WRT, while the #36 Alpine pocketed the final point.

Cadillac conceded time after a stop to check the brakes, with the drivers reporting some strange noises coming from the #2 entry. That, allied to an extra pit-stop for a tyre that had not been properly mounted earlier in the race, dropped the car outside of the top ten. Lamborghini's SC63 was also a casualty, losing time due to a puncture that necessitated an extra pit-stop and resulted in a non-score, while the Isotta Fraschini was the only Hypercar not to finish, having suffered a problem with its engine at the end of the fourth hour.

"The #7 car was flying and they had less degradation," said Hartley after the race. "I was losing two or three seconds per lap in the second stint. We called in early to try to get rid of that tyre, but we were definitely a bit slower than car #7 today."

Toyota's triumph boosted its position in the Manufacturers' standings, while Porsche's double podium maintained the pressure. With second place, Kévin Estre, André Lotterer and Laurens Vanthoor extended their lead in the Drivers' table to 19 points, ahead of Ferrari's Antonio Fuoco, Miguel Molina and Nicklas Nielsen with three races left to run. For Sébastien Buemi, the result marked a significant milestone, with the Swiss star becoming the first driver to register 25 overall victories in the FIA World Endurance Championship. Hartley and Conway sit joint-second on 22 wins apiece.

CAPTION INDEX

Pages 224-225
HYPERCAR #51
Ferrari 499P Ferrari AF Corse

HYPERCAR #20
BMW M Hybrid V8 BMW M Team WRT

Page 228
HYPERCAR #5
Porsche 963 Porsche Penske Motorsport

Page 229
HYPERCAR #93
Peugeot 9X8 Team Peugeot TotalEnergies

HYPERCAR #38
Porsche 963 Hertz Team JOTA

Pages 230-231
LMGT3 #59 / #95
McLaren 720S LMGT3 Evo United Autosports

Page 232
HYPERCAR #11
Isotta Fraschini Tipo6-C Isotta Fraschini

HYPERCAR #83
Ferrari 499P AF Corse

Pages 238-239
HYPERCAR #8
Toyota GR010 Hybrid Toyota Gazoo Racing

HYPERCAR #63
Lamborghini SC63 Lamborghini Iron Lynx

Pages 240-241
LMGT3 #60
Lamborghini Huracán LMGT3 Evo2 Iron Lynx

HYPERCAR #7
Toyota GR010 Hybrid Toyota Gazoo Racing
Mike Conway

Page 242
LMGT3 #85
Lamborghini Huracán LMGT3 Evo2 Iron Dames
Sarah Bovy

LMGT3 #92
Porsche 911 GT3 R LMGT3 Manthey PureRxcing

Page 245
LMGT3 #87
Lexus RC F LMGT3 Akkodis ASP Team

Pages 246-247
HYPERCAR #51
Ferrari 499P Ferrari AF Corse

HYPERCAR #35
Alpine A424 Alpine Endurance Team

Pages 248-249
LMGT3 #27
Aston Martin Vantage AMR LMGT3 Heart of Racing Team

Pages 250-251
HYPERCAR #6
Porsche 963 Porsche Penske Motorsport

HYPERCAR #83
Ferrari 499P AF Corse

HYPERCAR #15
BMW M Hybrid V8 BMW M Team WRT

Pages 252-253
HYPERCAR #8
Toyota GR010 Hybrid Toyota Gazoo Racing

LMGT3 #92
Porsche 911 GT3 R LMGT3 Manthey PureRxcing

SÃO PAULO

> "Everyone in car #7 may not have gotten over their frustration yet. However, the way they fought back to fourth position even though they had dropped to 17th was fantastic. Especially Kamui's overtake at the end was really great!

Akio Toyoda
Chairman of the Board of Directors of Toyota Motor Corporation
Toyota Gazoo Racing

SÃO PAULO

SÃO PAULO

242

/ LMGT3

AN ACTION-PACKED AFFAIR

The debut for the LMGT3 cars at Brazil's Interlagos circuit resulted in an incredible race full of intrigue, overtakes and superb driving. One of the key stories was the return to the cockpit of Christian Ried, who piloted the #88 Proton Competition Ford GT3. By coming out of retirement, the German achieved his 86th FIA World Endurance Championship start – more than any other driver. Another notable point was the official attendance figure of more than 73,000 fans over the course of the weekend, representing a significant increase over the 55,000-strong crowd from 2014, when the series had last visited.

Porsche team Manthey PureRxcing took its second win of the season, following its victory in the curtain-raising contest in Qatar. It was the German manufacturer's fourth success from five races in 2024, with Manthey EMA having similarly triumphed twice. This time, it was the #92 entry of Klaus Bachler, Joel Sturm and Aliaksandr Malykhin that prevailed, a lap ahead of the #27 Heart of Racing Team Aston Martin driven by Ian James, Alex Riberas and Daniel Mancinelli. However, there was heartbreak once again for the Iron Dames Lamborghini, which failed to finish after encountering a mechanical issue mid-race.

The Dames had started from pole position in the hands of Sarah Bovy, but Malykhin found his way past in the second hour.

After taking over at the wheel, Sturm steadily extended the #92 car's advantage from Rahel Frey, but the order was shaken up when the Lamborghini stopped with a water leak and retired from the race early on.

The #92 Porsche thereafter largely held sway, only headed during the pit-stop sequences. In total, it led 160 of the 214 laps. Conversely, the sister #91 entry picked up penalties for contact with other cars that left its crew empty-handed.

The #27 Aston Martin got close to the pace-setting Porsche in the final hour, only for a drive-through penalty for speeding behind the safety car to put an end to its bid for glory.

United Autosports enjoyed a wonderful race, with its pair of McLarens finishing third and fourth. "United Autosports has celebrated great success in WEC with the LMP2s, but this has been a new challenge," acknowledged United co-owner, Richard Dean. "I cannot emphasise enough the time, passion and pure determination that the team has poured into the McLaren programme over the course of eight months, from all sides."

Behind Team WRT's #46 BMW and Vista AF Corse's #55 Ferrari, Proton Competition's #77 Ford Mustang finished seventh, ahead of the sole surviving Corvette.

SÃO PAULO

SÃO PAULO

251 SÃO PAULO

252 SÃO PAULO

Victorious in the opening round in Qatar, the Malykhin-Sturm-Bachler trio was back in the winners' circle in the LMGT3 category, confirming Porsche's domination.

BREAKING DOWN BARRIERS

While historically regarded as a male-dominated sport, successful women in motor racing are nothing new. As early as the 1920s, when the 24 Hours of Le Mans race was created, several women were already racing in motorsport, with the first all-female driving crew – Odette Siko and Marguerite Mareuse – taking the start at La Sarthe seven years later. The pair went on to finish seventh in a Bugatti T40.

In 1958, Maria Teresa de Filippis became the first woman to contest a Formula 1 grand prix, and in the 1980s, Michèle Mouton left her FIA World Rally Championship rivals eating her dust as she blazed a trail for many more fast females to follow. In 2011, Leena Gade hit the headlines as the first female race engineer to win Le Mans.

In current-day endurance racing, it is the Iron Dames that are setting the pace – as Sarah Bovy, Rahel Frey and Michelle Gatting break down barrier after barrier with their performances and results.

In 2023, the pioneering trio became the first all-female line-up to win a race in the FIA World Endurance Championship, in Bahrain in the final round of the LMGTE Am division. This year, at the wheel of a Lamborghini Huracán, they have once again demonstrated their speed by clinching pole position on more than one occasion, and routinely fighting at the front in the new LMGT3 category.

Nobody is better-placed than Frey, one of the stalwarts of the Iron Dames operation since the start to assess how this initiative has changed the way they are perceived: "At the beginning, nobody saw the clear intention or understood that this is a long-term project. Now, in our sixth year, people have got to know us and can see our character and motivation. And this brings us a lot of respect. Clearly, it is also a game-change when we are successful. Our first win in Bahrain last year was plainly a new benchmark. It was a huge achievement. So people take us seriously on-track and this makes me personally and all the team super super-happy. That's super-important for us, but also for the next generation of female drivers."

Even if the lack of reliability of their new car has often stymied their efforts, Frey, Gatting and Bovy have spread the Iron Dames mantra far and wide this season: "We really try to drive home the message that people should dare to dream and dream big, because dreaming is the best motivation for hard work. And hard work always pays off. This is what we know best."

Deborah Mayer has good reason to be proud of her protégés. The Frenchwoman, who made a career in finance, is the co-founder of the Iron Lynx team and the instigator of the Iron Dames programme launched in 2018. She does not hide the satisfaction she feels with her ambassadors: "I've experienced every

emotion imaginable with the Iron Dames. We win and lose together, and the results establish the credibility of the project. The podiums and victories achieved in recent months show in the most telling fashion that this is a viable project built on the right foundations."

While the #85 Lamborghini crew frequently steal the spotlight, many other women have similarly made a place for themselves in the endurance paddocks in positions previously occupied by men. Just a few pit garages away from the Iron Dames team, Laura Wontrop Klauser is hard at work. This American engineer heads the endurance racing programmes of Cadillac and Corvette, the two General Motors brands involved in the World Championship.

Having joined GM after her studies – during which she discovered motorsport – Wontrop Klauser did not feel that being a woman in this very masculine environment was a drawback: "I feel like my youth created more difficulties for me than being a woman! I've never felt like I was being treated differently as such and I've established very good relationships with all my colleagues. I like to think that one of my strengths is knowing how to exchange ideas with others and seeing how we can improve things together rather than following a personal agenda.

> " *At the beginning, nobody saw the clear intention or understood that this is a long-term project.*
>
> **Rahel Frey**

It's helped me to succeed. In fact, I would say it is really more of a strength to be able to rely on qualities generally associated with women."

Even so, Wontrop Klauser refuses to regard herself as an icon: "I don't really see myself as a role model, but I do appreciate the growing number of young women who contact me to share their aspirations. We talk and I try to guide them on how to get into the sport. I also see a lot of great women in the paddock. I find it encouraging that their numbers are increasing. I'm convinced diversity brings richness."

Among these women, Christie Bagne is an intriguing case – and a real petrolhead. She was raised in Detroit, the American capital of the motor car, in the right milieu as her mother and grandmother both drove Chevrolet Camaros. It was not long before she was taking part in track days in a Subaru WRX, and after that, ice races. From then on, her studies in neuroscience no longer seemed to fit with her new passion. A quick handbrake turn later, she switched to a mechanical engineering school. Hired by GM Motorsports in 2021, she now leads the Corvette LMGT3 programme while competing in club races in the USA as a privateer.

Bagne is not the only female engineer in the World Endurance Championship. Frenchwoman Élise Moury is in charge of strategy for Cadillac Racing, working alongside her husband Jonathan, who is chief engineer at the same team. At TotalEnergies, the World Endurance Championship's fuel supplier, Marjorie Alliot is the fuel development manager who makes sure the entire WEC field is provided with a non-fossil, renewable fuel composed mainly of wine residues.

> " *I see a lot of great women in the paddock. I find it encouraging that their numbers are increasing. I'm convinced diversity brings richness.*
>
> **Laura Wontrop Klauser**

Laura Wontrop Klauser, Sports Car Racing Program Manager at General Motors

Élise Bauquel is a race mechanic for Hertz Team JOTA

Christie Bagne, Corvette GT3 Program Manager at General Motors

The increase of women engineers in the WEC has been accompanied by that of female mechanics like Élise Bauquel. After pursuing technical studies in industrial product design and rapid prototyping, the French-woman had a brainwave: "I realised I didn't really like the design office after all, so I enrolled at Nogaro's performance school to become a mechanic. My father didn't agree, but once he saw that I was very motivated, he gave in and encouraged me. I don't regret my choice. It's a fast-paced job. I can't sit on a chair in front of a computer screen all day. In the beginning I struggled physically, but I soon adapted."

Bauquel has been working in the World Endurance Championship since 2013. "I started at the 24 Hours of Le Mans. The first time, I wasn't paid, but it didn't matter. I would have paid to be able to work at that race at least once!" Since then, she has joined the ranks of the JOTA team. After being assigned to wheel changes for a while, she is now in charge of assisting driver changes during races. She also manages everything related to bodywork. This year, she has experienced very powerful emotions, with Will Stevens and Callum Ilott winning outright at Spa ahead of the entire world endurance elite. "The further up the order my car is, the more stressed am!" she jokes. A few weeks later, she again found herself in the front line when the JOTA team had to rebuild one of its Porsches in less than two days at Le Mans following Ilott's accident on the Wednesday evening.

Elsewhere in the pit-lane, Sophie Bull is chief mechanic on TF Sport's #82 Corvette Z06 LMGT3.R in the LMGT3 category. Trained in the British Touring Car Championship, she wanted to work in WEC so took the plunge and contacted Tom Ferrier's team which hired her in 2023.

However, you don't need to be a technical expert to find your niche. Jana Koegel is coordinator of the Cadillac Racing Hypercar team, while Charlaine Robert-Fondeville is team manager of the ASP-Akkodis squad in LMGT3. Unsurprisingly, the position of team manager in the Iron Dames outfit is filled by a woman – Alice Menin.

Drivers, engineers, mechanics, team managers, programme managers... women have now proven themselves in almost all positions historically occupied by men. Sporting delegate at the Automobile Club de l'Ouest and right-hand woman of race director Eduardo Freitas, Lisa Weishard found the words to sum up the spirit in WEC: "I think today, we are past the time when it was necessary for women to justify themselves at all costs

ROUND 06
SEPTEMBER 1st

AUSTIN

LONE STAR LE MANS

AUSTIN

The World Endurance Championship received
a warm welcome to the Texan track
four years after its last visit.

261 AUSTIN

AUSTIN

266 AUSTIN

/ HYPERCAR
PRIVATEERS BEAT THE BIG GUNS

It might have been a very hot, humid weekend, but with its Labor Day holiday timing, there were still plenty of fans thronging the paddock and grandstands at the Circuit of The Americas. Qualifying saw the factory Ferraris set the pace, with Antonio Giovinazzi posting a time three tenths-of-a-second faster than team-mate Antonio Fuoco. The Cadillac of Alex Lynn split the three Italian cars, with Robert Kubica slotting into fourth. Less than a second covered the top 12, which also included one Alpine, two Porsches, two BMWs, two Toyotas and a Peugeot. Only the top ten advanced to the Hyperpole, but the session nonetheless demonstrated how close the different cars were in terms of single-lap speed.

Giovinazzi continued to impress by grabbing pole position in the #51 Ferrari, joined on the front row of the grid by the yellow 499P of Kubica. The Cadillac and #35 Alpine shared row two, followed by the #50 Ferrari, the #5 Porsche, the two BMWs, Kamui Kobayashi's Toyota and Norman Nato's JOTA Porsche.

The Toyota of Sébastien Buemi missed out on Hyperpole, as both of the Japanese manufacturer's cars started further down the order than usual, but during the race they swiftly made up ground and went on to battle it out with Ferrari for victory, with the result ultimately coming down to penalties – and how teams handled them.

Kubica ran second behind Giovinazzi in the early stages, with the Italian subsequently being instructed to allow the Pole past so the former grand prix-winner could step up the pace. That increased rhythm meant Kubica required a full set of new tyres at the first round of pit-stops, while Giovinazzi took fresh boots only on the left-hand side, but the Italian's race came to a premature end following contact with an LMGT3 car that damaged his Ferrari's wheel rim, which in-turn led to a failure in the drivetrain.

Yifei Ye climbed into the cockpit of the #83 entry midway through, and was given the hard-compound rubber to ensure he could complete a full double stint. This tyre, however, was not the fastest, causing the Chinese driver to fall into the clutches of the Toyota of Nyck de Vries. The Dutchman closed more than 11 seconds on the leading Ferrari, although he was not able to find a way past before the two cars pitted, with Ye making way for Robert Shwartzman and Kobayashi taking over from de Vries for a final showdown to the chequered flag. Toyota turned its car around faster than Ferrari to propel Kobayashi into the lead, but there were further twists in the tale still to come. The Japanese driver was deemed by the stewards to have not slowed sufficiently for a yellow flag, caused when Paul di Resta stopped his Peugeot 9X8 Evo on-track due to a mechanical failure, earning Kobayashi a drive-through penalty and handing the advantage back to Ferrari.

The Prancing Horse duly celebrated its second win of the year after its Le Mans triumph. This time, however, it was not the official factory car that took the flag first, but the privately-entered AF Corse-run 499P of Kubica, Shwartzman and Ye. In characteristic fashion, Kobayashi refused to give up and charged down Shwartzman, falling just 1.780s shy of victory following six hours of racing and a thrilling late chase, with Antonio Fuoco, Miguel Molina and Nicklas Nielsen rounding out the podium in third.

Toyota's day was soured by a brace of penalties for Buemi for not respecting blue flags and contact with Kévin Estre in the #6 Porsche. That dropped the #8 Toyota to the tail-end

of the classified finishers, and its crew left the USA empty-handed. With their points for second place, by contrast, Kobayashi and de Vries moved up to the same position in the Drivers' classification, just ten points shy of Porsche Penske Motorsport trio Estre, André Lotterer and Laurens Vanthoor in first place.

Cadillac and Alpine enjoyed good results. Earl Bamber was hit by Ferdinand Habsburg on the opening tour, but otherwise the New Zealander and team-mate Lynn had a solid run to fourth ahead of Habsburg, Paul-Loup Chatin and Charles Milesi. Both teams conceded they did not have the pace to take the fight to Toyota and Ferrari, but vowed to work hard and improve in all areas in order to challenge for wins.

Porsche, conversely, did not have a perfect day. The #5 pitted at the end of the first lap to remove a safety cone from a Pitot tube that had been missed before the start, and the team had to change driver rotation when Michael Christensen found that his drinks bottle was not properly connected. In high ambient temperatures, that meant the Dane had to single-stint twice, rather than completing a double stint.

They ended up seventh, just behind the sister car of Estre, Vanthoor and Lotterer, which picked up a drive-through penalty for overtaking under a yellow flag. The championship leaders pulled back one position when Sheldon van der Linde had to serve a stop-and-go of 100 seconds for exceeding the maximum power allowance in his #20 BMW. The #15 Team WRT car wound up eighth.

One of the more curious incidents occurred in the JOTA pit. The #12 entry encountered an electrical issue that caused it to shut down suddenly, so quickly that the team didn't know what had caused it to fail. The mechanics changed multiple parts and kept sending it out, mindful that the car would be shipped the day after the race to the following round at Fuji.

272 AUSTIN

273 **AUSTIN**

/ **LMGT3**

COMPETITION HOTS UP IN TEXAS

The battle for glory in LMGT3 continued to rage as the series headed to Texas' Circuit of The Americas. Corvette looked strong in the practice sessions on home territory, but during qualifying, it was Sarah Bovy in the Iron Dames Lamborghini who topped the timesheets, a tenth-of-a-second faster than the Heart of Racing Team Aston Martin of Ian James and two tenths up on the TF Sport Corvette.

In Hyperpole, James turned the tables on the Lamborghini to secure pole position, ahead of Bovy and François Hériau in the Vista AF Corse Ferrari.

James started the race, but he didn't have an easy time of it over the opening two hours as Bovy piled on the pressure in a thrilling nose-to-tail duel.

The leader pitted the Aston Martin to relinquish the wheel to Daniel Mancinelli for the middle stint, during which came the race-deciding move. Rahel Frey, now in for the Iron Dames, lunged up the inside of TF Sport's Rui Andrade approaching mid-distance, with the pair making contact. The Lamborghini trailed back to the pits with broken suspension, while the Corvette was able to continue albeit carrying bodywork damage to its front-left corner.

With the two most likely challengers to the Aston Martin effectively out of the picture, Mancinelli was able to establish a firm lead, which left Alex Riberas with a more straightforward job to bring the car home.

As the Corvette and Lamborghini dropped down the order, it was the Manthey PureRxcing Porsche of Aliaksandr Malykhin, Joel Sturm and Klaus Bachler that took up the chase. The #92 crew tried everything to close the gap to the Aston Martin, double-stinting tyres in a bid to save time in the pit-lane, but the performance drop-off at the end of the second stint allowed the Vantage to comfortably stay ahead.

The result marked the first triumph in the series for the new model and the first for Heart of Racing Team in WEC, not to mention the tenth time that the legendary British manufacturer had scored a class win at COTA. James, Mancinelli and Riberas ultimately took the chequered flag more than 20 seconds clear of the championship-leading Porsche, with the Aston Martin leading for 160 of the 164 laps, underscoring a dominant all-round display.

"Today, every pit-stop was flawless, the strategy was good and the tyres performed perfectly," reflected Riberas.

The Porsche pit, too, was happy as its drivers were able to increase their advantage at the top of the standings to 28 points with two races remaining. Team-mates Richard Lietz, Yasser Shahin and Morris Schuring, their nearest contenders for the crown, rounded out the podium but lost ground in the title ratings. McLaren continued to score well, finishing fourth in-class.

Ford's Dennis Olsen stopped on-track late in the race with a steering problem, while Maxime Martin was able to drive his Team WRT BMW back to the pits having suffered a similar issue.

CAPTION INDEX

Pages 258-259 **HYPERCAR #6**
Porsche 963 Porsche Penske Motorsport

Page 260 **HYPERCAR #50**
Ferrari 499P Ferrari AF Corse

Page 261 *Frankie Muniz flags the field away at the start*

LMGT3 #81
Corvette Z06 LMGT3.R TF Sport

Page 266 **HYPERCAR #83 / #51**
Ferrari 499P AF Corse / Ferrari AF Corse

Page 267 **HYPERCAR #50**
Ferrari 499P Ferrari AF Corse

LMGT3 #81
Corvette Z06 LMGT3.R TF Sport

Page 271 **HYPERCAR #35**
Alpine A424 Alpine Endurance Team
Paul-Loup Chatin

HYPERCAR #20
BMW M Hybrid V8 BMW M Team WRT

Page 274 **HYPERCAR #63**
Lamborghini SC63 Lamborghini Iron Lynx

HYPERCAR #12
Porsche 963 Hertz Team JOTA

Page 275 **HYPERCAR #36**
Alpine A424 Alpine Endurance Team
Mick Schumacher

HYPERCAR #93
Peugeot 9X8 Team Peugeot TotalEnergies

Page 276 **LMGT3 #27**
Aston Martin Vantage AMR LMGT3 Heart of Racing Team

Pages 280-281 **LMGT3 #55**
Ferrari 296 LMGT3 Vista AF Corse

HYPERCAR #5
Porsche 963 Porsche Penske Motorsport

Pages 282-283 **LMGT3 #91**
Porsche 911 GT3 R LMGT3 Manthey EMA

LMGT3 #59
McLaren 720S LMGT3 Evo United Autosports

Page 284 **LMGT3 #31**
BMW M4 LMGT3 Team WRT

HYPERCAR #5
Porsche 963 Porsche Penske Motorsport

Page 285 **HYPERCAR #20**
BMW M Hybrid V8 BMW M Team WRT

HYPERCAR #51
Ferrari 499P Ferrari AF Corse

Pages 286-287 **HYPERCAR #99**
Porsche 963 Proton Competition

HYPERCAR #83
Ferrari 499P AF Corse

The first corner of the Circuit of The Americas
has a 40-metre elevation and a wide track,
allowing for a multitude of trajectories.

AUSTIN

AUSTIN

AUSTIN

> " We were among the only ones who could keep up with the Ferrari for the first half of the race. Now we have to learn how to do it until the end of the race, without making any mistakes.

Vincent Vosse
Team Principal *BMW M Team WRT*

This year, the Proton Competition outfit has been a model
of consistency, as reflected in its performances. In Austin,
it scored its fourth consecutive top three finish in the FIA World Cup
for Hypercar Teams, reserved for independent entrants.

The AF Corse team's Ferrari 499P defeated all
the factory cars to the great joy of Robert Kubica,
winner of a world championship event for the first time
since his victory in the 2008 Canadian Grand Prix.

ANDRÉ LOTTERER

/ 2024 WORLD ENDURANCE CHAMPION
Porsche Penske Motorsport

AT THE BEGINNING OF THE YEAR, YOU DECIDED TO WITHDRAW FROM FORMULA E IN ORDER TO FOCUS ON ENDURANCE RACING. WHY WAS THAT?

Well, I come from endurance racing, first of all. My endurance career started even a bit before WEC was created. When I went to race in Japan in Super GT from 2004, that was a kind of semi-endurance. I developed a bit of endurance spirit there, and then of course I went to race at Le Mans for the first time in 2009 and really liked it. My career really boomed through endurance and with the beginning of WEC in 2012, that became my world basically. Formula E was becoming something really interesting for drivers and manufacturers, so I went to tackle that challenge, but when I knew that Porsche would come back to endurance racing, it was immediately on my radar. At some point, they asked me what I wanted to do: Formula E or endurance? I wanted to go back to endurance because I wanted to win Le Mans a few more times, especially with Porsche.

ENDURANCE RACING MEANS SHARING A CAR AND THE GLORY WITH OTHER DRIVERS. IS THAT EASY TO COPE WITH?

For me, yes, because I really like the team effort. I think endurance racing really represents team sport, and sharing the glory for me is fun, because I have always had really nice team-mates. Especially, I was lucky at the beginning with Ben [Tréluyer] and Marcel [Fässler] at Audi and now also with Laurens [Vanthoor] and Kévin [Estre], it's really cool. I really enjoy this teamwork. It's not easy for everyone to have that kind of mindset, because a lot of us have very big egos or too big egos, so maybe it suits some better than others. The camaraderie in endurance is quite nice, and I think it's quite nice also to each have a bit of a different role in the team, with different characters. Some might be more team players willing to compromise so the other one can perform better, or the other way around, and if you're really close together, you know, you can support and protect each other to have a good trio and be better than the others. So, yeah, I think

YOU WERE PART OF A LEGENDARY TRIO WITH BENOÎT TRÉLUYER AND MARCEL FÄSSLER WITHIN THE AUDI TEAM. HOW EASY OR DIFFICULT WAS IT TO FORM A NEW TRIO WITH KÉVIN ESTRE AND LAURENS VANTHOOR?

It wasn't difficult. The three of us have the mindset that we're here to have a good time; we have the same goal and want to extract the maximum out of each other. Laurens is a very particular character. He's very committed and determined off-track. We are all very focused and determined on-track. We all push the limits, but then, when you meet off-track, you live the way you like. When we go for dinner, Laurens always wants the healthy choice, whereas Kévin and I like a good dinner and, why not, a glass of wine. These are the main differences between us. Regarding Kévin, in terms of character, it's hard to find anything negative to say about him. He's really a very, very fair guy and team player. He is always very involved in the race and the strategy, but also in private, sometimes he calls just to check everything is ok. I really enjoy racing with them both and it's a great spirit. It was not difficult to form a trio there – it happened naturally.

WITH MARCEL FÄSSLER AND BENOÎT TRÉLUYER, YOU WERE THE FIRST WEC CHAMPIONS IN 2012. DID YOU EXPECT AT THAT TIME TO BE IN THE FIGHT FOR ANOTHER TITLE 12 YEARS LATER?

I never really thought in such long-term. I mean, I knew I wanted to race until at least 45, because we had good examples with Tom [Kristensen], Allan [McNish] and Dindo [Capello] having such good careers and still being competitive. To be honest, it was a wish that I would still be around and still be competitive, but I probably didn't imagine that I could still fight for the world championship 12 years later and be in that situation.

THE 963 PROJECT PRESENTED THE OPPORTUNITY TO RELAUNCH YOUR COLLABORATION WITH PORSCHE. DO YOU CONSIDER THAT YOU HAD UNFINISHED BUSINESS WITH THE BRAND?

Of course, because when the Audi project stopped, I had the opportunity to go to either Toyota or

> "When I won the title in 2012, I probably didn't imagine I could still fight for the world championship 12 years later and be in that situation."

Porsche, and my dream was always to race for Porsche and win Le Mans with Porsche. It's such an iconic brand with so much heritage, especially in endurance racing. Unfortunately, it lasted only one year – 2017 – but we almost won Le Mans. Three hours from the finish, we were leading comfortably and the engine broke. Then Porsche withdrew from WEC. That was a bitter pill to swallow.

LAST YEAR WAS A DIFFICULT YEAR FOR THE 963 PROJECT. HOW DO YOU EXPLAIN THAT THE CAR HAS PERFORMED SO WELL THIS YEAR?

Last year was, let's call it, a learning year. We had to understand the car. We were not in the 'sweet spot' in terms of set-up. This year, we made changes in the team; we brought some different people in and we understood the car better. So we basically just improved. It's a question of set-up as the rules don't allow you to bring any hardware evolutions. All you can do is springs, dampers, a bit of geometry set-up and all the systems, but that's enough to put the car in a better spot. I wouldn't say we were dominant at all. We were dominant in Qatar due to the track characteristics and maybe the way we optimised our car concept, but in the other races, we were never really dominant. We succeeded mainly through very good strategies and not making mistakes

Also, we had a bit of luck at Spa and a nice comeback in São Paulo. I don't think it was through dominant speed, but that's the beauty of endurance – it's not always the fastest car that wins.

LAST YEAR WAS A DIFFICULT LEARNING SEASON. NEVERTHELESS, WERE YOU CONVINCED THE CAR HAD THE POTENTIAL?
I wouldn't say that, because last year there were moments where we were a bit desperate. Personally, I was sometimes a bit pessimistic and questioning if our concept was good enough. But then we improved the set-up.

WHAT WAS THE KEY MOMENT OF YOUR SEASON?
Winning in Qatar. I think that was the key moment because coming from the previous season, we were not too sure where we would be. We went testing there and it didn't look too good. Then we made our learnings and we began the season with a bang. That was definitely a good milestone to start the season well.

I GUESS YOU PERSONALLY ENJOYED WINNING AT FUJI, TOO?
Yes, definitely! I went to Japan when I was 21 to pursue my professional racing career, not knowing how long I was going to stay there. It ended up being 15 years so obviously, that became my home. I made a lot of friendships there and had a great time. I won a lot of races at Fuji, but never in WEC, and it was always a dream and a target to win that race in WEC. I came close two or three times in the past and then this year, things came together, so I was very, very happy about that.

"We succeeded through very good strategies, and not making mistakes."

ROUND 07
SEPTEMBER 15th

FUJI

6 HOURS OF FUJI

FUJI

FUJI

FUJI

FUJI

FUJI

300

" I was really pleased with the start and my first stint.
I got into a good rhythm and felt like I had great pace.
Then, the heat got the better of me and I began making mistakes,
so it seemed to be the right thing to do to take a break.
When I got out of the car, I was very relieved.

James Cottingham
Driver - #59 McLaren 720S LMGT3 Evo
United Autosports

FUJI

/ HYPERCAR
TOYOTA TOPPLED AT HOME

As leader in the Manufacturers' battle and winner of the last six editions of the 6 Hours of Fuji, Toyota Gazoo Racing approached its home race with fierce determination to climb back onto the top step of the podium in the shadow of Mount Fuji. Undaunted by the local record of the multiple world championship-winning team, however, Alex Lynn was the first to show he intended to scupper the Japanese outfit's plan, claiming Cadillac's maiden pole position in the FIA World Endurance Championship as he pipped the #8 Toyota to Hyperpole glory by the narrow margin of just four hundredths-of-a-second.

Contested in front of 68,500 enthusiastic spectators, the race got off to a hectic start, which didn't really play into Toyota's hands as its pair of GR010 Hybrids lost ground on the opening lap, each dropping a place to third and fifth. Next time around, the Ferrari clan saw its ambitions dashed as Robert Kubica (#83 499P) missed his braking point at Turn One, triggering a chain reaction of incidents. His Ferrari hit the rear of the #5 Porsche, which in turn knocked the #51 Ferrari sideways and the latter tagged the #36 Alpine into a spin. Worse still, the #50 Ferrari was harpooned by its sister car! Judged responsible for this chaos, the yellow 499P was given a 30-second stop-and-go penalty.

After the cars involved in the pile-up had pitted and the safety car had briefly intervened, Earl Bamber's Cadillac headed Marco Wittmann's #15 BMW and Laurens Vanthoor

in the #6 Porsche, which had quickly overtaken the #8 Toyota. Although the American car led for the first hour, it rejoined behind the Porsche once the initial round of refuelling stops had played out, with the #6 assuming the top spot following a short spell at the front of the field for the #51 Ferrari. The circuit layout suited the Porsche 963s down to the ground and the Drivers' world championship-leading crew thereafter gave the impression of having the race firmly in-hand, only occasionally relinquishing their advantage during scheduled pit visits.

Among those who led briefly were the #50 Ferrari, the #15 BMW, the two Alpines and the #8 Toyota, but for the many Japanese fans who had made the trip to this circuit owned by their favourite manufacturer, the opportunities to wave their flags were rare. Halfway through the race, the Toyotas sat just fifth and sixth, although a virtual safety car one-and-a-half hours from the finish helped to close up the gaps.

At the re-start, the #6 Porsche – now in the hands of Kévin Estre – immediately reaffirmed its supremacy. Shortly afterwards, things went further south for Toyota. The #8 conceded third place to the #35 Alpine, driven by a hard-charging Charles Milesi, while Kamui Kobayashi in the #7 tangled with Matt Campbell's #5 Porsche, forcing it to quit the race, which was a body blow to the crew's chances of winning the world championship. The Toyota was soon joined on the sidelines by the #51 Ferrari.

While the #6 Porsche and the #15 BMW continued to impress, further back, the last half-hour of the race was full of action. Trying to avoid the #36 Alpine, Earl Bamber hit the guardrail and seriously damaged his Cadillac, which he made a desperate effort to bring back to the pits. Handed a drive-through penalty following contact with an LMGT3 car, the #35 Alpine lost third position to the #8 Toyota. In the stands, the flags were waving again, although not for long, as 15 minutes from the chequered flag, the GR010 Hybrid piloted by Ryō Hirakawa was similarly penalised for not respecting blue flags!

From then on, the battle for the bottom step of the rostrum intensified. Fitted with two new tyres, Mick Schumacher's #36 Alpine applied sustained pressure to Norman Nato, whose own tyres on the #12 JOTA Porsche were badly worn. The ex-Formula 1 driver found an opening six minutes from the end, thereafter keeping a keen eye on his rearview mirrors so as not to be jumped by the #93 Peugeot on fresh rubber. Schumacher managed to hold his position to give the Alpine A424 its first podium.

By triumphing in Japan, Vanthoor, Estre and André Lotterer achieved a major feat. In addition to ending Toyota's winning streak at home, the trio took a significant step towards clinching the Drivers' championship title, needing no more than an eighth-place finish in the season finale in Bahrain to seal the deal. For Vanthoor, the result had a particularly special significance as the Belgian was joined on the podium by his brother Dries, who finished second at the wheel of the #15 BMW M Hybrid V8 he shares with Wittmann and Raffaele Marciello.

The #6's victory also put Porsche back on top in the chase for the Manufacturers' crown. With one race to go, the German brand took the lead from Toyota, with ten points in hand over its closest rival and 27 over Ferrari. This made Urs Kuratle, Director of Porsche Factory Motorsport's LMDh programme, a very happy man: "That was definitely one of the best races we've contested so far with the Porsche 963 – our strategy was perfect and the pit-stops were sensational. Now, we're well and truly back in the hunt for the world championship title."

Before the final showdown in Bahrain, the Porsche clan already has several successes to celebrate – the FIA Endurance Trophy for LMGT3 Drivers and Teams, and the FIA World Cup for Hypercar Teams. By finishing fifth in Japan with its #12 963 and sixth with the sister #38 car, the JOTA team secured that honour for the second year running.

CAPTION INDEX

Pages 292-293 **LMGT3 #78**
Lexus RC F LMGT3 Akkodis ASP Team

HYPERCAR #94
Peugeot 9X8 Team Peugeot TotalEnergies

Page 296 **HYPERCAR #7**
Toyota GR010 Hybrid Toyota Gazoo Racing

HYPERCAR #8
Toyota GR010 Hybrid Toyota Gazoo Racing

HYPERCAR #6
Porsche 963 Porsche Penske Motorsport

Page 297 **HYPERCAR #2**
Cadillac V-Series.R Cadillac Racing

Page 298 **LMGT3 #78**
Lexus RC F Akkodis ASP Team
Kelvin van der Linde

Page 299 **HYPERCAR #5**
Porsche 963 Porsche Penske Motorsport

Page 301 **LMGT3 #59**
McLaren 720S LMGT3 Evo United Autosports

Pages 302-303 **HYPERCAR #2**
Cadillac V-Series.R Cadillac Racing

HYPERCAR #15
BMW M Hybrid V8 BMW M Team WRT

Pages 308-309 **LMGT3 #87**
Lexus RC F LMGT3 Akkodis ASP Team

LMGT3 #82
Corvette Z06 LMGT3.R TF Sport

Pages 310-311 **LMGT3 #87**
Lexus RC F LMGT3 Akkodis ASP Team

HYPERCAR #50
Ferrari 499P Ferrari AF Corse
Antonio Fuoco

HYPERCAR #5
Porsche 963 Porsche Penske Motorsport

Pages 312-313 **HYPERCAR #8**
Toyota GR010 Hybrid Toyota Gazoo Racing

HYPERCAR #50
Ferrari 499P Ferrari AF Corse

Page 314 **LMGT3 #54 / #55**
Ferrari 296 LMGT3 Vista AF Corse
François Hériau

Page 317 **LMGT3 #85**
Lamborghini Huracán LMGT3 Evo2 Iron Dames

Page 318 **HYPERCAR #2**
Cadillac V-Series.R Cadillac Racing

Pages 320-321 **HYPERCAR #6**
Porsche 963 Porsche Penske Motorsport

Pages 322-323 **HYPERCAR #6**
Porsche 963 Porsche Penske Motorsport
André Lotterer

LMGT3 #54
Ferrari 296 LMGT3 Vista AF Corse

FUJI

FUJI

310

FUJI

FUJI

312

FUJI

FUJI

314

/ LMGT3
PORSCHE CLINCHES FIRST LMGT3 CROWN

After the domination of the Porsche earlier in the season, was Heart of Racing Team's victory with its Aston Martin at COTA a shot in the arm for the competition? In any case, that was the impression given by the Fuji Hyperpole session, in which no fewer than seven brands disputed pole position – Porsche was not amongst them! François Hériau came out on top at the wheel of Vista AF Corse's Ferrari 293 LMGT3, with the championship-leading Porsches way down in 14th (#92) and 15th (#91). That promised plenty of action to come – and the race did not disappoint.

Right from the start, an ABS-related technical issue affected the pole-sitting #55 Ferrari, condemning the car to a brace of early pit-stops and ruling it out of contention. Tom Van Rompuy's Corvette duly snatched the lead ahead of the two McLarens, which were locked in battle. After 15 minutes of racing, contact between the British cars sent Joshua Caygill into a spin, before the Iron Dames' Sarah Bovy overhauled James Cottingham in the #59 United Autosports entry to claim second place.

During the second hour, the #59 McLaren – now helmed by Nicolas Costa – took the lead and opened up a gap over the chasing pack spearheaded successively by the #46 BMW, the #54 Ferrari, the #81 Corvette and the #85 Lamborghini, with the latter pair both subsequently enjoying spells at the front of the field.

The #92 Porsche produced a superb comeback from its qualifying struggles to rise to the top of the timing screens entering the race's final quarter, but following a safety car intervention, it was the McLaren that regained the advantage – albeit having run out of fresh tyres.

There were no such problems for the #54 Ferrari, in which a fired-up Davide Rigon went on a charge. Thirteenth at the beginning of his stint, the experienced Italian stormed into the top three approaching the five-hour mark. He overtook the #92 Porsche for second with 45 minutes to go prior to setting off in hot pursuit of the #59 McLaren, which he blasted past half-an-hour from the chequered flag to give the Ferrari 296 LMGT3 its maiden victory in the FIA World Endurance Championship. The Fuji circuit clearly suits Rigon, Thomas Flohr and Francesco Castellacci perfectly, with the trio having won there in LMGTE Am in 2023, and Flohr and Castellacci previously triumphing in 2017.

Assisted by a good strategy, the #92 Manthey PureRxcing Porsche snared the runner-up spoils to secure the German squad the inaugural FIA Endurance Trophy for LMGT3 Teams, as Belarus' Aliaksandr Malykhin, Germany's Joel Sturm and Austria's Klaus Bachler clinched the coveted Drivers' crown.

The Cadillac, the first leader of the race, failed to reach the finish despite the best efforts of Earl Bamber, determined to bring it back to the pits whatever the cost!

FUJI

FUJI

" I'm over the moon about the win! This is tremendous for the championship and very emotional for me. I really wanted to win at Fuji – after so many years living in Japan, this feels like a home race. Today, it finally worked out!

André Lotterer
Driver - #6 Porsche 963
Porsche Penske Motorsport

NICOLAS RAEDER

/ CEO
Manthey Racing GmbH - LMGT3 Champion Team

FIRST OF ALL, CAN YOU TELL US ABOUT YOUR COMPANY?

My brother Martin and I are the CEOs of Manthey, and we have 340 people working across our five business divisions. One of them is dedicated to racing – WEC, DTM, the Nürburgring 24h and more. We race or we support racing teams with engineers and we work closely together with Porsche as one of our share-holders. Then we have a road car business. We develop kits that are sold worldwide through Porsche to its customers and we offer services for road cars. In addition, we produce and develop plug-and-play equipment for every Porsche race car or homologation kits. Manthey also operates the Porsche Track Experience, a Porsche driving and racing school. My brother and I are both technical guys. Personally, I'm more involved in racing than Martin. I'm more a theoretical technical guy and my brother more a practical technical one.

HOW DID RAEDER MOTORSPORT AND MANTHEY RACING MERGE?

Olaf and Renate [Manthey]'s son died in a road car accident in 2007 and, after that, they didn't have anyone to take over from them. Simultaneously, my brother and I were developing our own company, Raeder Motorsport. Olaf was working with Porsche and we were doing a lot of stuff for Audi. We developed the front wheel-drive Audi TT RS race car. We impressed Olaf a lot with that, especially when we won a six-hour race at the Nürburgring that had almost 200 cars at the start. He was the first one who came and congratulated us. Then we got to know each other and Olaf saw that we had the same mindset, the same passion for technology and performance, even if we are completely different people. That was the reason why we merged in 2013. That was a major move. Back then, there were 45 of us and now there are 340 people! Porsche gives us a lot of opportunities.

HOW HAPPY ARE YOU ABOUT THE ARRIVAL OF THE LMGT3 CLASS IN THE WORLD ENDURANCE CHAMPIONSHIP THIS YEAR?

I'm very happy. In the beginning I wasn't so sure because I really liked the 911 RSR and the LMGTE cars but now, I think it's perfect for us. At first, we were disappointed not to get the opportunity to represent Porsche in the Hypercar class but, in the end, the Manthey business is all about GT. So it made sense for us to enter the LMGT3 category – no longer as a works team, but as a private team. In that case, it's much more difficult to get the funding but, in a way, you have much greater freedom. You can be more creative and daring in your decisions. I'm very proud that we put this project together with our customers and partners. It was a big challenge for the whole team. At the end of the day, the fact that the class changed was a big stroke of luck for us, because it would have been far too expensive with LMGTE cars. So for us, it was a good decision and we like it a lot. Otherwise, we wouldn't have had the opportunity to continue racing in WEC.

IS THE PORSCHE GT3 R LMGT3 AN EASY CAR TO OPERATE?

Even if it's a rather difficult car to drive, most of the drivers like the Porsche. I think if you want to compete at that level, no car is easy. And if it's too easy, the Balance of Performance (BoP) comes in and levels the playing field. The Porsche is a really, really good GT car – there's no question about that – but we can't say it's easy to get the best out of it. It's a car you have to put a lot of effort into. You have to really understand it. Everything is a bit different to most of the other cars.

Olaf is still involved as an advisor, especially in the DTM operation. I think one of the keys to being successful is to use all the modern tools and have a modern mindset, but without forgetting the history and the experience gathered in the past. We bring the future and the past together!

WHAT DO YOU LIKE BEST ABOUT ENDURANCE RACING?

I like the strategy opportunities. In sprint races, you have a qualifying session and if you're really lucky, you might gain a couple of places in the race, but your strategic options are more limited. In endurance racing, you can work from 6 to 24 hours on your result. We discuss a lot of things with lots of people in the team. If you see that from the outside, it may look a bit chaotic, but in that chaos, we discuss every situation. We don't have one race engineer who has to decide and everybody blames them after the race if they do something wrong. We do it as a group, and also discuss both cars together in order to collect every piece of information to learn from each other. It's a huge team sport, sometimes difficult to understand from the outside, but I like it a lot because everybody can bring in ideas. The whole team is necessary and this is what I love

> *"The last lap at Spa was my proudest moment of the season – as well as my biggest nightmare*

HOW DID YOU SELECT YOUR DRIVERS?

We didn't do a shootout like some other teams did. The LMGT3 is a customer category where the drivers play an important role in the financing, but you have to balance that with the fact that their performance is also a top priority – if your drivers are not talented, you've got no chance. In 2024, we had the perfect combination of both.

WERE YOU SURPRISED BY THEIR PERFORMANCE?

I was surprised by how hard they work – as hard as the works drivers and sometimes even more so, especially Alex [Malykhin]. He pushes everybody in the team, but we return the pressure by expecting the highest level. I was surprised by how they handled the pressure and how consistent they have been. I didn't expect that. I expected more chaos and more mistakes, especially as there were some really difficult tracks this year at which we had few possibilities to test.

DID YOU EXPECT THE TEAM TO BE SO DOMINANT THIS YEAR?

No, absolutely not! Especially with often having success ballast in the cars. There are very, very strong other teams from every brand. The level is very high. In the end, we had the best driver combination – best Bronze, best Silver and best Platinum. For sure, that's a big advantage. But also as a team, we did a good job. Even when we were not the fastest, we won races or finished on the podium. If you make statistics about all the strategic decisions – all the calls, pit-stops and everything – I think we're a step ahead. And, for sure, if you do a good job as a team and you have the best drivers, then this is the result. But I didn't expect this. It's really special.

WHAT'S IT LIKE DEALING WITH TWO CREWS IN THE SAME TEAM FIGHTING FOR THE SAME TITLE?

It's very difficult. The drivers wonder how much they need to share, but normally in the end, they realise it's an advantage for everybody to work together. This year, we experienced some critical situations for the whole team. On our side, we always aimed for the fairest decisions, but it wasn't easy.

The Spa race was a key example. We had two completely different strategies but, in the end, both cars finished in the top two spots. On the one hand the last lap there was my proudest moment of the season and on the other, my biggest nightmare because it was possible they might crash and that we'd lose everything! Spa was also special because the #92 car was totally destroyed in an accident on the Friday. We had to rebuild it completely during the night and that same car was fighting for the win on the last lap! Another highlight was our win at Le Mans. In the last two-and-a-half hours, Richie [Lietz] did a great job. It reminded me of when he did the same thing in 2013 in the LMGTE Pro class at the wheel of a works Porsche. I was his race engineer at the time.

AFTER THIS FIRST LMGT3 TITLE, DID YOU RECEIVE SOME CONGRATULATIONS FROM OLAF MANTHEY?

Yeah, for sure! He's very proud. He watches every race, even if it's at three o'clock in the night for him. He's one of our greatest supporters.

ROUND 08
NOVEMBER 2ⁿᵈ

BAHRAIN

BAPCO ENERGIES
8 HOURS OF BAHRAIN

BAHRAIN

The opening laps of the race were full of incidents, including for the #50 Ferrari, whose drivers were still in the running for the world title.

BAHRAIN

333

BAHRAIN

BAHRAIN

/ **HYPERCAR**

A BREATHTAKING FINALE

It all came down to the final race of the year, with titles to be decided in the Bahraini desert. Porsche trio André Lotterer, Laurens Vanthoor and Kévin Estre headed the chase for Drivers' world championship glory, with Ferrari's 24 Hours of Le Mans winners Miguel Molina, Nicklas Nielsen and Antonio Fuoco as well as Toyota duo Nyck de Vries and Kamui Kobayashi still mathematically in the mix – albeit requiring a slice of luck. Adding an extra pinch of spice, all three brands were similarly in contention to clinch the Manufacturers crown.

Competitors had just 26 tyres to use during the eight-hour race and a choice of hard and medium compounds, with high track temperatures meaning tyre management and strategy would be amongst the keys to success.

Peugeot, Alpine and Lamborghini looked strong during the practice sessions but when it came to qualifying, it was Toyota that secured pole position. Indeed, Brendon Hartley and de Vries locked out the front row of the grid for the Toyota GR010, with the #51 Ferrari and Proton Competition's privateer Porsche lining up just behind. The remaining title contenders – the #50 Ferrari and the championship-leading #6 Porsche – shared row three.

The scene was set for a spectacular showdown, and there was drama from the start. The lights changed to green very late, with Vanthoor finding himself swamped by other cars, making him vulnerable to attack. Contact with Molina pushed the Belgian off-track and left him battling a handling issue, while the Ferrari sustained a damaged nose.

Up front, Sébastien Buemi was in charge, but Toyota was not to be spared either, with the Swiss star hit from behind by a GT3 contender as lapped cars entered the equation. The four-time world champion rejoined in traffic, compromising his race strategy.

Into the lead went Antonio Giovinazzi, in the #51 car the Italian shared with James Calado and Alessandro Pier Guidi. The 499P held sway for more than six of the eight hours, but towards the end, the race began to unravel for the Italian squad. The Peugeot of Paul di Resta stopped at the side of the track with a hybrid problem which led to a safety car that bunched up the field, and a second safety car shortly afterwards offered teams the opportunity to bolt on their newest tyres.

One of the biggest benefactors of those two interventions was the recovering #8 Toyota of Buemi, Ryō Hirakawa and Brendon Hartley. They made up more than half-a-minute and had fresh rubber for the run to the flag, with plenty of pace to exploit. In the last hour, Buemi overturned a 15-second deficit to overhaul Matt Campbell in the #5 Porsche for the lead, going on to win by almost half-a-minute. The result ensured that Toyota secured the Manufacturers' crown once again, but by then, the destination of the Drivers' championship was already all-but decided in favour of Lotterer, Estre and Vanthoor.

De Vries had parked the #7 Toyota GR010 in the garage at the end of the sixth hour, after the team had grappled with a fuel pump issue and ultimately elected to focus on the sister car rather than embark upon a lengthy repair process. That spelt the end of the Dutchman and Kobayashi's bid for honours.

Ferrari's #50 crew similarly needed to win – with the Porsche trio finishing poorly – to stand any chance of glory. The team changed the nose of the 499P after Molina's opening lap clash with Vanthoor and the car subsequently moved forward, but further contact with one of the Alpines in the seventh hour gave Nielsen a puncture and with that went all their hopes.

It proved to be a disappointing finale for the Prancing Horse all-round. After taking the chequered flag in second place, Ferrari AF Corse was judged to have used two tyres more than its permitted allocation, with a consequent penalty dropping Calado, Pier Guidi and Giovinazzi to a frustrated 14th.

That elevated Porsche's Campbell, Michael Christensen and Frédéric Makowiecki to second, and the #93 Peugeot of Mikkel Jensen, Nico Müller and Jean-Éric Vergne to third.

Peugeot had looked strong during free practice, and technical director Olivier Jansonnie proudly described Bahrain as the team's best performance of the season. In fourth came the Alpine of Jules Gounon, Paul-Loup Chatin and Ferdinand Habsburg following another strong run, while despite finishing only tenth after picking up a series of late penalties, the greater issues for Ferrari and Toyota ensured the #6 Porsche trio successfully lifted the Drivers' laurels.

Hertz Team JOTA had already secured the 2024 FIA World Cup for Hypercar Teams in Japan, and Jenson Button crossed the finish line seventh in Bahrain to snatch second place in the independent standings for the British outfit as well. The former Formula 1 World Champion partnered Phil Hanson and Oliver Rasmussen in the car that won the privateer class in the race, just ahead of the #83 Ferrari, in so doing overtook it in the final ratings. The sister JOTA Porsche was in the hunt for outright victory in the hands of Will Stevens, but a puncture just after the final safety car blunted its chances.

BAHRAIN

BAHRAIN

343

BAHRAIN

344

BAHRAIN

BAHRAIN

346

/ LMGT3

FERRARI AND CORVETTE FACE OFF IN DESERT DUEL

Although the titles had already been decided, there was still plenty to fight for in the final race of the inaugural FIA Endurance Trophy for LMGT3 Drivers and Teams, with the high track temperatures and single-specification Goodyear tyre meaning competitors would need to be careful with car set-up and tyre management during the gruelling eight-hour race in Bahrain.

United Autosports got its bid off to the best possible start when Josh Caygill set pole position, with team-mate James Cottingham just two thousandths-of-a-second slower to secure a front row lockout for the British outfit in a thrilling Hyperpole session. Ferrari was third, as François Hériau lapped just a tenth shy of pole.

The race saw the two McLarens control the opening 40 minutes, prior to coming under pressure from the TF Sport Corvette of Tom Van Rompuy, who had started eighth on the grid but moved into a six-second lead at the end of the first hour.

The Corvette led the majority of the next 140 laps, with Charlie Eastwood taking over from Van Rompuy and Rui Andrade also sharing the cockpit. The team was performing superbly but the McLarens were still in the hunt, joined by the #55 Vista AF Corse Ferrari which had lost time early on needing to have a door replaced.

The deadlock was broken by safety car interruptions in the sixth and seventh hours, which wiped out Corvette's advantage and prompted a multi-car fight for honours. This was the point where those who had saved fresh tyres for a sprint finish would shine, and during the final pit-stop phase, Eastwood was overhauled by Alessio Rovera's Ferrari.

The Italian benefitted from the safety cars that had brought him to within striking-distance of the lead, and after seizing the initiative, he held on to the flag, crossing the finish line with a gap of three seconds over the first of the chasing Corvettes. The other Vista AF Corse entry, piloted by Francesco Castellacci, Thomas Flohr and Davide Rigon, looked set to make it a Ferrari one-two, but a drive-through penalty with less than an hour remaining dropped the Fuji-winning #54 entry to seventh.

With Ferrari and Corvette monopolising the podium, the Italian Iron Lynx team finished fourth, also part of the leading group that was ultimately separated by just 6.1 seconds. The #91 Manthey EMA Porsche took fifth, ahead of the best-placed McLaren of Cottingham, Nicolas Costa and Grégoire Saucy.

Lexus and Ford conversely had a day to forget, as both cars from both manufacturers retired from the race. BMW's two M4s did not have front-running pace in the Bahrain desert and finished 13th and 14th after picking up late penalties.

CAPTION INDEX

Pages 328-329 **HYPERCAR #8**
Toyota GR010 Hybrid Toyota Gazoo Racing

Page 332 **HYPERCAR #38**
Porsche 963 Hertz Team JOTA

HYPERCAR #50
Ferrari 499P Ferrari AF Corse

Page 333 **LMGT3 #27**
Aston Martin Vantage AMR LMGT3 Heart of Racing Team

LMGT3 #81
Corvette Z06 LMGT3.R TF Sport

HYPERCAR #5
Porsche 963 Porsche Penske Motorsport

Pages 334-335 **HYPERCAR #12**
Porsche 963 Hertz Team JOTA

HYPERCAR #2
Cadillac V-Series.R Cadillac Racing

Pages 336-337 **LMGT3 #88**
Ford Mustang LMGT3 Proton Competition

LMGT3 #87
Lexus RC F LMGT3 Akkodis ASP Team

LMGT3 #777
Aston Martin Vantage AMR LMGT3 D'Station Racing

Page 341 **HYPERCAR #93**
Peugeot 9X8 Team Peugeot TotalEnergies

Pages 342-343 **LMGT3 #91**
Porsche 911 GT3 R LMGT3 Manthey EMA

LMGT3 #81
Corvette Z06 LMGT3.R TF Sport

Page 344 **LMGT3 #59**
McLaren 720S LMGT3 Evo United Autosports

HYPERCAR #36
Alpine A424 Alpine Endurance Team

Page 345 **HYPERCAR #7**
Toyota GR010 Hybrid Toyota Gazoo Racing

Page 346 **LMGT3 #85**
Lamborghini Huracán LMGT3 Evo2 Iron Dames

LMGT3 #55
Ferrari 296 LMGT3 Vista AF Corse

Page 350 **HYPERCAR #38**
Porsche 963 Hertz Team JOTA

Page 351 **HYPERCAR #8**
Toyota GR010 Hybrid Toyota Gazoo Racing

LMGT3 #85
Lamborghini Huracán LMGT3 Evo2 Iron Dames

LMGT3 #27
Aston Martin Vantage AMR LMGT3 Heart of Racing Team

Pages 352-353 **HYPERCAR #5**
Porsche 963 Porsche Penske Motorsport

Pages 354-355 **HYPERCAR #6**
Porsche 963 Porsche Penske Motorsport

HYPERCAR #8
Toyota GR010 Hybrid Toyota Gazoo Racing

JOTA produced a standout performance in Bahrain in its last appearance as a privateer. It finished as the best-placed independent entrant and the #38 clinched second position in the final FIA World Cup for Hypercar Teams table, while a puncture dashed the #12 car's bid for overall victory in the race.

351

BAHRAIN

BAHRAIN

Even though the Bapco Energies 8 Hours of Bahrain did not go
as planned for the #6 crew, André Lotterer, Kévin Estre
and Laurens Vanthoor did enough to win
the Drivers' title, while the #8 Toyota crew celebrated
the Japanese team's Manufacturers' crown on the podium.

" It's crazy to think we won the race considering how it was going at some points. Against all the odds, with issues, penalties and bad luck, it's an amazing feeling for the team to win the World Championship. We fell to the back of the Hypercar field during the pit stops and I thought we were done, but my team-mates did a good job hanging on with old tyres and that meant I had a tyre advantage at the end.

Sébastien Buemi
Driver - #8 Toyota GR010 Hybrid
Toyota Gazoo Racing

RACE
DATA

QATAR

ROUND 01
QATAR AIRWAYS
QATAR 1812KM

LOSAIL INTERNATIONAL CIRCUIT
Qatar

5.418 km - 16 turns
335 laps

GRID		CAT.	N°	DRIVERS
1	5	1	#06	**K. Estre / A. Lotterer / L. Vanthoor**
2	3	2	#12	W. Stevens / C. Ilott / N. Nato
3	1 PP	3	#05	M. Campbell / M. Christensen / F. Makowiecki
4	12	4	#83	R. Kubica / R. Shwartzman / Y. Ye
5	2	5	#07	M. Conway / K. Kobayashi / N. De Vries
6	4	6	#50	A. Fuoco / M. Molina / N. Nielsen
7	17	7	#35	P.-L. Chatin / F. Habsburg / C. Milesi
8	11	8	#08	S. Buemi / B. Hartley / R. Hirakawa
9	13	9	#99	N. Jani / H. Tincknell / J. Andlauer
10	16	10	#20	S. van der Linde / R. Frijns / R. Rast
11	14	11	#36	N. Lapierre / M. Schumacher / M. Vaxiviere
12	8	12	#51	A. Pier Guidi / J. Calado / A. Giovinazzi
13	18	13	#63	M. Bortolotti / E. Mortara / D. Kvyat
14	15	14	#15	D. Vanthoor / R. Marciello / M. Wittmann
15	10	15	#94	S. Vandoorne / P. Di Resta / L. Duval
16	21	1	#92	**A. Malykhin / J. Sturm / K. Bachler**
17	24	2	#27	I. James / D. Mancinelli / A. Riberas
18	23	3	#777	C. Mateu / E. Bastard / M. Sørensen
19	28	4	#46	A. Al Harthy / V. Rossi / M. Martin
20	22	5	#54	T. Flohr / F. Castellacci / D. Rigon
21	33	6	#31	D. Leung / S. Gelael / A. Farfus
22	29	7	#55	F. Hériau / S. Mann / A. Rovera
23	25	8	#85	S. Bovy / D. Pin / M. Gatting
24	31	9	#88	G. Roda / M. Pedersen / D. Olsen
25	30	10	#82	H. Koizumi / S. Baud / D. Juncadella
26	37	11	#77	R. Hardwick / Z. Robichon / B. Barker
27	36	12	#60	C. Schiavoni / M. Cressoni / F. Perera
28	27	13	#95	J. Caygill / N. Pino / M. Sato
29	26	14	#59	J. Cottingham / N. Costa / G. Saucy
30	32	15	#91	Y. Shahin / M. Schuring / R. Lietz
31	35	16	#87	T. Kimura / E. Masson / J.-M. López
NC	9		#38	J. Button / P. Hanson / O. Rasmussen
DNF	34		#78	A. Robin / T. Boguslavskiy / K. van der Linde
DNF	20 PP		#81	T. Van Rompuy / R. Andrade / C. Eastwood
DNF	19		#11	A. Serravalle / C.W. Bennett / J.-K. Vernay
DIS	7		#02	E. Bamber / A. Lynn / S. Bourdais
DIS	6		#93	J.-É. Vergne / M. Jensen / N. Müller

● HYPERCAR

Fastest lap — Matt Campbell [#5 Porsche 963]
1m39.748s • 195.5 Kph

CAR	TEAM	LAPS	TIME / GAP
Porsche 963	**Porsche Penske Motorsport**	335	9h55:51.926
Porsche 963	Hertz Team JOTA	335	+ 33.297
Porsche 963	Porsche Penske Motorsport	335	+ 34.396
Ferrari 499P	AF Corse	334	+ 1 lap
Toyota GR010 Hybrid	Toyota Gazoo Racing	334	+ 1 lap
Ferrari 499P	Ferrari AF Corse	333	+ 2 laps
Alpine A424	Alpine Endurance Team	333	+ 2 laps
Toyota GR010 Hybrid	Toyota Gazoo Racing	333	+ 2 laps
Porsche 963	Proton Competition	333	+ 2 laps
BMW M Hybrid V8	BMW M Team WRT	332	+ 3 laps
Alpine A424	Alpine Endurance Team	332	+ 3 laps
Ferrari 499P	Ferrari AF Corse	332	+ 3 laps
Lamborghini SC63	Lamborghini Iron Lynx	330	+ 5 laps
BMW M Hybrid V8	BMW M Team WRT	327	+ 8 laps
Peugeot 9X8	Team Peugeot TotalEnergies	316	+ 19 laps
Porsche 911 GT3 R LMGT3	**Manthey PureRxcing**	299	+ 36 laps
Aston Martin Vantage AMR LMGT3	Heart of Racing Team	299	+ 36 laps
Aston Martin Vantage AMR LMGT3	D'Station Racing	298	+ 37 laps
BMW M4 LMGT3	Team WRT	298	+ 37 laps
Ferrari 296 LMGT3	Vista AF Corse	297	+ 38 laps
BMW M4 LMGT3	Team WRT	297	+ 38 laps
Ferrari 296 LMGT3	Vista AF Corse	297	+ 38 laps
Lamborghini Huracán LMGT3 Evo2	Iron Dames	295	+ 40 laps
Ford Mustang LMGT3	Proton Competition	294	+ 41 laps
Corvette Z06 LMGT3.R	TF Sport	294	+ 41 laps
Ford Mustang LMGT3	Proton Competition	293	+ 42 laps
Lamborghini Huracán LMGT3 Evo2	Iron Lynx	291	+ 44 laps
McLaren 720S LMGT3 Evo	United Autosports	284	+ 51 laps
McLaren 720S LMGT3 Evo	United Autosports	284	+ 51 laps
Porsche 911 GT3 R LMGT3	Manthey EMA	284	+ 51 laps
Lexus RC F LMGT3	Akkodis ASP Team	273	+ 62 laps
Porsche 963	Hertz Team JOTA	309	
Lexus RC F LMGT3	Akkodis ASP Team	249	
Corvette Z06 LMGT3.R	TF Sport	177	
Isotta Fraschini Typo6-C	Isotta Fraschini	157	
Cadillac V-Series.R	Cadillac Racing	334	
Peugeot 9X8	Team Peugeot TotalEnergies	334	

● LMGT3
Fastest lap — Alessio Rovera [#55 Ferrari 296 LMGT3] 1m53.529s • 171.8 Kph

PP = Pole Position / **NC** = Not Classified / **DNF** = Did Not Finish / **DIS** = Disqualified

IMOLA

ROUND 02
6 HOURS OF IMOLA

AUTODROMO INTERNAZIONALE ENZO E DINO FERRARI
Italy

4.909 km - 21 turns
205 laps

GRID	CAT.	N°	DRIVERS	
1	6	● 1	**#07**	**M. Conway / K. Kobayashi / N. De Vries**
2	4	● 2	#06	K. Estre / A. Lotterer / L. Vanthoor
3	5	● 3	#05	M. Campbell / M. Christensen / F. Makowiecki
4	1 PP	● 4	#50	A. Fuoco / M. Molina / N. Nielsen
5	8	● 5	#08	S. Buemi / B. Hartley / R. Hirakawa
6	7	● 6	#20	S. van der Linde / R. Frijns / R. Rast
7	3	● 7	#51	A. Pier Guidi / J. Calado / A. Giovinazzi
8	2	● 8	#83	R. Kubica / R. Shwartzman / Y. Ye
9	15	● 9	#93	J.-É. Vergne / M. Jensen / N. Müller
10	12	● 10	#02	E. Bamber / A. Lynn
11	11	● 11	#38	O. Rasmussen / P. Hanson / J. Button
12	16	● 12	#63	M. Bortolotti / D. Kvyat / E. Mortara
13	17	● 13	#35	P.-L. Chatin / J. Gounon / C. Milesi
14	9	● 14	#12	W. Stevens / N. Nato / C. Ilott
15	14	● 15	#94	S. Vandoorne / P. Di Resta / L. Duval
16	18	● 16	#36	N. Lapierre / M. Schumacher / M. Vaxiviere
17	19	● 17	#11	C.W. Bennett / J.-K. Vernay / A. Serravalle
18	23	● 1	**#31**	**D. Leung / S. Gelael / A. Farfus**
19	22	● 2	#46	A. Al Harthy / V. Rossi / M. Martin
20	20 PP	● 3	#92	A. Malykhin / J. Sturm / K. Bachler
21	27	● 4	#55	F. Hériau / S. Mann / A. Rovera
22	21	● 5	#27	I. James / D. Mancinelli / A. Riberas
23	34	● 6	#95	J. Caygill / N. Pino / M. Sato
24	30	● 7	#81	T. Van Rompuy / R. Andrade / C. Eastwood
25	32	● 8	#82	H. Koizumi / S. Baud / D. Juncadella
26	33	● 9	#77	R. Hardwick / Z. Robichon / B. Barker
27	31	● 10	#777	C. Mateu / E. Bastard / M. Sørensen
28	29	● 11	#59	J. Cottingham / N. Costa / G. Saucy
29	28	● 12	#54	T. Flohr / F. Castellacci / D. Rigon
30	36	● 13	#60	C. Schiavoni / M. Cressoni / F. Perera
31	35	● 14	#78	A. Robin / T. Boguslavskiy / K. van der Linde
32	37	● 15	#87	T. Kimura / E. Masson / J.-M. López
33	26	● 16	#91	Y. Shahin / M. Schuring / R. Lietz
NC	10	●	#99	N. Jani / H. Tincknell / J. Andlauer
NC	24	●	#85	S. Bovy / D. Pin / M. Gatting
DNF	25	●	#88	G. Roda / M. Pedersen / D. Olsen
DIS	13	●	#15	D. Vanthoor / R. Marciello / M. Wittmann

● HYPERCAR

Fastest lap Antonio Fuoco [#50 Ferrari 499P]
1m31.794s • 192.5 Kph

CAR	TEAM	LAPS	TIME / GAP
Toyota GR010 Hybrid	**Toyota Gazoo Racing**	205	6h00:34.717
Porsche 963	Porsche Penske Motorsport	205	+ 7.081
Porsche 963	Porsche Penske Motorsport	205	+ 25.626
Ferrari 499P	Ferrari AF Corse	205	+ 31.469
Toyota GR010 Hybrid	Toyota Gazoo Racing	205	+ 33.777
BMW M Hybrid V8	BMW M Team WRT	204	+ 1 lap
Ferrari 499P	Ferrari AF Corse	204	+ 1 lap
Ferrari 499P	AF Corse	204	+ 1 lap
Peugeot 9X8	Team Peugeot TotalEnergies	203	+ 2 laps
Cadillac V-Series.R	Cadillac Racing	203	+ 2 laps
Porsche 963	Hertz Team JOTA	203	+ 2 laps
Lamborghini SC63	Lamborghini Iron Lynx	203	+ 2 laps
Alpine A424	Alpine Endurance Team	201	+ 4 laps
Porsche 963	Hertz Team JOTA	200	+ 5 laps
Peugeot 9X8	Team Peugeot TotalEnergies	199	+ 6 laps
Alpine A424	Alpine Endurance Team	199	+ 6 laps
Isotta Fraschini Typo6-C	Isotta Fraschini	191	+ 14 laps
BMW M4 LMGT3	**Team WRT**	187	+ 18 laps
BMW M4 LMGT3	Team WRT	187	+ 18 laps
Porsche 911 GT3 R LMGT3	Manthey PureRxcing	186	+ 19 laps
Ferrari 296 LMGT3	Vista AF Corse	186	+ 19 laps
Aston Martin Vantage AMR LMGT3	Heart of Racing Team	185	+ 20 laps
McLaren 720S LMGT3 Evo	United Autosports	185	+ 20 laps
Corvette Z06 LMGT3.R	TF Sport	185	+ 20 laps
Corvette Z06 LMGT3.R	TF Sport	185	+ 20 laps
Ford Mustang LMGT3	Proton Competition	184	+ 21 laps
Aston Martin Vantage AMR LMGT3	D'Station Racing	184	+ 21 laps
McLaren 720S LMGT3 Evo	United Autosports	184	+ 21 laps
Ferrari 296 LMGT3	Vista AF Corse	184	+ 21 laps
Lamborghini Huracán LMGT3 Evo2	Iron Lynx	183	+ 22 laps
Lexus RC F LMGT3	Akkodis ASP Team	183	+ 22 laps
Lexus RC F LMGT3	Akkodis ASP Team	182	+ 23 laps
Porsche 911 GT3 R LMGT3	Manthey EMA	171	+ 34 laps
Porsche 963	Proton Competition	167	
Lamborghini Huracán LMGT3 Evo2	Iron Dames	33	
Ford Mustang LMGT3	Proton Competition	82	
BMW M Hybrid V8	BMW M Team WRT	163	

● LMGT3
Fastest lap Alessio Rovera [#55 Ferrari 296 LMGT3]
1m42.257s • 172.8 Kph

PP = Pole Position / NC = Not Classified / DNF = Did Not Finish / DIS = Disqualified

SPA

ROUND 03
TOTALENERGIES 6 HOURS OF SPA-FRANCORCHAMPS

CIRCUIT DE SPA-FRANCORCHAMPS
Belgium

7.004 km - 20 turns
141 laps

	GRID	CAT.	N°	DRIVERS
1	4	● 1	#12	**W. Stevens / C. Ilott**
2	5	● 2	#06	K. Estre / A. Lotterer / L. Vanthoor
3	DIS	● 3	#50	A. Fuoco / M. Molina / N. Nielsen
4	10	● 4	#51	A. Pier Guidi / J. Calado / A. Giovinazzi
5	3	● 5	#99	N. Jani / J. Andlauer
6	6	● 6	#08	S. Buemi / B. Hartley / R. Hirakawa
7	14	● 7	#07	M. Conway / K. Kobayashi / N. De Vries
8	8	● 8	#83	R. Kubica / R. Shwartzman / Y. Ye
9	7	● 9	#35	P.-L. Chatin / J. Gounon / C. Milesi
10	13	● 10	#93	M. Jensen / N. Müller
11	12	● 11	#15	D. Vanthoor / R. Marciello / M. Wittmann
12	11	● 12	#36	N. Lapierre / M. Schumacher / M. Vaxiviere
13	9	● 13	#20	S. van der Linde / R. Frinjs / R. Rast
14	15	● 14	#94	P. Di Resta / L. Duval
15	18	● 15	#11	C.W. Bennett / J.-K. Vernay / A. Serravalle
16	21	● 1	#91	**Y. Shahin / M. Schuring / R. Lietz**
17	26	● 2	#92	A. Malykhin / J. Sturm / K. Bachler
18	35	● 3	#60	C. Schiavoni / M. Cressoni / F. Perera
19	22	● 4	#59	J. Cottingham / N. Costa / G. Saucy
20	19 PP	● 5	#85	S. Bovy / M. Gatting / R. Frey
21	24	● 6	#54	T. Flohr / F. Castellacci / D. Rigon
22	32	● 7	#777	C. Mateu / E. Bastard / M. Sørensen
23	28	● 8	#88	G. Roda / M. Pedersen / D. Olsen
24	29	● 9	#77	R. Hardwick / Z. Robichon / B. Barker
25	27	● 10	#78	A. Robin / C. Schmid / R. Miyata
26	23	● 11	#27	I. James / D. Mancinelli / A. Riberas
27	33	● 12	#82	H. Koizumi / S. Baud / D. Juncadella
28	31	● 13	#55	F. Hériau / S. Mann / A. Rovera
29	34	● 14	#87	T. Kimura / E. Masson / J.-M. López
DNF	2	●	#02	E. Bamber / A. Lynn
DNF	30	●	#31	D. Leung / S. Gelael / A. Farfus
DNF	1 PP	●	#05	M. Campbell / M. Christensen / F. Makowiecki
DNF	16	●	#63	M. Bortolotti / A. Caldarelli / D. Kvyat
DNF	DIS	●	#95	J. Caygill / N. Pino / M. Sato
DNF	25	●	#81	T. Van Rompuy / R. Andrade / C. Eastwood
DNF	17	●	#38	O. Rasmussen / P. Hanson / J. Button
DNF	20	●	#46	A. Al Harthy / V. Rossi / M. Martin

● HYPERCAR

Fastest lap Julien Andlauer [#99 Porsche 963]
2m06.459s • 199.4 Kph

CAR	TEAM	LAPS	TIME / GAP
Porsche 963	**Hertz Team JOTA**	141	5h57:31.542
Porsche 963	Porsche Penske Motorsport	141	+ 12.363
Ferrari 499P	Ferrari AF Corse	141	+ 1:14.020
Ferrari 499P	Ferrari AF Corse	141	+ 1:17.710
Porsche 963	Proton Competition	141	+ 1:26.326
Toyota GR010 Hybrid	Toyota Gazoo Racing	141	+ 1:34.955
Toyota GR010 Hybrid	Toyota Gazoo Racing	141	+ 1:38.331
Ferrari 499P	AF Corse	141	+ 1:49.162
Alpine A424	Alpine Endurance Team	141	+ 2:07.089
Peugeot 9X8	Team Peugeot TotalEnergies	140	+ 1 lap
BMW M Hybrid V8	BMW M Team WRT	140	+ 1 lap
Alpine A424	Alpine Endurance Team	140	+ 1 lap
BMW M Hybrid V8	BMW M Team WRT	140	+ 1 lap
Peugeot 9X8	Team Peugeot TotalEnergies	139	+ 2 laps
Isotta Fraschini Typo6-C	Isotta Fraschini	138	+ 3 laps
Porsche 911 GT3 R LMGT3	**Manthey EMA**	130	+ 11 laps
Porsche 911 GT3 R LMGT3	Manthey PureRxcing	130	+ 11 laps
Lamborghini Huracán LMGT3 Evo2	Iron Lynx	130	+ 11 laps
McLaren 720S LMGT3 Evo	United Autosports	130	+ 11 laps
Lamborghini Huracán LMGT3 Evo2	Iron Dames	130	+ 11 laps
Ferrari 296 LMGT3	Vista AF Corse	130	+ 11 laps
Aston Martin Vantage AMR LMGT3	D'Station Racing	130	+ 11 laps
Ford Mustang LMGT3	Proton Competition	130	+ 11 laps
Ford Mustang LMGT3	Proton Competition	130	+ 11 laps
Lexus RC F LMGT3	Akkodis ASP Team	129	+ 12 laps
Aston Martin Vantage AMR LMGT3	Heart of Racing Team	129	+ 12 laps
Corvette Z06 LMGT3.R	TF Sport	129	+ 12 laps
Ferrari 296 LMGT3	Vista AF Corse	129	+ 12 laps
Lexus RC F LMGT3	Akkodis ASP Team	128	+ 13 laps
Cadillac V-Series.R	Cadillac Racing	95	
BMW M4 LMGT3	Team WRT	87	
Porsche 963	Porsche Penske Motorsport	64	
Lamborghini SC63	Lamborghini Iron Lynx	59	
McLaren 720S LMGT3 Evo	United Autosports	59	
Corvette Z06 LMGT3.R	TF Sport	56	
Porsche 963	Hertz Team JOTA	37	
BMW M4 LMGT3	Team WRT	33	

● LMGT3
Fastest lap: Sébastien Baud [#82 Corvette Z06 LMGT3.R] 2m21.525s • 178.2 Kph

PP = Pole Position / **DNF** = Did Not Finish / **DIS** = Disqualified

LE MANS

ROUND 04
24 HOURS OF LE MANS

CIRCUIT DES
24 HEURES DU MANS
France

13.626 km - 38 turns
311 laps

GRID		CAT.	N°	DRIVERS
1	5	1	#50	**A. Fuoco / M. Molina / N. Nielsen**
2	23	2	#07	J.-M. López / K. Kobayashi / N. De Vries
3	4	3	#51	A. Pier Guidi / J. Calado / A. Giovinazzi
4	1 PP	4	#06	K. Estre / A. Lotterer / L. Vanthoor
5	11	5	#08	S. Buemi / B. Hartley / R. Hirakawa
6	10	6	#05	M. Campbell / M. Christensen / F. Makowiecki
7	2	7	#02	E. Bamber / A. Lynn / A. Palou
8	8	8	#12	W. Stevens / N. Nato / C. Ilott
9	17	9	#38	O. Rasmussen / P. Hanson / J. Button
10	13	10	#63	M. Bortolotti / D. Kvyat / E. Mortara
11	20	11	#94	S. Vandoorne / P. Di Resta / L. Duval
12	15	12	#93	J.-É. Vergne / M. Jensen / N. Müller
13	21	13	#19	R. Grosjean / A. Caldarelli / M. Cairoli
14	22	14	#11	C.W. Bennett / J.-K. Vernay / A. Serravalle
15	28	1	#22	**O. Jarvis / B. Garg / N. Siegel**
16	34	2	#34	J. Smiechowski / V. Lomko / C. Novalak
17	25	3	#28	P. Lafargue / J. Van Uitert / R. de Gerus
18	32	4	#183	F. Perrodo / B. Barnicoat / N. Varrone
19	31	5	#10	R. Cullen / P. Pilet / S. Richelmi
20	24 PP	6	#14	P.J. Hyett / L. Deletraz / A. Quinn
21	30	7	#33	A. Mattschull / R. Binder / L. Horr
22	38	8	#25	M. Kaiser / O. Caldwell / R. de Angelis
23	26	9	#65	R. Sales / M. Beche / S. Huffaker
24	37	10	#47	N. Rao / M. Bell / F. Vesti
25	33	11	#24	F. Scherer / D. Heinemeier Hansson / K. Simpson
26	29	12	#37	L. Fluxa / M. Jakobsen / R. Miyata
27	55	1	#91	**Y. Shahin / M. Schuring / R. Lietz**
28	54	2	#31	D. Leung / S. Gelael / A. Farfus
29	18	15	#311	L. F. Derani / J. Aitken / F. Drugovich
30	56	3	#88	G. Roda / M. Pedersen / D. Olsen
31	53	4	#44	J. Hartshorn / B. Tuck / C. Mies
32	48	5	#85	S. Bovy / M. Gatting / R. Frey
33	61	6	#55	F. Hériau / S. Mann / A. Rovera
34	60	7	#78	A. Robin / T. Boguslavskiy / K. van der Linde
35	59	8	#155	J. Laursen / C. Laursen / J. Taylor
36	45	9	#777	S. Hoshino / E. Bastard / M. Sørensen
37	49	10	#87	T. Kimura / E. Masson / J. Hawksworth
38	46	11	#82	H. Koizumi / S. Baud / D. Juncadella
39	62	12	#86	M. Wainwright / D. Serra / R. Pera
40	40	13	#70	B. Iribe / Q. Millroy / F. Schandorff
41	41 PP	14	#92	A. Malykhin / J. Sturm / K. Bachler
42	27	15	#23	B. Keating / F. Albuquerque / B. Hanley
43	57	16	#81	T. Van Rompuy / R. Andrade / C. Eastwood
44	47	17	#60	C. Schiavoni / M. Cressoni / F. Perera
45	14	18	#99	N. Jani / H. Tincknell / J. Andlauer
46	43	19	#77	R. Hardwick / Z. Robichon / B. Barker
NC	16		#20	S. van der Linde / R. Frinjs / R. Rast
DNF	12		#83	R. Kubica / R. Shwartzman / Y. Ye
DNF	3		#03	S. Bourdais / R. van der Zande / S. Dixon
DNF	50		#59	J. Cottingham / N. Costa / G. Saucy
DNF	58		#95	H. Hamaguchi / N. Pino / M. Sato
DNF	19		#04	M. Jaminet / F. Nasr / N. Tandy
DNF	44		#27	I. James / D. Mancinelli / A. Riberas
DNF	39		#45	G. Kurtz / C. Braun / N. Catsburg
DNF	36		#30	J. Falb / J. Allen / J.-B. Simmenauer
DNF	42		#66	G. Petrobelli / L. Ten Voorde / S. Yoluc
DNF	51		#46	A. Al Harthy / V. Rossi / M. Martin
DNF	7		#15	D. Vanthoor / R. Marciello / M. Wittmann
DNF	9		#36	N. Lapierre / M. Schumacher / M. Vaxiviere
DNF	35		#09	J. Ried / M. Capietto / B. Viscaal
DNF	6		#35	P.-L. Chatin / F. Habsburg / C. Milesi
DNF	52		#54	T. Flohr / F. Castellacci / D. Rigon

CAR	TEAM	LAPS	TIME / GAP
Ferrari 499P	**Ferrari AF Corse**	311	24h01:55.856
Toyota GR010 Hybrid	Toyota Gazoo Racing	311	+ 14.221
Ferrari 499P	Ferrari AF Corse	311	+ 36.730
Porsche 963	Porsche Penske Motorsport	311	+ 37.897
Toyota GR010 Hybrid	Toyota Gazoo Racing	311	+ 1:02.824
Porsche 963	Porsche Penske Motorsport	311	+ 1:45.654
Cadillac V-Series.R	Cadillac Racing	311	+ 2:34.468
Porsche 963	Hertz Team JOTA	311	+ 3:02.691
Porsche 963	Hertz Team JOTA	311	+ 3:36.756
Lamborghini SC63	Lamborghini Iron Lynx	309	+ 2 laps
Peugeot 9X8	Team Peugeot TotalEnergies	309	+ 2 laps
Peugeot 9X8	Team Peugeot TotalEnergies	309	+ 2 laps
Lamborghini SC63	Lamborghini Iron Lynx	309	+ 2 laps
Isotta Fraschini Typo6-C	Isotta Fraschini	302	+ 9 laps
Oreca 07 Gibson	**United Autosports**	**297**	**+ 14 laps**
Oreca 07 Gibson	Inter Europol	297	+ 14 laps
Oreca 07 Gibson	IDEC Sport	297	+ 14 laps
Oreca 07 Gibson	AF Corse	297	+ 14 laps
Oreca 07 Gibson	Vector Sport	297	+ 14 laps
Oreca 07 Gibson	AO by TF	295	+ 16 laps
Oreca 07 Gibson	DKR Engineering	295	+ 16 laps
Oreca 07 Gibson	Algarve Pro Racing	294	+ 17 laps
Oreca 07 Gibson	Panis Racing	293	+ 18 laps
Oreca 07 Gibson	Cool Racing	291	+ 20 laps
Oreca 07 Gibson	Nielsen Racing	291	+ 20 laps
Oreca 07 Gibson	Cool Racing	289	+ 22 laps
Porsche 911 GT3 R LMGT3	**Manthey EMA**	**281**	**+ 30 laps**
BMW M4 LMGT3	Team WRT	280	+ 31 laps
Wheelen Cadillac V-Series.R	Whelen Cadillac Racing	280	+ 31 laps
Ford Mustang LMGT3	Proton Competition	280	+ 31 laps
Ford Mustang LMGT3	Proton Competition	280	+ 31 laps
Lamborghini Huracán LMGT3 Evo2	Iron Dames	279	+ 32 laps
Ferrari 296 LMGT3	Vista AF Corse	279	+ 32 laps
Lexus RC F LMGT3	Akkodis ASP Team	279	+ 32 laps
Ferrari 296 LMGT3	Spirit of Race	279	+ 32 laps
Aston Martin Vantage AMR LMGT3	D'Station Racing	279	+ 32 laps
Lexus RC F LMGT3	Akkodis ASP Team	279	+ 32 laps
Corvette Z06 LMGT3.R	TF Sport	278	+ 33 laps
Ferrari 296 LMGT3	GR Racing	278	+ 33 laps
McLaren 720S LMGT3 Evo	Inception Racing	275	+ 36 laps
Porsche 911 GT3 R LMGT3	Manthey PureRxcing	273	+ 38 laps
Oreca 07 Gibson	United Autosports	272	+ 39 laps
Corvette Z06 LMGT3.R	TF Sport	267	+ 44 laps
Lamborghini Huracán LMGT3 Evo2	Iron Lynx	258	+ 53 laps
Porsche 963	Proton Competition	251	+ 60 laps
Ford Mustang LMGT3	Proton Competition	227	+ 84 laps
BMW M Hybrid V8	BMW M Team WRT	96	
Ferrari 499P	AF Corse	248	
Cadillac V-Series.R	Cadillac Racing	223	
McLaren 720S LMGT3 Evo	United Autosports	220	
McLaren 720S LMGT3 Evo	United Autosports	212	
Porsche 963	Porsche Penske Motorsport	211	
Aston Martin Vantage AMR LMGT3	Heart of Racing Team	196	
Oreca 07 Gibson	Crowdstrike Racing by APR	149	
Oreca 07 Gibson	Duqueine Team	112	
Ferrari 296 LMGT3	JMW Motorsport	112	
BMW M4 LMGT3	Team WRT	109	
BMW M Hybrid V8	BMW M Team WRT	102	
Alpine A424	Alpine Endurance Team	88	
Oreca 07 Gibson	Proton Competition	86	
Alpine A424	Alpine Endurance Team	75	
Ferrari 296 LMGT3	Vista AF Corse	30	

● **HYPERCAR**
Fastest lap Kamui Kobayashi [#7 Toyota GR010 Hybrid]
3m28.756s - 235 Kph

● **LMGT3**
Fastest lap Morris Schuring [#91 Porsche 911 GT3 R LMGT3]
3m57.435s - 206.6 Kph

● **LMP2**
Fastest lap Oliver Jarvis [#22 Oreca O7 Gibson]
3m38.284s - 224.7 Kph

PP = Pole Position **/ NC** = Not Classified
DNF = Did Not Finish

SÃO PAULO

ROUND 05
ROLEX 6 HOURS OF SÃO PAULO

AUTÓDROMO JOSÉ CARLOS PACE
Brasil

4.309 km - 15 turns
236 laps

#	GRID	CAT.	N°	DRIVERS
1	2	● 1	#08	**S. Buemi / B. Hartley / R. Hirakawa**
2	5	● 2	#06	K. Estre / A. Lotterer / L. Vanthoor
3	3	● 3	#05	M. Campbell / M. Christensen / F. Makowiecki
4	1 PP	● 4	#07	M. Conway / K. Kobayashi / N. De Vries
5	9	● 5	#51	A. Pier Guidi / J. Calado / A. Giovinazzi
6	6	● 6	#50	A. Fuoco / M. Molina / N. Nielsen
7	8	● 7	#38	O. Rasmussen / P. Hanson / J. Button
8	17	● 8	#93	J.-É. Vergne / M. Jensen / N. Müller
9	14	● 9	#15	D. Vanthoor / R. Marciello / M. Wittmann
10	11	● 10	#36	N. Lapierre / M. Schumacher / M. Vaxiviere
11	15	● 11	#83	R. Kubica / R. Shwartzman / Y. Ye
12	13	● 12	#35	P.-L. Chatin / F. Habsburg / C. Milesi
13	4	● 13	#02	E. Bamber / A. Lynn
14	10	● 14	#20	S. van der Linde / R. Frijns / R. Rast
15	12	● 15	#99	N. Jani / J. Andlauer
16	16	● 16	#94	S. Vandoorne / P. Di Resta / L. Duval
17	18	● 17	#63	M. Bortolotti / D. Kvyat / E. Mortara
18	7	● 18	#12	W. Stevens / N. Nato / C. Ilott
19	21	● 1	#92	**A. Malykhin / J. Sturm / K. Bachler**
20	28	● 2	#27	I. James / D. Mancinelli / A. Riberas
21	22	● 3	#95	J. Caygill / N. Pino / M. Sato
22	23	● 4	#59	J. Cottingham / N. Costa / G. Saucy
23	31	● 5	#46	A. Al Harthy / V. Rossi / M. Martin
24	26	● 6	#55	F. Hériau / S. Mann / A. Rovera
25	30	● 7	#77	R. Hardwick / Z. Robichon / B. Barker
26	27	● 8	#81	T. Van Rompuy / R. Andrade / C. Eastwood
27	33	● 9	#777	C. Mateu / E. Bastard / M. Sørensen
28	25	● 10	#31	D. Leung / S. Gelael / A. Farfus
29	34	● 11	#87	T. Kimura / E. Masson / J.-M. López
30	24	● 12	#91	Y. Shahin / M. Schuring / R. Lietz
31	36	● 13	#88	C. Ried / M. Pedersen / D. Olsen
32	35	● 14	#60	C. Schiavoni / M. Cressoni / F. Perera
33	29	● 15	#54	T. Flohr / F. Castellacci / D. Rigon
DNF	19	●	#11	C.W. Bennett / J.-K. Vernay / A. Serravalle
DNF	20 PP	●	#85	S. Bovy / M. Gatting / R. Frey
DNF	32	●	#82	H. Koizumi / S. Baud / D. Juncadella
DNS		●	#78	A. Robin / T. Boguslavskiy / K. van der Linde

● HYPERCAR

Fastest lap Mike Conway [#7 Toyota GR010 Hybrid]
1m24.801s - 182.9 Kph

CAR	TEAM	LAPS	TIME / GAP
Toyota GR010 Hybrid	**Toyota Gazoo Racing**	**236**	**6h01:02.554**
Porsche 963	Porsche Penske Motorsport	236	+ 1'08"811
Porsche 963	Porsche Penske Motorsport	236	+ 1'15"993
Toyota GR010 Hybrid	Toyota Gazoo Racing	236	+ 1'23"571
Ferrari 499P	Ferrari AF Corse	236	+ 1'27"395
Ferrari 499P	Ferrari AF Corse	235	+ 1 lap
Porsche 963	Hertz Team JOTA	235	+ 1 lap
Peugeot 9X8	Team Peugeot TotalEnergies	235	+ 1 lap
BMW M Hybrid V8	BMW M Team WRT	235	+ 1 lap
Alpine A424	Alpine Endurance Team	234	+ 2 laps
Ferrari 499P	AF Corse	234	+ 2 laps
Alpine A424	Alpine Endurance Team	234	+ 2 laps
Cadillac V-Series.R	Cadillac Racing	234	+ 2 laps
BMW M Hybrid V8	BMW M Team WRT	234	+ 2 laps
Porsche 963	Proton Competition	234	+ 2 laps
Peugeot 9X8	Team Peugeot TotalEnergies	234	+ 2 laps
Lamborghini SC63	Lamborghini Iron Lynx	234	+ 2 laps
Porsche 963	Hertz Team JOTA	233	+ 3 laps
Porsche 911 GT3 R LMGT3	**Manthey PureRxcing**	**214**	**+ 22 laps**
Aston Martin Vantage AMR LMGT3	Heart of Racing Team	213	+ 23 laps
McLaren 720S LMGT3 Evo	United Autosports	213	+ 23 laps
McLaren 720S LMGT3 Evo	United Autosports	212	+ 24 laps
BMW M4 LMGT3	Team WRT	212	+ 24 laps
Ferrari 296 LMGT3	Vista AF Corse	212	+ 24 laps
Ford Mustang LMGT3	Proton Competition	212	+ 24 laps
Corvette Z06 LMGT3.R	TF Sport	212	+ 24 laps
Aston Martin Vantage AMR LMGT3	D'Station Racing	212	+ 24 laps
BMW M4 LMGT3	Team WRT	211	+ 25 laps
Lexus RC F LMGT3	Akkodis ASP Team	211	+ 25 laps
Porsche 911 GT3 R LMGT3	Manthey EMA	209	+ 27 laps
Ford Mustang LMGT3	Proton Competition	208	+ 28 laps
Lamborghini Huracán LMGT3 Evo2	Iron Lynx	208	+ 28 laps
Ferrari 296 LMGT3	Vista AF Corse	191	+ 45 laps
Isotta Fraschini Typo6-C	Isotta Fraschini	149	
Lamborghini Huracán LMGT3 Evo2	Iron Dames	139	
Corvette Z06 LMGT3.R	TF Sport	133	
Lexus RC F LMGT3	Akkodis ASP Team		

● LMGT3
Fastest lap — Sarah Bovy [#85 Lamborghini Huracán LMGT3 Evo2]
1m35.777s • 162.0 Kph

PP = Pole Position / **DNF** = Did Not Finish / **DNS** = Did Not Start

AUSTIN

ROUND 06
LONE STAR LE MANS

CIRCUIT OF THE AMERICAS
USA

5.513 km - 20 turns
183 laps

GRID		CAT.	N°	DRIVERS
1	2	1	#83	**R. Kubica / R. Shwartzman / Y. Ye**
2	9	2	#07	M. Conway / K. Kobayashi / N. De Vries
3	5	3	#50	A. Fuoco / M. Molina / N. Nielsen
4	3	4	#02	E. Bamber / A. Lynn
5	4	5	#35	P.-L. Chatin / F. Habsburg / C. Milesi
6	14	6	#06	K. Estre / A. Lotterer / L. Vanthoor
7	6	7	#05	M. Campbell / M. Christensen / F. Makowiecki
8	8	8	#15	D. Vanthoor / R. Marciello / M. Wittmann
9	13	9	#36	N. Lapierre / M. Schumacher / M. Vaxiviere
10	17	10	#38	O. Rasmussen / P. Hanson / J. Button
11	16	11	#99	N. Jani / H. Tincknell / J. Andlauer
12	11	12	#93	J.-É. Vergne / M. Jensen / N. Müller
13	7	13	#20	S. van der Linde / R. Frinjs / R. Rast
14	18	14	#63	M. Bortolotti / D. Kvyat / E. Mortara
15	12	15	#08	S. Buemi / B. Hartley / R. Hirakawa
16	19 PP	1	#27	**I. James / D. Mancinelli / A. Riberas**
17	22	2	#92	A. Malykhin / J. Sturm / K. Bachler
18	34	3	#91	Y. Shahin / M. Schuring / R. Lietz
19	25	4	#59	J. Cottingham / N. Costa / G. Saucy
20	28	5	#31	D. Leung / S. Gelael / A. Farfus
21	32	6	#77	R. Hardwick / Z. Robichon / B. Barker
22	29	7	#95	J. Caygill / N. Pino / M. Sato
23	31	8	#82	H. Koizumi / S. Baud / D. Juncadella
24	30	9	#78	A. Robin / C. Schmid / K. van der Linde
25	21	10	#55	F. Hériau / S. Mann / A. Rovera
26	35	11	#87	T. Kimura / E. Masson / J.-M. López
27	36	12	#60	C. Schiavoni / M. Cressoni / F. Perera
28	20	13	#85	S. Bovy / M. Gatting / R. Frey
NC	33		#46	A. Al Harthy / V. Rossi / M. Martin
NC	27		#88	B. Keating / M. Pedersen / D. Olsen
NC	10		#12	W. Stevens / N. Nato / C. Ilott
DNF	23		#81	T. Van Rompuy / R. Andrade / C. Eastwood
DNF	15		#94	S. Vandoorne / P. Di Resta / L. Duval
DNF	26		#777	C. Mateu / E. Bastard / M. Sørensen
DNF	1		#51	A. Pier Guidi / J. Calado / A. Giovinazzi
DNF	24 PP		#54	T. Flohr / F. Castellacci / D. Rigon

● HYPERCAR

Fastest lap Kamui Kobayashi [#7 Toyota GR010 Hybrid]
1m52.564s - 176.3 Kph

CAR	TEAM	LAPS	TIME / GAP
Ferrari 499P	**AF Corse**	183	6h00:23.755
Toyota GR010 Hybrid	Toyota Gazoo Racing	183	+ 1.780
Ferrari 499P	Ferrari AF Corse	183	+ 26.282
Cadillac V-Series.R	Cadillac Racing	183	+ 46.924
Alpine A424	Alpine Endurance Team	183	+ 1:10.513
Porsche 963	Porsche Penske Motorsport	183	+ 1:36.873
Porsche 963	Porsche Penske Motorsport	183	+ 1:41.494
BMW M Hybrid V8	BMW M Team WRT	182	+ 1 lap
Alpine A424	Alpine Endurance Team	182	+ 1 lap
Porsche 963	Hertz Team JOTA	182	+ 1 lap
Porsche 963	Proton Competition	182	+ 1 lap
Peugeot 9X8	Team Peugeot TotalEnergies	182	+ 1 lap
BMW M Hybrid V8	BMW M Team WRT	182	+ 1 lap
Lamborghini SC63	Lamborghini Iron Lynx	182	+ 1 lap
Toyota GR010 Hybrid	Toyota Gazoo Racing	181	+ 2 laps
Aston Martin Vantage AMR LMGT3	**Heart of Racing Team**	164	+ 19 laps
Porsche 911 GT3 R LMGT3	Manthey PureRxcing	164	+ 19 laps
Porsche 911 GT3 R LMGT3	Manthey EMA	164	+ 19 laps
McLaren 720S LMGT3 Evo	United Autosports	164	+ 19 laps
BMW M4 LMGT3	Team WRT	164	+ 19 laps
Ford Mustang LMGT3	Proton Competition	163	+ 20 laps
McLaren 720S LMGT3 Evo	United Autosports	163	+ 20 laps
Corvette Z06 LMGT3.R	TF Sport	163	+ 20 laps
Lexus RC F LMGT3	Akkodis ASP Team	163	+ 20 laps
Ferrari 296 LMGT3	Vista AF Corse	163	+ 20 laps
Lexus RC F LMGT3	Akkodis ASP Team	162	+ 21 laps
Lamborghini Huracán LMGT3 Evo2	Iron Lynx	162	+ 21 laps
Lamborghini Huracán LMGT3 Evo2	Iron Dames	160	+ 23 laps
BMW M4 LMGT3	Team WRT	155	
Ford Mustang LMGT3	Proton Competition	146	
Porsche 963	Hertz Team JOTA	71	
Corvette Z06 LMGT3.R	TF Sport	137	
Peugeot 9X8	Team Peugeot TotalEnergies	121	
Aston Martin Vantage AMR LMGT3	D'Station Racing	81	
Ferrari 499P	Ferrari AF Corse	55	
Ferrari 296 LMGT3	Vista AF Corse	54	

● LMGT3
Fastest lap Augusto Farfus [#31 BMW M4 LMGT3]
2m04.707s - 159.1 Kph

PP = Pole Position / **NC** = Not Classified / **DNF** = Did Not Finish

ROUND 07
6 HOURS OF FUJI

FUJI INTERNATIONAL SPEEDWAY
Japan

4.563 km - 16 turns
213 laps

GRID	CAT.	N°	DRIVERS
1	5	#06	K. Estre / A. Lotterer / L. Vanthoor
2	3	#15	D. Vanthoor / R. Marciello / M. Wittmann
3	15	#36	N. Lapierre / M. Schumacher / M. Vaxiviere
4	14	#93	J.-É. Vergne / M. Jensen / N. Müller
5	16	#12	W. Stevens / N. Nato / C. Ilott
6	17	#38	O. Rasmussen / P. Hanson / J. Button
7	6	#35	J. Gounon / F. Habsburg / C. Milesi
8	18	#94	S. Vandoorne / P. Di Resta / L. Duval
9	7	#50	A. Fuoco / M. Molina / N. Nielsen
10	2	#08	S. Buemi / B. Hartley / R. Hirakawa
11	10	#99	N. Jani / H. Tincknell / J. Andlauer
12	13	#83	R. Kubica / R. Shwartzman / Y. Ye
13	27	#54	T. Flohr / F. Castellacci / D. Rigon
14	32	#92	A. Malykhin / J. Sturm / K. Bachler
15	30	#46	A. Al Harthy / V. Rossi / M. Martin
16	20	#81	T. Van Rompuy / R. Andrade / C. Eastwood
17	22	#85	S. Bovy / M. Gatting / R. Frey
18	19 PP	#55	F. Hériau / S. Mann / A. Rovera
19	31	#777	C. Mateu / E. Bastard / M. Sørensen
20	23	#59	J. Cottingham / N. Costa / G. Saucy
21	26	#27	I. James / D. Mancinelli / A. Riberas
22	34	#31	D. Leung / S. Gelael / A. Farfus
23	24	#78	A. Robin / C. Schmid / K. van der Linde
24	29	#87	T. Kimura / E. Masson / J.-M. López
25	36	#60	C. Schiavoni / M. Cressoni / F. Perera
26	33	#91	Y. Shahin / M. Schuring / R. Lietz
27	28	#77	R. Hardwick / Z. Robichon / B. Barker
28	35	#88	C. Ried / M. Pedersen / D. Olsen
29	21	#95	J. Caygill / N. Pino / M. Sato
NC	4	#07	M. Conway / K. Kobayashi / N. De Vries
DNF	11	#20	S. van der Linde / R. Frijns / R. Rast
DNF	1 PP	#02	E. Bamber / A. Lynn
DNF	12	#51	A. Pier Guidi / J. Calado / A. Giovinazzi
DNF	25	#82	H. Koizumi / S. Baud / D. Juncadella
DNF	8	#05	M. Campbell / M. Christensen / F. Makowiecki
DNF	9	#63	M. Bortolotti / D. Kvyat / E. Mortara

● HYPERCAR

Fastest lap Charles Milesi [#35 Alpine A424]
1m30.943s • 180.6 Kph

CAR	TEAM	LAPS	TIME / GAP
Porsche 963	**Porsche Penske Motorsport**	**213**	**6h00:32.196**
BMW M Hybrid V8	BMW M Team WRT	213	+ 16.601
Alpine A424	Alpine Endurance Team	213	+ 42.321
Peugeot 9X8	Team Peugeot TotalEnergies	213	+ 45.846
Porsche 963	Hertz Team JOTA	213	+ 49.689
Porsche 963	Hertz Team JOTA	213	+ 51.916
Alpine A424	Alpine Endurance Team	213	+ 54.316
Peugeot 9X8	Team Peugeot TotalEnergies	213	+ 54.324
Ferrari 499P	Ferrari AF Corse	213	+ 57.874
Toyota GR010 Hybrid	Toyota Gazoo Racing	213	+ 58.879
Porsche 963	Proton Competition	212	+ 1 lap
Ferrari 499P	AF Corse	211	+ 2 laps
Ferrari 296 LMGT3	**Vista AF Corse**	**194**	**+ 19 laps**
Porsche 911 GT3 R LMGT3	Manthey PureRxcing	194	+ 19 laps
BMW M4 LMGT3	Team WRT	194	+ 19 laps
Corvette Z06 LMGT3.R	TF Sport	194	+ 19 laps
Lamborghini Huracán LMGT3 Evo2	Iron Dames	194	+ 19 laps
Ferrari 296 LMGT3	Vista AF Corse	194	+ 19 laps
Aston Martin Vantage AMR LMGT3	D'Station Racing	194	+ 19 laps
McLaren 720S LMGT3 Evo	United Autosports	194	+ 19 laps
Aston Martin Vantage AMR LMGT3	Heart of Racing Team	194	+ 19 laps
BMW M4 LMGT3	Team WRT	194	+ 19 laps
Lexus RC F LMGT3	Akkodis ASP Team	194	+ 19 laps
Lexus RC F LMGT3	Akkodis ASP Team	194	+ 19 laps
Lamborghini Huracán LMGT3 Evo2	Iron Lynx	193	+ 20 laps
Porsche 911 GT3 R LMGT3	Manthey EMA	193	+ 20 laps
Ford Mustang LMGT3	Proton Competition	193	+ 20 laps
Ford Mustang LMGT3	Proton Competition	192	+ 21 laps
McLaren 720S LMGT3 Evo	United Autosports	191	+ 22 laps
Toyota GR010 Hybrid	Toyota Gazoo Racing	163	
BMW M Hybrid V8	BMW M Team WRT	202	
Cadillac V-Series.R	Cadillac Racing	193	
Ferrari 499P	Ferrari AF Corse	168	
Corvette Z06 LMGT3.R	TF Sport	164	
Porsche 963	Porsche Penske Motorsport	163	
Lamborghini SC63	Lamborghini Iron Lynx	146	

● LMGT3
Fastest lap — Alex Riberas [#27 Aston Martin Vantage AMR LMGT3]
1m40.987s • 162.7 Kph

PP = Pole Position / NC = Not Classified / DNF = Did Not Finish

BAHRAIN

ROUND 08
BAPCO ENERGIES 8 HOURS OF BAHRAIN

BAHRAIN INTERNATIONAL CIRCUIT
Bahrain

5.412 km - 15 turns
235 laps

	GRID	CAT.	N°	DRIVERS
1	1 PP	1	#08	**S. Buemi / B. Hartley / R. Hirakawa**
2	7	2	#05	M. Campbell / M. Christensen / F. Makowiecki
3	18	3	#93	J.-É. Vergne / M. Jensen / N. Müller
4	14	4	#35	P.-L. Chatin / F. Habsburg / J. Gounon
5	9	5	#15	D. Vanthoor / R. Marciello / M. Wittmann
6	13	6	#02	E. Bamber / A. Lynn / S. Bourdais
7	11	7	#38	O. Rasmussen / P. Hanson / J. Button
8	12	8	#83	R. Kubica / R. Shwartzman / Y. Ye
9	17	9	#36	C. Milesi / M. Schumacher / M. Vaxiviere
10	6	10	#06	K. Estre / A. Lotterer / L. Vanthoor
11	5	11	#50	A. Fuoco / M. Molina / N. Nielsen
12	4	12	#99	N. Jani / H. Tincknell / J. Andlauer
13	8	13	#12	W. Stevens / N. Nato / C. Ilott
14	3	14	#51	A. Pier Guidi / J. Calado / A. Giovinazzi
15	21	1	#55	**F. Hériau / S. Mann / A. Rovera**
16	26	2	#81	T. Van Rompuy / R. Andrade / C. Eastwood
17	27	3	#82	H. Koizumi / S. Baud / D. Juncadella
18	36	4	#60	C. Schiavoni / M. Cressoni / M. Cairoli
19	32	5	#91	Y. Shahin / M. Schuring / R. Lietz
20	20	6	#59	J. Cottingham / N. Costa / G. Saucy
21	25	7	#54	T. Flohr / F. Castellacci / D. Rigon
22	19 PP	8	#95	J. Caygill / N. Pino / M. Sato
23	23	9	#92	A. Malykhin / J. Sturm / K. Bachler
24	22	10	#85	S. Bovy / M. Gatting / R. Frey
25	24	11	#27	I. James / D. Mancinelli / A. Riberas
26	29	12	#777	C. Mateu / E. Bastard / M. Sørensen
27	30	13	#31	D. Leung / S. Gelael / A. Farfus
28	31	14	#46	A. Al Harthy / V. Rossi / M. Martin
DNF	16		#63	M. Bortolotti / D. Kvyat / E. Mortara
DNF	15		#94	S. Vandoorne / P. Di Resta / L. Duval
DNF	34		#77	R. Hardwick / Z. Robichon / B. Barker
DNF	35		#87	T. Kimura / E. Masson / J.-M. López
DNF	2		#07	M. Conway / K. Kobayashi / N. De Vries
DNF	33		#88	G. Roda / G. Levorato / D. Olsen
DNF	10		#20	S. van der Linde / R. Frijns / R. Rast
DNF	28		#78	A. Robin / C. Laursen / K. van der Linde

● HYPERCAR

Fastest lap Sébastien Buemi [#8 Toyota GR010 Hybrid]
1m50.492s - 176.3 Kph

CAR	TEAM	LAPS	TIME / GAP
Toyota GR010 Hybrid	**Toyota Gazoo Racing**	**235**	**8h01:25.839**
Porsche 963	Porsche Penske Motorsport	235	+ 29.177
Peugeot 9X8	Team Peugeot TotalEnergies	235	+ 36.799
Alpine A424	Alpine Endurance Team	235	+ 37.404
BMW M Hybrid V8	BMW M Team WRT	235	+ 47.916
Cadillac V-Series.R	Cadillac Racing	235	+ 55.841
Porsche 963	Hertz Team JOTA	235	+ 1:00.834
Ferrari 499P	AF Corse	235	+ 1:03.539
Alpine A424	Alpine Endurance Team	235	+ 1:12.064
Porsche 963	Porsche Penske Motorsport	235	+ 1:19.711
Ferrari 499P	Ferrari AF Corse	235	+ 1:30.651
Porsche 963	Proton Competition	234	+ 1 lap
Porsche 963	Hertz Team JOTA	234	+ 1 lap
Ferrari 499P	Ferrari AF Corse	233	+ 2 laps
Ferrari 296 LMGT3	**Vista AF Corse**	**214**	**+ 21 laps**
Corvette Z06 LMGT3.R	TF Sport	214	+ 21 laps
Corvette Z06 LMGT3.R	TF Sport	214	+ 21 laps
Lamborghini Huracán LMGT3 Evo2	Iron Lynx	214	+ 21 laps
Porsche 911 GT3 R LMGT3	Manthey EMA	214	+ 21 laps
McLaren 720S LMGT3 Evo	United Autosports	214	+ 21 laps
Ferrari 296 LMGT3	Vista AF Corse	214	+ 21 laps
McLaren 720S LMGT3 Evo	United Autosports	214	+ 21 laps
Porsche 911 GT3 R LMGT3	Manthey PureRxcing	214	+ 21 laps
Lamborghini Huracán LMGT3 Evo2	Iron Dames	214	+ 21 laps
Aston Martin Vantage AMR LMGT3	Heart of Racing Team	214	+ 21 laps
Aston Martin Vantage AMR LMGT3	D'Station Racing	214	+ 21 laps
BMW M4 LMGT3	Team WRT	214	+ 21 laps
BMW M4 LMGT3	Team WRT	213	+ 22 laps
Lamborghini SC63	Lamborghini Iron Lynx	200	
Peugeot 9X8	Team Peugeot TotalEnergies	179	
Ford Mustang LMGT3	Proton Competition	178	
Lexus RC F LMGT3	Akkodis ASP Team	176	
Toyota GR010 Hybrid	Toyota Gazoo Racing	175	
Ford Mustang LMGT3	Proton Competition	148	
BMW M Hybrid V8	BMW M Team WRT	111	
Lexus RC F LMGT3	Akkodis ASP Team	36	

● LMGT3
Fastest lap Matteo Cairoli [#60 Lamborghini Huracán LMGT3 Evo2]
2m01.914s • 159.8 Kph

PP = Pole Position / DNF = Did Not Finish

/ HYPERCAR

FIA ENDURANCE CHAMPIONSHIP // DRIVERS

		QAT.	IMOLA	SPA	L.M.	SAO P.	AUST.	FUJI	BAH.	TOTAL
1	**A. Lotterer [DEU] / K. Estre [FRA] / L. Vanthoor [BEL]**	**38**	**18**	**18**	**24+1**	**18**	**8**	**25**	**2**	**152**
2	A. Fuoco [ITA] / M. Molina [ESP] / N. Nielsen [DNK]	12	12+1	15	50	8	15	2	0	115
3	K. Kobayashi [JPN] / N. De Vries [NLD]	15	25	6	36	12+1	18	0	0	113
4	B. Hartley [NZL] / R. Hirakawa [JPN] / S. Buemi [CHE]	6	10	8	20	25	0	1	38+1	109
5	F. Makowiecki [FRA] / M. Campbell [AUS] / M. Christensen [DNK]	23+1	15	0+1	16	15	6	0	27	104
6	M. Conway [GBR]	15	25	6	-	12+1	18	0	0	77
7	C. Ilott [GBR] / W. Stevens [GBR]	27	0	25	8	0	0	10	0	70
8	A. Pier Guidi [ITA] / J. Calado [ITA] / A. Giovinazzi [GBR]	0	6	12	30	10	0+1	0	0	59
9	R. Kubica [POL] / R. Shwartzman [ISR] / Y. Ye [CHN]	18	4	4	0	0	25	0	6	57
10	N. Nato [FRA]	27	0	-	8	0	0	10	0	45
11	F. Habsburg [AUT]	9	-	-	0	0	10	6	18	43
12	M. Jensen [DNK] / N. Müller [CHE]	0	2	1	0	0	0	12	23	42
13	J.-É. Vergne [FRA]	0	2	-	0	4	0	12	15	41
14	D. Vanthoor [BEL] / M. Wittmann [DEU] / R. Marciello [CHE]	0	0	0	0	2	4	18	15	39
15	E. Bamber [NZL]	0	1	0	12	0	12	0+1	12	38
16	J.-M. López [ARG]	-	-	-	36	-	-	-	-	36
17	C. Milesi [FRA]	9	0	2	0	0	10	6	3	30
18	P.-L. Chatin [FRA]	9	0	2	0	0	0	-	18	29
19	J. Button [GBR] / O. Rasmussen [DNK] / P. Hanson [GBR]	0	0	0	4	6	1	8	9	28
20	A. Lynn [GBR]	0	1	0	12	0	12	0+1	0	26
21	J. Gounon [FRA]	-	0	0	-	-	-	6	18	24
22	M. Vaxiviere [FRA] / M. Schumacher [DEU]	0	0	0	0	1	2	15	3	21
23	N. Lapierre [FRA]	0	0	0	0	1	2	15	-	18
24	J. Andlauer [FRA] / N. Jani [CHE]	3	0	10	0	0	0	0	0	13
25	S. Bourdais [FRA]	0	-	-	0	-	-	-	12	12
26	A. Palou [ESP]	-	-	-	12	-	-	-	-	12
27	R. Rast [DEU] / R. Frijns [NLD] / S. van der Linde [ZAF]	2	8	0	0	0	0	0	0	10
28	L. Duval [FRA] / P. Di Resta [GBR]	0	0	0	0	0	0	4	0	4
29	S. Vandoorne [BEL]	0	0	-	0	0	0	4	0	4
30	H. Tincknell [GBR]	3	0	-	0	-	0	0	0	3
31	D. Kvyat [RUS]	0	0	0	2	0	0	0	0	2
31	M. Bortolotti [ITA]	0	0	0	2	0	0	0	0	2
32	E. Mortara [ITA]	0	0	-	2	0	0	0	0	2
33	A. Serravalle [CAN]	0	0	0	0	0	-	-	-	0
33	C.W. Bennett [THA]	0	0	0	0	0	-	-	-	0
33	J.-K. Vernay [FRA]	0	0	0	0	0	-	-	-	0
34	A. Caldarelli [ITA]	-	0	0	0	-	-	-	-	0

FIA ENDURANCE CHAMPIONSHIP // MANUFACTURERS

		QAT.	IMOLA	SPA	L.M.	SAO P.	AUST.	FUJI	BAH.	TOTAL
1	**Toyota**	**23**	**25**	**12**	**36**	**25+1**	**25**	**4**	**38+1**	**190**
2	Porsche	38+1	18	25+1	24+1	18	10	25	27	188
3	Ferrari	18	12+1	18	50	10	18+1	6	3	137
4	Alpine	15	0	8	0	2	12	15	18	70
5	BMW	9	8	4	0	4	6	18	15	64
6	Peugeot	0	4	6	4	6	2	12	23	57
7	Cadillac	0	2	0	12	0	15	0+1	12	42
8	Lamborghini	2	1	0	8	0	0	0	0	11
9	Isotta Fraschini	0	0	0	0	-	-	-	-	0

	6 hours race	8h/10h/1812 km race	24h Le Mans
1st	25 pts	38 pts	50 pts
2nd	18 pts	27 pts	36 pts
3th	15 pts	23 pts	30 pts
4th	12 pts	18 pts	24 pts
5th	10 pts	15 pts	20 pts
6th	8 pts	12 pts	16 pts
7th	6 pts	9 pts	12 pts
8th	4 pts	6 pts	8 pts
9th	2 pts	3 pts	4 pts
10th	1 pt	2 pts	2 pts

+1 = bonus point for pole position

FIA WORLD CUP // TEAMS

		QAT.	IMOLA	SPA	L.M.	SAO P.	AUST.	FUJI	BAH.	TOTAL
1	**#12 Hertz Team Jota**	**38**	**15**	**25**	**50**	**12**	**0**	**25**	**18**	**183**
2	#38 Hertz Team Jota	0	18	0	36	25	18	18	38	153
3	#83 AF Corse	27	25	15	0	18	25	12	27	149
4	#99 Proton Competition	23	0	18	30	15	15	15	23	139

/ LMGT3

FIA ENDURANCE TROPHY // DRIVERS

		QAT.	IMOLA	SPA	L.M.	SAO P.	AUST.	FUJI	BAH.	TOTAL
1	**A. Malykhin** [KNA] / **J. Sturm** [DEU] / **K. Bachler** [AUT]	38	15+1	18	2+1	25	18	18	3	139
2	M. Schuring [NED] / R. Lietz [AUT] / Y. Shahin [AUS]	0	0	25	50	0	15	0	15	105
3	A. Rovera [ITA] / F. Hériau [FRA] / S. Mann [USA]	9	12	0	20	8	1	8+1	38	97
4	A. Farfus [BRA] / D. Leung [GBR] / S. Gelael [IND]	12	25	0	36	1	10	1	0	85
5	A. Riberas [ESP] / D. Mancinelli [ITA] / I. James [USA]	27	10	0	0	18	25+1	2	0	83
6	A. Al Harthy [OMN] / M. Martin [BEL] / V. Rossi [ITA]	18	18	0	0	10	0	15	0	61
7	D. Rigon [ITA] / F. Castellacci [ITA] / T. Flohr [CHE]	15	0	8	0	0	0	25	9	57
8	M. Gatting [DNK] / S. Bovy [BEL]	6	0	10+1	24	0+1	0	10	2	54
9	G. Saucy [CHE] / J. Cottingham [GBR] / N. Costa [BRA]	0	0	12	0	12	12	4	12	52
10	C. Eastwood [IRL] / R. Andrade [AGO] / T. Van Rompuy [BEL]	0+1	6	0	0	4	0	12	27	50
11	E. Bastard [FRA] / M. Sørensen [DNK]	23	1	6	12	2	0	6	0	50
12	R. Frey [CHE]	-	-	10+1	24	0+1	0	10	2	48
13	C. Mateu [FRA]	23	1	6	-	2	0	6	0	38
14	D. Juncadella [ESP] / H. Koizumi [JPN] / S. Baud [FRA]	2	4	0	4	0	4	0	23	37
15	D. Olsen [NOR]	3	0	4	30	0	0	0	0	37
16	M. Pedersen [DNK]	3	0	4	30	0	0	0	-	37
17	G. Roda [ITA]	3	0	4	30	-	-	-	0	37
18	J. Caygill [GBR]	0	8	0	-	15	6	0	6+1	36
18	M. Sato [JPN] / N. Pino [CHL]	0	8	0	0	15	6	0	6+1	36
19	C. Schiavoni [ITA] / M. Cressoni [ITA]	0	0	15	0	0	0	0	18	33
20	A. Robin [FRA]	0	0	1	16	-	2	0	0	19
21	M. Cairoli [ITA]	-	-	-	-	-	-	-	18	18
22	B. Barker [GBR] / R. Hardwick [USA] / Z. Robichon [CAN]	0	2	2	0	6	8	0	0	18
23	K. van der Linde [ZAF]	0	0	-	16	-	2	0	0	18
24	T. Boguslavskiy [RUS]	0	0	-	16	-	-	-	-	16
25	F. Perera [FRA]	0	0	15	0	0	0	0	-	15
26	S. Hoshino [JPN]	-	-	-	12	-	-	-	-	12
27	E. Masson [FRA] / T. Kimura [JPN]	0	0	0	8	0	0	0	0	8
28	J. Hawksworth [USA]	-	-	-	8	-	-	-	-	8
29	D. Pin [FRA]	6	0	-	-	-	-	-	-	6
30	C. Schmid [AUT]	-	-	1	-	-	2	0	-	3
31	R. Miyata [JPN]	-	-	1	-	-	-	-	-	1
32	J.-M. López [ARG]	0	0	0	-	0	0	0	0	0
33	C. Ried [DEU]	-	-	-	-	0	-	0	-	0
34	H. Hamaguchi [JPN]	-	-	-	0	-	-	-	-	0
35	B. Keating [USA]	-	-	-	-	-	-	0	-	0
36	G. Levorato [ITA]	-	-	-	-	-	-	-	0	0
37	C. Laursen [DNK]	-	-	-	0	-	-	-	0	0

FIA ENDURANCE TROPHY // TEAMS

			QAT.	IMOLA	SPA	L.M.	SAO P.	AUST.	FUJI	BAH.	TOTAL
1	#92	**Manthey PureRxcing**	38	15+1	18	1+2	25	18	18	3	139
2	#91	Manthey EMA	0	0	25	50	0	15	0	15	105
3	#55	Vista AF Corse	9	12	0	20	8	1	1+8	38	97
4	#31	Team WRT	12	25	0	36	1	10	1	0	85
5	#27	Heart of Racing Team	27	10	0	0	18	25+1	2	0	83
6	#46	Team WRT	18	18	0	0	10	0	15	0	61
7	#54	Vista AF Corse	15	0	8	0	0	0	25	9	57
8	#85	Iron Dames	6	0	10+1	24	0+1	0	10	2	54
9	#59	United Autosports	0	0	12	0	12	12	4	12	52
10	#81	TF Sport	0+1	6	0	0	4	0	12	27	50
11	#777	D'Station Racing	23	1	6	12	2	0	6	0	50
12	#82	TF Sport	2	4	0	4	0	4	0	23	37
13	#88	Proton Competition	3	0	4	30	0	0	0	0	37
14	#95	United Autosports	0	8	0	0	15	6	0	6+1	36
15	#60	Iron Lynx	0	0	15	0	0	0	0	18	33
16	#78	Akkodis ASP Team	0	0	1	16	-	2	0	0	19
17	#77	Proton Competition	0	2	2	0	6	8	0	0	18
18	#87	Akkodis ASP Team	0	0	0	8	0	0	0	0	8

Photo credits

Fabrizio Boldoni - Julien Delfosse - Thomas Fenêtre - André Ferreira - João Filipe - François Flamand - Florent Gooden - Germain Hazard - Marius Hecker - Javier Jimenez - Frédéric Le Floc'h - Clément Luck - Charly Lopez - Paulo Maria - Antonin Vincent - Jan-Patrick Wagner - Marcel Wulf

WEC Marketing Director
Marius Louvet

WEC Communication Manager
Lucas Vinois

WEC Media Manager
Russell Atkins

WEC Head of Design
Guillaume Guitard

Graphic Design, Layout
Camille Delahousse, François Meunier

Editorial Coordination
Sylvie Poignet

Production
Angeline Durand, Bernard Champeau

Photo-engraving
Les Caméléons, Paris

DPPI Director
Fabrice Connen

DPPI Manager for FIA WEC
Julien Delfosse

Printed and bound by Agpograf, in Barcelona, Spain
Fouth Quarter of 2024

FSC MIX Paper | Supporting responsible forestry FSC® C104592